Voices from the Stone Age

A Search for Cave and Canyon Art

VOICES FROM

Written and Illustrated by

DOUGLAS MAZONOWICZ

THOMAS Y. CROWELL COMPANY
Established 1834　New York

THE STONE AGE

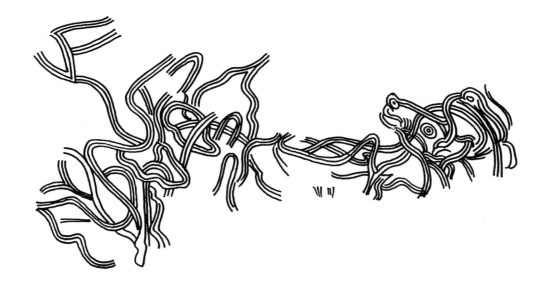

NOTE: Photographs marked with an asterisk (*) are reproduced from the author's actual-size screenprinted copies, and dimensions are given.

Copyright © 1974 by DOUGLAS MAZONOWICZ

Designed by ABIGAIL MOSELEY

Manufactured in the United States of America

ISBN 0-690-00574-1

Library of Congress Cataloging in Publication Data
Mazonowicz, Douglas.
 Voices from the stone age.

 Bibliography: p.
 1. Rock paintings. 2. Cave drawings. I. Title.
N5310.M33 759.01'1 74-8590
ISBN 0-690-00574-1

1 2 3 4 5 6 7 8 9 10

To my wife
LOTTI

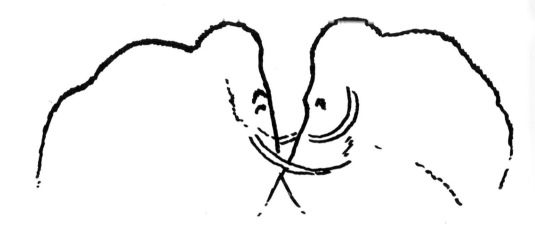

Two mammoths, Rouffignac, Les Eyzies, France.

Acknowledgments

A STRONG EMOTIONAL driving force is needed to change one's life pattern suddenly and completely, particularly on reaching middle age when habits are set and hard to break. To start afresh and commence new work in a strange country with no knowledge of the language requires a great deal of concentrated effort. Such a decision cannot gather momentum, nor can it be accomplished, without encouragement and practical assistance from a number of people.

In England, my early and absorbing interest in prehistoric art was originally sparked by the Honorable Robert Erskine, graphic gallery director and knowledgeable archaeologist, who provided my first commission to print a rock art scene. He later introduced me to the highest authorities, who, in turn, commended my efforts and gave me much valuable advice—Dr. Miles Burkitt and Dr. Glyn Daniel of Cambridge University. At the British Museum in London I enjoyed long talks with Dr. Kenneth Oakley and Gale Sieveking.

During April 1961, I showed my work to the late Abbé Breuil at his home in Paris, where we enjoyed a long conversation. His encouraging remarks and praise have since held me in good stead.

My wife and I were made to feel welcome in Spain by the generous assistance of Charles Harker and the warm friendship of Dr. Luis Pericot, whose excellent command of English provided a welcome relief from my poor efforts in Spanish. His advice concerning the museum, cave, and shelter sites proved invaluable during the years that followed, and we have

remained in close contact. I am grateful also for the detailed description of Spain's rock shelter sites kindly provided by Dr. Eduardo Ripoll, director of Barcelona's Museum of Prehistory. He sketched maps, listed the names and addresses of guides, and supplied the many fragments of information that are vital to successful fieldwork. I wish to stress the considerable aid and encouragement that Dr. Martín Almagro afforded me during our stay in Spain; for this I shall always be most grateful.

There were, of course, the guides, village dignitaries, and a host of Spanish friends who made life happier and easier for us. Although they need no reassurance of my gratitude, let one name embrace them all: Margarita Fabrega, a young village girl whose perfect English minimized many of our early and difficult experiences and who became a valuable liaison between suspicious villagers and two strange foreigners.

Following our decision to move west, our ties with the United States were greatly strengthened by kind cooperation from the Archaeological Institute of America, which sponsored my first lecture tour, and a most friendly union with the California Academy of Sciences, which programed my lectures and published several of my articles. In all, four traveling exhibitions of my works have been mounted and circulated by the Smithsonian Institution, Washington, D.C., a stamp of approval for which I am most honored. My wife and I have met so many helpful friends in the United States that to list them all is impossible. However, several have been exceptional in their efforts on our behalf, and have subscribed, albeit unknowingly, to the emergence of this book: Alan Gingritch, Campbell Grant, Bill Kidd, Dr. George Lindsay, Dr. Major McCollough, Robert T. Nickerson, and Dr. James Swauger. I am also most grateful to Roy Porter, Sheila Arnott, and the editors of Thomas Y. Crowell Company for their encouraging interest in my manuscript.

I am indebted to Lotti, who has withstood the rigors and uncertainty of an artist's wife for over twenty-five years, and to my brother Jack, who has been so close, understanding, and helpful to me since I was just a lad.

My greatest thanks and deepest respects are reserved for my fellow artists of a much earlier age: the men who worked so diligently and well in the caverns of prehistory, spontaneously producing an art that was totally mature at birth, an art that has never been equaled.

DOUGLAS MAZONOWICZ

California, 1974

Contents

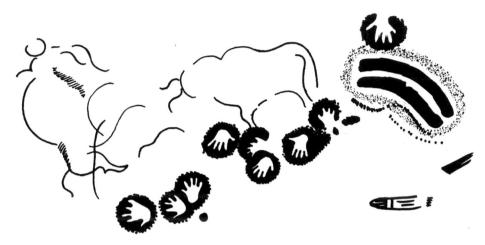

Stenciled hands, El Castillo, Puente Viesgo, Spain.

Introduction

DEEP WITHIN THE DARK CAVE, little Maria stood and stared. Suddenly the child's echoing scream pierced the silence, bringing a worried father stumbling into this far corner of the great cavern.

"Look, Papa! Look at the painted bulls!"

The year was 1879, the cave was Altamira in northern Spain. It was the first discovery of prehistoric paintings.

This early art, so recently brought to light, is of great importance, but its full significance has yet to be appreciated by modern man.

The Stone Age hunters have left to us a pictorial commentary that should be studied closely. The paintings depict a way of life that might return again in the wake of a universal plague or nuclear conflagration. Survival from such a holocaust would depend upon man's ability to make effective tools and hunting weapons. His philosophy would require adjusting to his new and strange surroundings, and the future would lie in agile hands and inventive minds, two great assets that are being sadly neglected in this computerized age.

We should seek and find these paintings, wherever they may be. Where possible, they should be protected, but above all, they must be recorded and carefully studied.

Can the paintings and engravings of the past help us to solve the problems of the future?

I believe that a great deal may be learned from the study of prehistoric art. More descriptive than words, and amid a mass of information, the

paintings highlight early man's failings and mistakes, blundering errors that almost brought the human race to the brink of extinction.

We are already witnessing the Stone Age pattern of behavior being repeated today, but now, unfortunately, at a highly accelerated pace.

In the following chapters I have attempted to describe the problems that confronted our early ancestors, and we can relate them to similar situations arising today.

Emerging from the study of prehistoric paintings comes the realization of the colossal wastage of food that existed in those far-off days when huge herds were slaughtered for the sake of a few. Man gave little thought to the future, and a "live for today" attitude prevailed. The increase in human population and the decrease of the animal species brought many grave problems. How were they solved?

Not by domesticating the herds, but by the invention of more effective hunting weapons and highly sophisticated ambush techniques.

The ancient cave and rock paintings tell a story. From dark caverns clear voices call out to us warnings and advice that we should heed before it is too late.

The following pages tell the story of a search, a journey that began fifteen years ago in London, then progressed through France, Spain, the Algerian Sahara, the United States, and is even still continuing.

It is a search for the earliest art of man—those countless thousands of prehistoric paintings and engravings that are to be found deep in underground caves, on rock ledges high in the mountains, in the middle of great deserts, in bare canyons, and in thickly wooded forests.

During recent years the search has become more concentrated and urgent. Prehistoric paintings have been discovered in many countries, in many parts of the world, and public interest has been aroused.

I often wonder if we realize how fortunate we are to be able to view these art works at this time. The 20,000-year-old paintings, so carefully preserved by nature, were completely unknown less than a century ago. Yet with the shocking rate of damage and vandalism continuing to intensify, these prehistoric treasures will soon vanish, wiped away by the unthinking hand of modern man.

Vandals, souvenir hunters, ignorant and careless visitors, construction engineers, all combine to obliterate the extremely valuable and decorative documentation that describes so vividly the day-by-day activities of our earliest ancestors.

This very birth of art, so recently discovered, must not be allowed to disappear. Every effort should be made to preserve what remains, and during the past few years I have done my utmost to help solve the problem.

But let me start at the beginning.

Until fifteen years ago my way of life was much the same as a million others. Army service during World War II had provided all the adventure that I expected ever to encounter. Aged forty, married, no children, a comfortable home an hour from London, small studio, a teaching job at a

local art school, Rotary every Thursday, and golf on the weekends—a repeating pattern that was unlikely to change.

Then along came a day that was different from all others.

The time: late afternoon in December 1959.

The place: West End of London, England.

The weather was cold and bright, the drive up had been pleasant, my car was safely anchored beside a parking meter, the Christmas lights and tinsel of Bond Street glittered in the setting sun. I had a few calls to make and a little shopping to do. As I turned into Cork Street a sign in the window of St. George's Gallery caught my eye:

STONE AGE PAINTINGS OF EASTERN SPAIN—LAST DAY OF EXHIBITION

Being an artist I was mildly curious. A quick look wouldn't hurt. I entered.

Hours later and full of excitement I drove hurriedly away from London. My life had suddenly and remarkably changed. My thoughts and plans went racing ahead. We would sell the house, I would resign my job, Rotary, and golf. On this day I had decided to devote my future to making accurate copies of the world's oldest masters wherever they might be found.

It was quite a day.

What happened during the following years is the subject of this book.

Archer, Valltorta, Castellón, Spain.

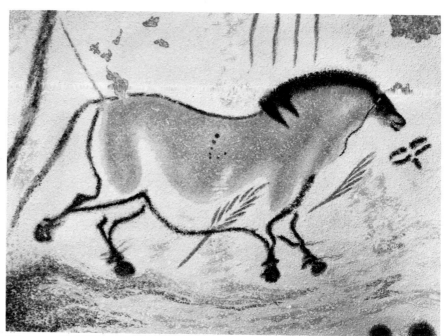

The so-called "Chinese Horse," Lascaux, France.

1
The Painted Caves of France

It RAINED HARD all night, but I had been warned that it would be particularly wet in this region of southern France during the months of July and August, and the year of 1960 was no exception. The narrow streets of Montignac were drenched, and as I drove through the little town and crossed the bridge, the mud-discolored waters of the Vézère swirled below.

Thickly wooded hills covered the south bank of the river, and the road twisted upward. Within minutes my short journey ended abruptly as the narrow track led into a car park. Although early in the day, the parking attendant hurried through the constant stream of new arrivals to collect his dues. The vast number of visitors at this time of year would keep him busy all day long.

For here was the great painted cave of Lascaux, a cavern that had attracted thousands of sightseers since its opening in 1948 eleven years previously, and this year's attendance eventually broke all records. Despite the drizzling rain, a long line had formed and as we shuffled forward I overheard snatches of conversation in several languages. Mosquitoes had been most active during the night and the skin irritation increased as rivulets of rain trickled across my face and down my neck. I silently hoped that this visit to the cave would compensate me for my present discomfort, the expense, preparation, and planning that the trip had entailed.

The long wait—which was occasionally punctuated by short bursts of forward movement—gave me time to think over the past months and review once again the many important decisions that I had made since my fateful December visit to St. George's Gallery, London.

I remembered entering the bookshop and walking along the narrow corridor that led to the small gallery. The four sides of the display area were covered with large watercolor copies of ancient rock paintings from eastern Spain. These meticulous works, transcribed by J. B. Porcar, had taken months to complete and mirrored the finest examples of Mesolithic art yet discovered in the mountains of eastern Spain.

The Honorable Robert Erskine, gallery owner, archaeologist, and friend, described the paintings to me in detail. Though primarily interested in graphic art and printmaking, Robert possessed a great love for ancient painting. The small exhibition was extremely well presented and had quickly won the great acclaim it so richly deserved. Television, radio, daily press, and glossy magazines all had featured the brilliant though tiny show.

Only six works were on view, and each depicted a version of early man's way of life. A battle scene was most impressive, but one large panel stood alone and dominated the whole display. It was an eight-by-four-foot composition in watercolor that portrayed a boar hunt, a scene full of incident which was undoubtably the finest painting of its kind so far discovered.

Robert told me of the many museum curators and private collectors who wished to have this copy.

"Could you," he asked, "produce accurate copies of this watercolor by utilizing your knowledge of the screenprinting technique? Is there equipment and paper available for such large works? Would it be possible to print by hand, at an economical price, one hundred copies?"

Before replying I carefully considered the problems involved. There were no supplies immediately available for such an operation—therefore I would have to make my own equipment. Screenprinting had been my specialty for many years, and it was the subject I taught at the art school. I held no doubts about being able to capture in serigraphy an exact likeness of the original.

But the physical aspect of the proposal held many problems. Large studio space would have to be found. An enormous screen, working surface, and over a hundred drying racks would have to be made. Every item of the equipment and materials I normally used would have to be magnified ten times.

I described to Robert Erskine the problems of preparation. The making of equipment alone would take several weeks; in the meantime inks, paper, and other materials must be ordered. Only when all was ready would we know for certain whether I could carry out in practice what I considered possible in theory. I ended by saying:

"This is an exciting challenge, Robert. I'd like to try."

And I did, with great success.

The whole operation took three months to complete, and it was with mixed feelings that I placed the last print onto its drying rack. Relief that all had gone so successfully—yet sadness that it was over and finished. It was then that I reaffirmed my decision to continue with the work in which I had been immersed so suddenly. I also decided that for my next series I would

gather material by visiting the caves personally, where I would make tracings and take photographs from carefully chosen examples at the sites concerned before returning to my studio to make the finished prints.

Perhaps within a year I would have sufficient works to display in London; then, with luck, my future would be assured. It would mean working hard every day for a whole year with no income. How could such a program be financed?

My wife and I held a long discussion.

By selling our house and moving into a rented apartment we could raise the necessary capital. Time was of vital importance. I would resign from all associations and concentrate solely on the task I had chosen. Next came the research work. Which site or cave should be visited first? I read all I could on the subject, I wrote to the authors and visited them at their homes. All of them applauded my intentions, helped me all they could, and wished me well. They were unanimous in their advice: the paintings of the great cave of Lascaux should be my first series. Yet each person added a warning note:

Waste no time.

So, here I was, standing patiently in line, armed with letters of introduction, camera equipment, tracing plastic, tape measure, and sketching pads. There was no other method of reaching the cave entrance but to shuffle slowly forward. It was comforting to know that quite soon, after the presentation of my documents, I would be receiving VIP treatment!

At the box office a lean old man was busily occupied collecting admission fees, while groups of twenty ticket holders were being herded like cattle into three separate small corrals to await entry.

My French was poor and limited to a few words so, mumbling a greeting, I handed over the letters I had been given by the Cultural Department of the French Embassy in London. With mild interest he read the pages quickly, passed them back, and spoke rapidly in French.

I would not be allowed to stay and work in the cave.

This was a bitter blow indeed. All the planning, expense, and trouble for nothing. Feeling sick with disappointment, I asked if I might at least view the paintings. This he agreed to, and went on to explain carefully the rigid rules that must be enforced. Accompanied by a guide, visitors were allowed into the cave in groups of twenty but were not permitted to stay longer than twenty minutes, at which time they must leave to allow entry of the next batch of waiting people.

Undaunted I tried again.

"Supposing," I asked, "I went in with a group and left at the appointed time, then rejoined the line to make yet another visit. Would this be permitted?"

Open-mouthed, he stared blankly for a moment.

"If monsieur abides by the rules," he said slowly, "he may enter the cave as often as he wishes. The important thing for monsieur to remember is that on each occasion he must pay for admission—three new francs."

And so began my strange work schedule.

I passed through a large metal door into a small chamber and was

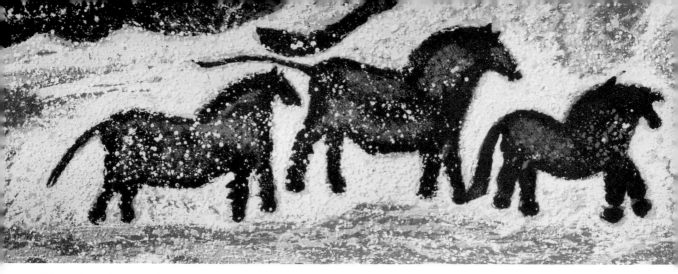

Frieze of small horses, Lascaux.
*(27 × 67 in.)**

surprised by the hum of electric motors operating a special air-conditioning device. While the guide briefly told the story of the cave's discovery, hot bodies were cooling down in readiness for the entry through another steel door into the main painted hall of the cavern.

As if in a cathedral, people talked in whispers as they gazed at the hundreds of animals—large ponderous bulls, charging bison, delicate deer, trotting horses, goats, and ponies—painted in bright colors on a background of dazzling white calcite. The cave was dimly lit with concealed electric lamps, and the guide pinpointed interesting features with a small flashlight. His chanting words and gestures had been repeated innumerable times; he refused to be interrupted, and exactly twenty minutes later his expressionless, bored face and open hand wished everyone *au revoir* while he scanned the next group of twenty people, herded in a small pen awaiting their turn.

I left the wonderful cave of Lascaux feeling slightly dazed. In such a short time it was not possible to absorb fully the hundreds of painted animals that appeared to prance over the calcite-covered walls and ceilings. Heavy bulls—over sixteen feet long—jostled for space with tiny deer. Leaping cows straddled groups of small ponies, and ibex butted one another like animated bookends. Rounding a sharp corner, I was suddenly confronted by two large black bison, shown rushing away in opposite directions. In the stillness, one could almost hear the animals' stampeding hooves as they hurried to escape capture.

The artist was entirely successful in his intent to shock and surprise. The painting, with its suddenness of impact, showed the underlying humor of a keen and intelligent mind.

With my first visit to a painted cave came an awareness that I could never be content simply with recording and copying these magnificent works. Being an artist, I felt an overwhelming desire to delve deeper into the mysteries that shroud prehistoric cave paintings.

Feeling more determined and much happier, I joined the line again and moved slowly forward toward my second glimpse of this underground wonderland.

When the guardians arrived to unlock the cave each day, there they would see me patiently waiting. Only the mornings were spent at the cave of Lascaux; during the afternoons I visited important authorities in the area in vain attempts to improve my present method of research. They were most sympathetic but held little hope. Lascaux was privately owned and written permission must be obtained from Paris; this could take weeks. They explained that under the circumstances I should consider myself most fortunate, for this might well be the last opportunity to view the paintings. There was talk of closing the cave (I recalled the warnings of my friends). Perhaps next year it would be too late.

While my slow cuckoo-clock working schedule continued, my standing with the guides greatly improved. On leaving the cave after each twenty-minute visit, I was escorted immediately to the head of the line, a privilege for which I was most grateful. I grew friendly with Jacques Marsal, who one day related to me, in halting English, the detailed story of his great discovery.

At the age of fourteen he was out walking with three friends and his small dog Robot. The date was September 12, 1940, and the spot was one mile from the little town of Montignac. The dog, on finding a largish hole, disappeared from sight, and it was decided that one of the boys should go after him to find out what had happened. After covering a short distance the ground beneath the boy subsided and he fell several yards down into a cavern. He called for the others to follow and they all lit matches to take stock of their surroundings.

The scene was a paradise of artistic magic—a very large cavern with walls and ceiling coated with dazzling white calcite crystals on which were painted in beautiful colors the many animals that abounded in prehistoric days. The massive bulls, the smaller cows, and the groups of stags were all animated by the flickering light from the boys' matches. For 20,000 years the secrets of the cave had lain hidden and sealed, and might not have been seen for another such period of time but for the scratching of an inquisitive dog.

*Two male bison, Lascaux. (48 × 93 in.)**

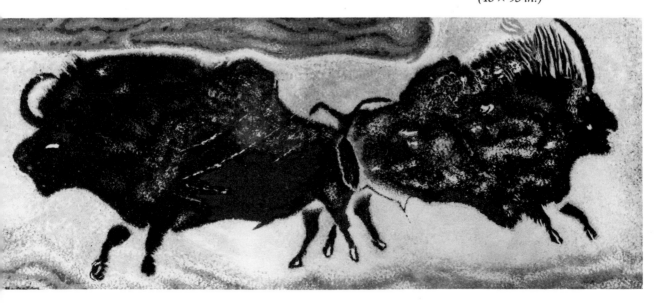

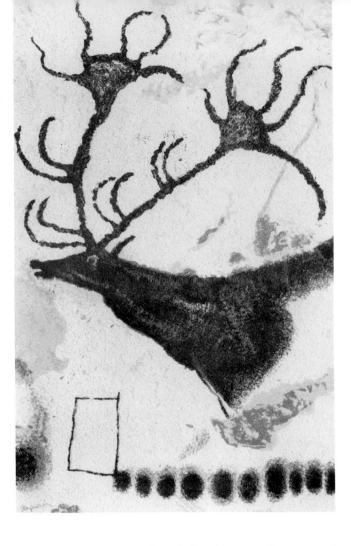

*Head of a stag with enlarged
antlers, Lascaux. (48 × 29 in.)**

The boys decided to keep their newly found "headquarters" secret and return the next day with more adequate lighting to make a really thorough inspection. Their second exploration revealed two more galleries containing wonderfully preserved paintings of horses, deer, bison, and bulls. Realizing at last that they had stumbled onto something of immense historical value, they returned to the town and reported their find. The news was flashed to Paris, resulting in the early arrival on the scene of many eminent authorities led by the late Abbé Breuil, who explained the paintings to the journalists and sightseers assembled. The cave was then sealed until a more detailed study could be made. The young explorers were given a tent, some food, and the responsibility of guarding their find until special protective measures could be arranged.

Even today, Marsal and his friend Ravidat are still the official guides and custodians of their memorable find.

There were many other painted and engraved caverns in the area, and, though of less importance than Lascaux, I visited them all. My letters of introduction proved most helpful; I photographed and worked happily and at leisure. For a few days I stayed at the modest Hôtel de la Poste in the

small village of Les Eyzies, and at the local museum I obtained a guidebook, written in English, containing maps and detailed information about the locations of the many caverns in the region.

The following list describes briefly the more important cave sites, all of which are easy of access, open to the public, and situated within a few miles of Les Eyzies:

FONT DE GAUME

The cave was discovered in 1901 by D. Peyrony, and is situated less than two miles from the village of Les Eyzies. A narrow, well-maintained path leads up to the sealed entrance, where guides are available and an admission fee charged.

The painted gallery is over a hundred yards long, and to date, two hundred paintings and engravings have been recorded, many drawn one over the other. This superposition permits placing the art works in an approximate chronological order, covering a period of 10,000 years or more, and seven distinct styles are evident. Stenciled hands are covered in places by drawings in red and black; these in turn are painted over with dark

Horse in black, Font de Gaume, Les Eyzies, France.

Reindeer, Font de Gaume.

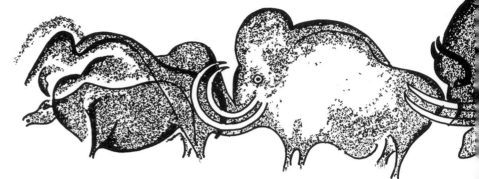

*Frieze of mammoth and bison,
Font de Gaume.*

brown pigments. Then follow deep incised outlines filled with red, yellow, and black colors. The last works consist of finely engraved lines that depict animal forms, many of which are mammoth.

The cave is famous for its great frieze of animals overlying one another that stretches for yards along the cavern's wall. Bison, deer, mammoth, and horses form a magnificent procession—though some are face to face. It is a great pity that several of the paintings near the cave's entrance have been mutilated and damaged by graffiti.

LES COMBARELLES

Situated three miles from Les Eyzies, the cave is just off the roadside and is easily located. It was during the year 1901 that the engravings were first noticed, and since that time over three hundred drawings have been recorded. The long narrow twisting gallery penetrates 250 yards into the hillside. It contains no paintings, but its walls are literally covered with

*Two engraved horses sharing a
single mane, Les Combarelles,
Les Eyzies.*

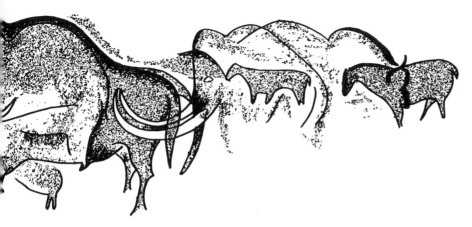

finely engraved figures, some isolated, others superimposed, but almost all of them clearly recognized even by the untrained observer. Many animals are depicted: horses, bison, deer, and ibex. But I have three great favorites: the head and shoulders of a female lion, the full figure of a cave bear, and the finest of all, a small delicate deer shown in the attitude of drinking.

Among the more familiar drawings of animals, there are also strange engravings thought to represent human beings, though they are shown with animal heads (masks?) or distorted and grotesque human heads.

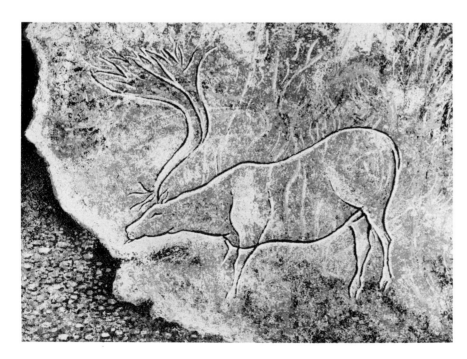

*Engraved drinking deer, Les Combarelles. (20 × 26 in.)**

Engraved head of a lioness, Les Combarelles.

Engraved wounded cave bear, Les Combarelles.

The engravings at Les Combarelles present a dating problem, as it is harder to determine the order of superimposed and interwoven engraved lines than of the painted figures of other caves; yet the most recent of the drawings date back almost 15,000 years.

Visitors to Les Combarelles should resist the guide's attempts to make the stay brief. It is a remarkable cave, crowded with excellent engravings.

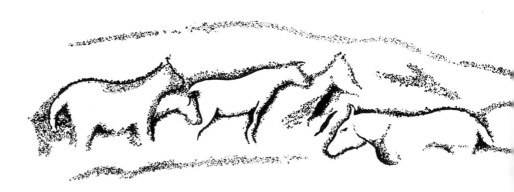

CAP BLANC

This site is not a cave but a sealed-off cavity sheltering beneath a rock overhang, just four miles from Les Eyzies. During 1914, when excavations were being carried out, a prehistoric burial place was discovered and it was decided to remove and examine the earth right back to the vertical rock face. It was here that a surprise awaited the archaeologists, a work of art so remarkable that a protective building was hastily constructed.

On removal of the soil, bas-relief sculptures of six horses and two bison were exposed. The sheer elegance and beauty of these almost life-size animals is quite astonishing. The artist's care for detail is immediately apparent. I have never seen a photograph that does justice to this fine work of art, and to appreciate its magnificence one must view the forty-foot-long frieze firsthand. With the primitive tools available, this monumental work must have taken many weeks to complete.

LA MOUTHE

A little over a mile from Les Eyzies, the cave entrance has been walled up with rough stones, and an ancient wooden door is at its center. Within the entrance, the farmer stores his field tools, winter firewood, and boxes of slowly rotting apples and potatoes. There is no artificial light, and one must follow the guide closely along the narrow passage, avoiding sharp protuberances that hang from the ceiling. It was first examined in 1895 when traces of incised lines were noticed. The 140-yard-long corridor contains engravings of horses, bulls, bison, and ibex; yet the cavern is noted mainly for its solitary small, strange painting that is located low down upon the wall at the cave's furthermost point.

It is thought to be a prehistoric hut, the only one seen in cave art, with

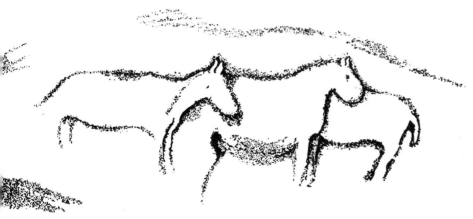

Frieze of sculptured horses, 40 feet long, Cap Blanc, Les Eyzies.

Prehistoric hut: painted and engraved, La Mouthe, Les Eyzies.

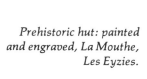

stripes of red and black pigment representing logs of trees placed tightly together and joined at the top to form a tent-shaped construction. In such crude shelters, men must have lived during the warm seasons. In winter they would seek refuge just within the cave entrances under the rock overhang. Without doubt they would return to their outdoor shelters as soon as weather permitted.

BARA-BAHAU

Situated at Le Bugue, almost eight miles from Les Eyzies, this cave with its strange sounding name is a fairly recent discovery (1951) and one that improves with acquaintance. It is a large, high, and wide cavern with enormous boulders that block the passage and prevent further exploration fifty yards from its entrance. The name Bara-Bahau, in local dialect, describes the sound of falling rocks.

Engraved bull, Bara-Bahau, Le Bugue, France.

Its main interest lies in the large, crudely drawn engravings that cover the cave's ceiling. There are no paintings, but several macaroni-like scrawls made by dragging the fingertips through the soft clay. Once again the animals portrayed are bulls, bison, and horses. The cave is well lit, and illuminated drawings on glass are positioned beneath each panel of engravings to help with recognition.

LA GRÈZE

Apart from a single engraved bison measuring twenty-three inches long, there is little to be seen in this cave. There are traces of a horse, an ibex, and a low-relief sculpture of a bison.

The key to the cave is kept by the same guide who is in charge at Cap Blanc.

*Engraved bison, La Grèze,
Les Eyzies.*

ROUFFIGNAC

The cavern is ten miles from Les Eyzies, and is well known because of the doubt that has arisen regarding the authenticity of its paintings, which were not discovered until 1956. It is indeed strange that this cave, familiar always to the local inhabitants, should have kept its paintings so secret until quite recently.

Some authorities believe that members of the Resistance made the drawings while occupying the cave during World War II. There are many modern words and initials scribbled in charcoal on and around the black paintings that are apt to create feelings of doubt. Although a few forgeries may exist, I am convinced that most of the paintings are authentic, particularly a large ceiling panel that one could pass by unnoticed. The

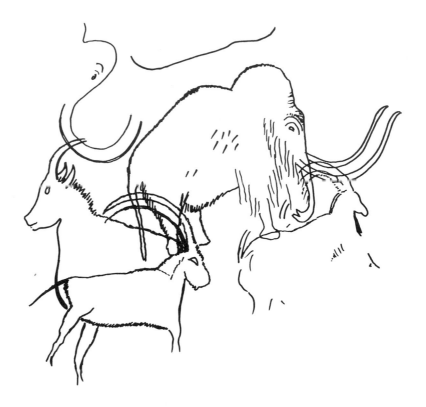

Mammoth and ibex in black outline, Rouffignac, Les Eyzies.

horses, drawn in black line and partially obscured by lampsmoke, are reminiscent of the fine paintings at Niaux cave in the Pyrenees.

The maze of galleries that make up this enormous cavern stretch, turn, and twist for seven miles into the hillside. However, a small electric train

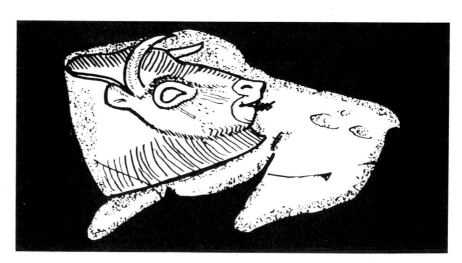

Bison licking itself: carved bone, La Madeleine, Les Eyzies.

takes the visitor comfortably through the cave, halting briefly at each panel of paintings.

Leaving the valley of the Dordogne, I traveled south to visit and photograph five more important cave sites.

PECH-MERLE

This large and important cavern lies two miles from the village of Cabrerets and twenty miles from the city of Cahors. The entrance reminds one of a subway station, with souvenir and refreshment stands, and a small gift shop.

The well-lit interior is festooned with stalactites and stalagmites, while the black line drawings of bulls and mammoths stand out clearly on the dazzling white calcite background. The most interesting panel consists of two large dappled horses, back to back, their bodies and immediate surroundings covered by sprayed black dots.

On the ceiling of the main hall are finger meanderings on clay. Many of the figures thus drawn resemble mammoths, and human female forms.

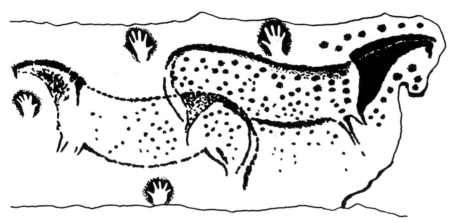

Spotted horses and stenciled hands, Pech-Merle, Cabrerets, France.

COUGNAC

The cave is at Gourdon, seventeen miles from Sarlat, and was sealed up prior to its discovery in 1952. Compared with many caves, this one is remarkably clean, bright, and fresh-looking. Needles of stalactites hang everywhere, and on the white calcite-covered walls the paintings in red and black stand out clearly. Crystals of clear calcite have since formed over the paintings, providing a delicate porcelain effect and proving also their great antiquity.

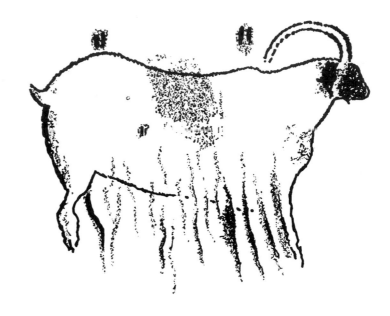

Ibex painted in red outline over calcite formation, Cougnac, Gourdon, France.

Sheep and ibex predominate and, though few in number, the paintings are of a high quality. The artist has used the natural calcite curtaining to good effect; the deep vertical ridges representing the creature's long shaggy coat add a third dimension to the work.

GARGAS

Although of great interest, this cave is not among my favorites. It lies at the foot of the Pyrenees at Aventignan, a few miles from Montréjeau. It has a tunnel-like entrance that leads into a series of large rooms. A few animal engravings exist, but the cave is noted mainly for its hundred or more stenciled hands that cover the walls. Many of the hands, some belonging to children, show mutilation, with one or more fingers missing. Careful examination of the walls and ceiling shows animals outlined in the clay, but several drawings have been partially obscured by the claw marks of cave bears. Yet the mysterious hands are everywhere.

The artist would hold his hand still and flat against the cave wall. Then he would place a small hollow bone filled with powdered pigment between his lips and blow the fine grains over and around the hand, leaving a negative imprint on the rock surface.

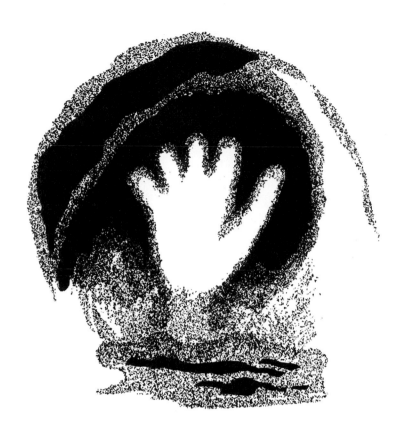

Stenciled hand showing mutilations, Gargas, Aventignan, France.

Stenciled hands occur in almost every painted cave in France and Spain. I was later to see them in Arizona, Utah, and in the middle of the Sahara Desert. They also appear on cave and rock shelter walls in Australia, Ethiopia, and South Africa.

What do the stenciled hands signify?

It is difficult to determine. One theory connects them with the hunting ceremonies and suggests that, on the completion of a successful kill, the hunters would sacrifice a joint from the finger and at the same time record the action in paint. Many of them do, in fact, show severe mutilations.

It is also possible that a disease such as leprosy may have been prevalent in those far-off days. This too could account for the missing joints. Yet the thumb is hardly ever mutilated, and imprints showing joints of the little finger missing are the most common.

Interesting, yes, but gruesome and unpleasant. A morbid and sad atmosphere pervades Gargas.

LE PORTEL

This cave is at Loubens, eight miles from Foix. It is privately owned and permission to enter must first be obtained from its owner, M. Vezian.

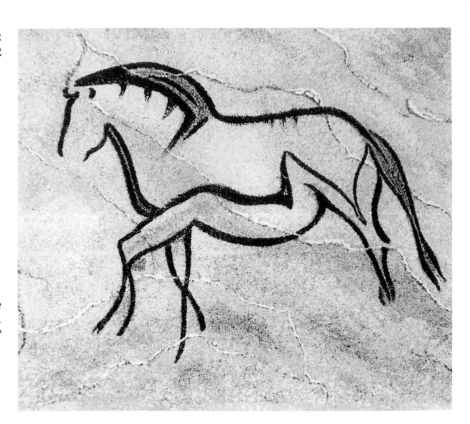

*Horse in black line pawing the ground, Le Portel, Loubens, France. (22 × 30 in.)**

Although not open to the public, I mention it here because it has one of the most beautiful horse paintings I have ever seen.

Without doubt, this is one of the most charming cave drawings so far discovered. No color is used, but the boundaries of the color areas are indicated by strong black lines. Every part of the animal's outline is expressive, a perfect interplay of lines that provides a remarkable sense of movement.

NIAUX

I have left until last this famous and wonderful cave, which is possibly the greatest of all the French caverns. The paintings are not the largest, nor are they the most colorful or the most plentiful. The cave's great charm lies in the high quality of the paintings, and in the actual location of the art works. In many caves, certain areas have been set aside for the engravings and paintings. Usually found in the far reaches of the caverns, these carefully chosen sanctuaries were used for ancient ceremonies, and in such special places we find the finest works of art.

Niaux cave is a brilliant example.

The wide-mouthed entrance is high on a mountainside two miles from the town of Tarascon-sur-Ariège near the Pyrenees. As I passed through a

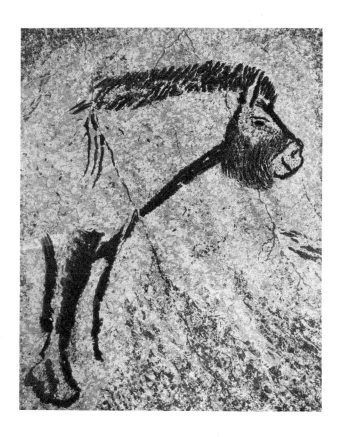

*Bearded horse in the
Salon Noir, Niaux,
Tarascon-sur-Ariège,
France. (31 × 24 in.)**

series of metal doors, I was pleased to note that no artificial illumination had been installed, for the heat produced by electric lamps can seriously affect the cave's temperature that remains constant throughout the year.

The guide handed me a carbide gas lamp that hissed and spluttered as we made our way through the long wide passages. Wading through shallow subterranean lakes we eventually came to a crossroads. As I hesitated, the guide's lamp revealed a cornerstone on which were painted strange unintelligible symbols—a prehistoric signpost pointing the way. Toward the end of the long gallery we climbed steeply over a sand-covered floor until we could go no farther.

I found myself standing in the center of an almost circular hall of calcite, with the walls reaching up to a domed ceiling 250 feet above my head. The walls of this rotunda were punctuated at regular intervals by a series of four alcoves, large cavities in the rock that held the paintings. We were in the famous sanctuary named the Salon Noir—the hall of the black paintings.

It is an unforgettable experience to stand silently in the center of this prehistoric temple and admire the mastery of the world's earliest artists. The mounting excitement of passing through the long dark corridors reaches a climax in the Salon Noir, and the sudden impact of the paintings is overwhelming.

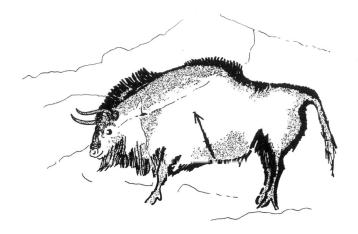

Bison struck by spears, Niaux.

Almost fifty animals cover the alcove walls: bison, horses, ibex, and a solitary deer. Many of the drawings are superimposed one upon the other, and lances or spears in red and black are shown on the hides of the animals. Most could be the work of the same artist, yet the various animals appear to possess individual characters, and several seem to be smiling like the little bearded horse that bears a resemblance to the Mona Lisa painting.

The visit to Niaux had taken over three hours, and provided a fitting experience with which to terminate my journey through the caves of France. The foregoing descriptions include almost but not all the painted caves in France. I have listed the ones I have personally visited that are not difficult of access and do not require special permission. I have not dwelled upon my varied and oftimes harassing experiences at low-budget hotels, camping, or hostel accommodations, or upon the language barrier that I encountered when trying desperately to learn as much as possible from the guides. Even the simple matter of looking for lodgings became a daily major operation, and I was beginning to feel the strain.

My work in the caves had progressed well, and it was now time to leave. I was anxious to return to England and begin printing the large Lascaux panels. From the vividly painted walls of that great cavern I had already chosen six subjects: a frieze of small horses; the head of a magnificent bull; two stampeding bison; a group of running deer; the head of a deer with enlarged antlers; and lastly, a trotting horse delicately painted in yellow and black, possibly the most decorative subject of all. Other print editions would eventually emerge from the vast amount of material that I had collected during those few weeks in France, but they had to wait until I had completed the Lascaux series.

Back in England, as the winter months passed, the screenprinting of the large panels proceeded smoothly. The work of retracing the lines of

prehistoric man was utterly fascinating. I grew increasingly excited as each print edition was completed, and in March 1961 my copies were displayed at the St. George's Gallery in London.

The press, magazine, and TV reports were most flattering in their praise, and the sales of prints increased accordingly. The lean year of hard work and expense had proved to be well worth while.

With a great feeling of satisfaction, I began to plan my next journey into prehistory.

It was at this time that I decided to show my work to the world's greatest authority on cave art, the Abbé Breuil. We had previously corresponded, and his advice and encouragement had been invaluable.

On April 12, 1961, I flew from London to Paris and, with a set of prints under my arm, made my way to the Avenue de la Motte Picquet. Fortunately, Miss Mary Boyle—his assistant and close companion for many years—was present at the meeting and able to translate when necessary. The three of us enjoyed an interesting conversation. At the time of my visit the Abbé was eighty-four and, though he experienced difficulty in standing for long periods, his mind was still extremely active.

He thoroughly scrutinized my work and asked many questions regarding the technique I employed in making the copies. The largest of the Lascaux panels filled his tiny apartment which already overflowed with books, papers, and maps. His future plans, he told me, would include a visit to Spain. Would I care to work with him on his next project?

A dream come true but, alas, one that never did materialize. His sudden death later that year robbed the world of its greatest prehistorian.

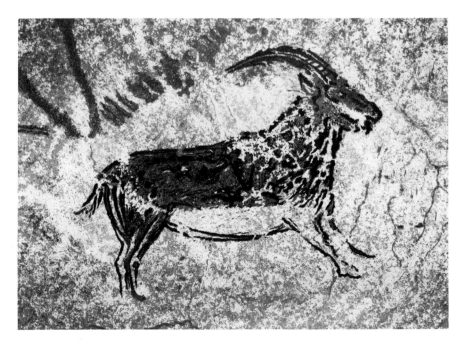

*Ibex in black, Niaux. (24 × 30 in.)**

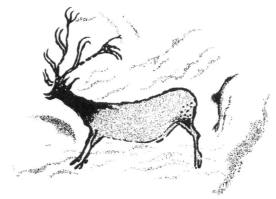

2
The Green Sickness

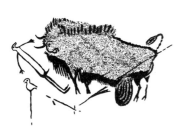

Scene from the well, Lascaux.

STANDING QUITE STILL deep within a cave, the silence becomes heavy and intense. The only sounds come from the guide's quiet breathing and the hiss and occasional sputter of his carbide gas lamp. Suddenly, somewhere, a drop of water falls from a stalactite, and the sound waves, like miniature explosions, vibrate and echo along the narrow passages and through the great, high-ceilinged halls of rock and calcite. It is a strange unknown world of darkness and silence.

For the visitor, the cave's constant temperature of around 50° F. makes it refreshingly cool in summer and comfortably warm in winter. Except for a few bats that hang near the entrances, nothing lives or moves in these solitary caverns. Passages often stretch for miles into the mountains, twisting and turning, rising and falling, only to double back again around sharp corners. The floor is wet and slippery, the walls feel damp and slimy to the touch. The guide constantly warns, *"La tete, monsieur!"* or *"Su cabeza, señor!"* and, without understanding the words, one learns quickly, for sharp stalactites scrape the scalp and stumpy stalagmites trip the unwary. Both hands are needed to negotiate the boulder-strewn passages, and much comfort is gained from the knowledge that the guide is as well acquainted with every inch of the cave's dark interior as he is with the sunlit world outside.

In such an atmosphere, the heart beats a little faster—imagine the feeling of excitement when the soft light of the hand lamp falls upon a charging bison or leaping stag. The paintings, animated by flickering

Hand lamp used by the cave artists, discovered at La Mouthe.

flames, would undoubtedly stir the hearts and minds of the prehistoric hunters who stood in the dark cavern and gazed at them with respect many thousands of years ago.

Here men gathered prior to departing for the hunt. It is believed that in these places they performed their acts of magic, rituals to ensure the hunt's success. Here in the dark cave they would become accustomed to facing—in the imagination—what they would soon have to confront in reality. The hunting and killing of bison and other large beasts was an absolute necessity, a task fraught with danger and accomplished only through bravery and confidence. Familiarity with the adversary in the dark cavern would help to breed contempt for him on the day of the kill, and the hunter's fears would accordingly diminish.

This is but one theory. Another, and I think more likely, explanation of the paintings is that the hunter, always fearing the possibility of the animal's failing to appear, wished to create a realistic likeness of his source of food, and so in some mysterious way insure the continuance of the species. To assist him in this task, he carefully chose for his backgrounds strange rock formations that were gifts of nature: bulges, cracks, and indentations that, when enhanced with brush and color, would add a third dimension to his painting, thus giving the completed work a high degree of realism. The finest examples of this skill are to be found on the ceiling in the famous cave of Altamira in northern Spain.

Ocher, oxide, and carbon were the minerals that he dug from the earth and patiently ground to powder between slabs of stone. Then, mixing the powder with varying quantities of animal fat, bone marrow, or vegetable oils, he made his paint and crayon sticks. His simple palette was limited to red, yellow, and black; these he intermixed to provide additional shades of color.

Walls were carefully cleaned and prepared, then the pigment was applied by fine brushwork and fingertips, and blown through small hollow bones to produce a delicate sprayed effect. As a modern artist carefully chooses his canvas, so prehistoric man was most selective in his choice of natural backgrounds. If a curve in the rock suggested the bulky shoulders of a bison, or the flaking calcite resembled the antlers of a deer, so much the

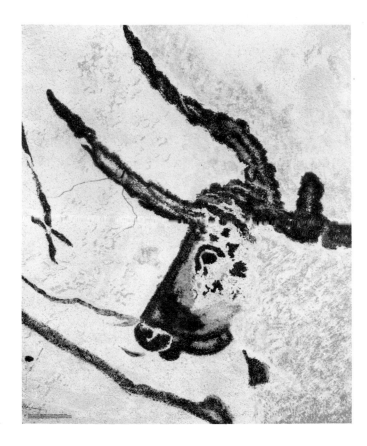

*Head of a bull: detail, the complete figure measures 18 feet long, Lascaux. (58 × 48 in.)**

better. These "natural accidents" were utilized with an uncanny inventiveness which clearly demonstrates the artist's strong desire to work as one with nature in creating an animal that might well live forever.

How close he came to achieving his wish is proved by the thousands of visitors that each year flock to the caves of France and Spain to gaze in awe and wonder at his paintings. Visitors become immediately aware that prehistoric man was no grunting, shambling ape that snarled and fought with his neighbors. Physically he differed little from man of today, undoubtedly stronger but possessing a simpler and more sensitive mind, a brain uncluttered with the problems and the million and one irritating situations that mar our modern daily life.

This free, unfettered mind is reflected in his paintings, all of which depict animals of one sort or another. Men are hardly ever seen, and when they are their bodies are covered with animal skins and horned masks cover their heads. Maximum results were obtained with the minimum of line. Always spontaneous, the paintings were never altered or erased. Many were carried out in the most inaccessible places, high on narrow ledges or in low alcoves close to the ground.

Early man was not a troglodyte by nature, and this fact becomes immediately obvious when visiting a cave for the first time. Who would

wish to live in such a cool, damp, and dark atmosphere where one might be buried alive by falling rocks? A fire would be of no help at all; it would merely cause the passages to become smoke-filled, intolerable, and even more dangerous.

But, during the winter months when deep snow blanketed the landscape and bitterly cold winds swept through the valleys, man would take refuge just within the cave entrance, protected by the rock overhang and usually commanding views of the surrounding countryside. Excavations made deep inside the caves disclose no sign of habitation, but solely the few tools and equipment of the artist. Finds made at the cave entrances, however, show periodic occupations over thousands of years.

With the coming of spring he would emerge and build his shelter under the overhanging cliffs, usually facing south and overlooking the fertile wooded valleys where he fished and hunted. So our "cave man" did not in fact live in a cave unless forced to do so. But he did use the caves (or certain parts of them) to paint and engrave, and to perform his ceremonies. How fortunate for us that he did, for the constant, even temperature of the deep interior has been the main contributing factor in the preservation of his works. Thin layers of transparent calcite have formed over the paint, thus providing a natural protective covering. Falls of earth over the entrances completed the sealing off, and here the paintings stayed in safe storage for thousands of years.

We may never know for certain how man thought and acted 20,000 years ago, but on one point we can rest assured. He was, as his recently discovered paintings prove, a man of high intellect, possessing an intelligence that we moderns are loathe to grant him. His simple economy of life permitted a great deal of leisure time—time spent in painting, engraving, and sculpture, abundant proof of his outstanding abilities that has miraculously survived millennia.

While observing and admiring his graphic art, one wonders about his musical achievements. These may have equaled the paintings. Were his dances and ceremonies, too, artistic endeavors handed down with due solemnity through the generations? In the deep, remote caverns, while studying and recording his pictorial art, I have often longed to hear his music, observe his dances, listen to the folklore.

These early days have been named the Stone Age simply because the artifacts that have survived beneath the soil are either of stone or bone. Thus we imagine a man who made everything he possessed from these two basic materials. We are, of course, utterly mistaken. Bison and other animal skins were used for clothing, footwear, bedding, and shelter. Animal intestines were dried and used for food containers, the long hair used for making rope, the fat for candles, deer antlers for tools and weapons.

For here was a man with time enough—and the inventiveness—to devise uses for everything that came to hand.

Without doubt, the herbs gathered in the countryside provided him with cures for the more common ailments. Serious diseases would have caused a much shorter life span than is expected today. Mortality at birth

Distribution of Cave Art in France and Spain

France:
1. Lascaux
2. Rouffignac
3. Bara-Bahau
4. La Mouthe
5. Font de Gaume
6. Les Combarelles
7. La Grèze
8. Cap Blanc
9. Cougnac
10. Pech-Merle
11. Le Portel
12. Niaux
13. Gargas

Spain:
14. Santimamiñe
15. Covalanas
16. La Haza
17. El Castillo
18. La Pasiega
19. Las Chimeneas
20. Las Monedas
21. Altamira
22. Pindal
23. Buxu
24. Tito Bustillo
25. Candamo
26. Pileta

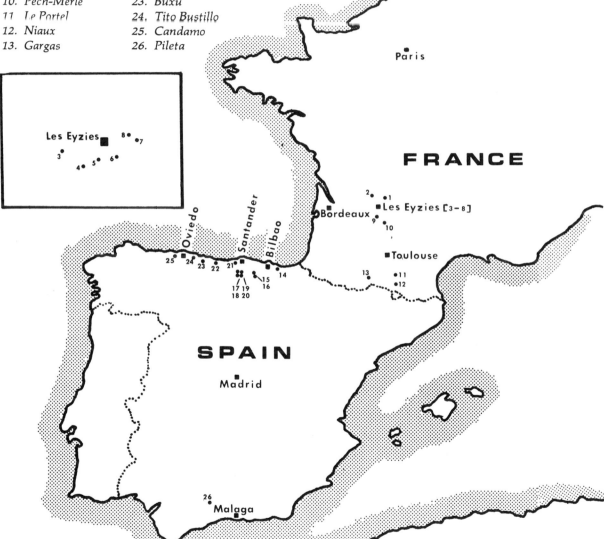

must have been high, something expected and accepted. Yet death was treated with reverence, and prehistoric burial sites show a deep concern for the hereafter.

So let us cast away the imaginary picture of a cave man dragging his wife around by her hair while snarling and quarreling with his neighbors. He lived in a community, albeit small, and conducted a well-organized life pattern—close to the earth and at one with nature.

Perhaps his life span was short by our standards, but I feel certain that he lived, savored, and enjoyed every moment that was granted to him.

Since the discovery of prehistoric art, interest in the subject has increased rapidly and each year vast numbers of people enter the painted caves of France and Spain, mostly during the summer months. In 1961 over 100,000 visitors passed through the galleries and halls of the Lascaux cavern and, although air-conditioning equipment had been installed to retain the original atmosphere, the precautions were insufficient and the cave walls became contaminated by a strange green algae.

Carried into the cave on the shoes and clothing of visitors, this funguslike growth thrived in the warmer atmosphere and spread quickly. Soon, almost a hundred small green patches marred the walls and threatened the paintings.

In 1963 the French government decided to close the cave to all visitors, and so save the paintings from possible damage. Periodic and detailed

*Herd of stags: each animal measures about 18 inches long, Lascaux. (48 × 60 in.)**

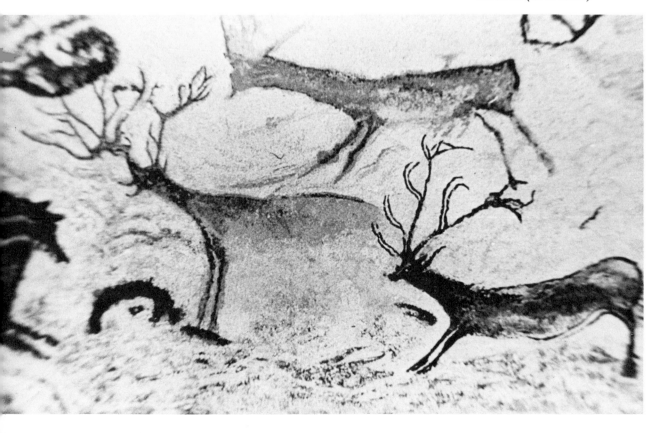

examinations were made by members of a scientific commission appointed to investigate the problem, and twelve weeks later their worst fears were confirmed.

The "green sickness" had continued to spread rapidly; almost a thousand patches had appeared.

Following exhaustive tests, the scientists discovered a method of destroying the bacteria on which the organic algae fed by spraying the contaminated areas with antibiotics. Then came the problem of algae removal, without causing damage to the paintings themselves. It was a long and tedious task, and not until 1967 were the walls pronounced clean and the cure complete. But the fear of the sickness returning will keep the cave barred to the general public indefinitely.

At the time of writing, plans are going ahead to build a replica of the cave's interior close by the actual site. A detailed portion will present the visiting public with an impression of the famous cavern's painted walls. Closed-circuit color television will give tourists a small-screen glimpse of Lascaux's wonders. At present, this provides the best and only solution— but a poor alternative. However, a great cave has been saved.

What will be the fate of the others?

The Spanish authorities have sought a compromise. In September of each year, after the bustle of summer visitors, the vulnerable caves are tightly sealed until the following June. During these nine months of inactivity the caves are shrouded in darkness, and enjoy the cool atmosphere that existed for the thousands of years prior to modern man's curiosity. Any organic life encouraged during the warm summer months dies away, starved of light, warmth, and nurture. The cave paintings slowly regain their pristine glory until once again June arrives, bringing with it the rapidly growing crowds of visitors.

It may be many years before an adequate solution emerges to this ever-increasing problem. There is, at present, no feasible or inexpensive remedy. But to clear up one point that often arises: the caves of France and Spain are not closed to the public. Of the twenty-five painted and engraved caverns mentioned in the text, only one or two are permanently sealed; the rest may be viewed and enjoyed.

At least for the present.

Imaginary animal, Lascaux.

Cave entrance
La Hoza, Spain

3
Cave Paintings of Spain

WITHIN A FEW WEEKS of the London showing of my Lascaux copies, I was once again driving through southern France, this time heading toward the north coast of Spain. It was Easter 1961 and the weather grew brighter and warmer as I crossed the frontier and passed through San Sebastián.

At intervals, the winding road provided glimpses of the Bay of Biscay where busy waves pounded the rugged coastline and deserted beaches. I stopped frequently at small fishing villages and explored, on foot, the narrow cobbled streets, carefully avoiding possible kicks from the numerous loaded donkeys that appeared to be the popular form of transport.

I seemed to be the only bearded person in Spain—a fact that provoked a great deal of comment throughout my stay. Groups of little boys would follow me chanting "Castro!" and giggling all the while. When, with map and phrasebook in hand, I approached to ask a question, people turned and fled. I learned to avoid contact with very young children, most of whom were liable to go into hysterics.

Again the language barrier; I found great difficulty in making myself understood. No one seemed to have heard of Bilbao—the largest city in the region. I finally discovered that "bao" should be pronounced to rhyme with "now."

This was Basque country, a region that seeks to be separated from Spain, an industrial area of continual unrest and a source of great concern to Madrid.

As I approached Guernica, the city that suffered such devastation during the Spanish Civil War, and later was immortalized by Picasso's famous painting, I was surprised to find that my entrance to the city was forbidden and police pointed to a detour route. Driving slowly around the outskirts of the quiet town, I saw thousands of people lining the streets. The motionless crowd was silent and waiting, the atmosphere was tense. I was curious. I decided to leave my car and investigate.

A large banner stretched across the main highway. It read FIN. The end to what? I became a little scared; I had no wish to become involved in a demonstration.

Suddenly and in silence, the answer came flashing around the bend of the road. The crowd roared and cheered—these were the final moments of an important bicycle race!

With relief I drove on to Santander and went directly to the Museum of Prehistory. What a difference from my reception at Lascaux! The Spanish authorities assisted me in every way they could and permission was granted to work and photograph in all the caves.

I found the guides knowledgeable, courteous, keen, and helpful. Although considerably poorer than their French counterparts, they refused monetary tips and were satisfied to accept a cigarette while showing me their family photographs. Their wish was to make friends, not money. My stay in the Spanish cave region was simple, rewarding, and most enjoyable.

I had no definite itinerary; it is just not possible to make one in the rural areas where the caves are found. When each day ended I searched for shelter, or slept in my car. By removing the passenger seat of my tiny Austin Mini stationwagon, I was able to stretch my six-foot-plus body diagonally across the interior. An inflated mattress and warm blankets provided many nights of comfortable sleep; it was an arrangement that I found preferable to some of the available alternatives. I accepted one night's lodging in the loft of a barn. The bed was clean and comfortable enough, but the odors and noise of the cattle and pigs below were such as to keep me wide awake throughout the night.

Cave entrance at Altamira, Spain.

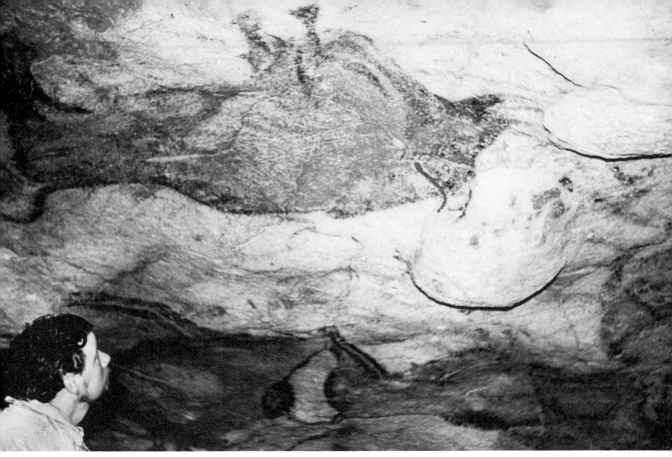

Author examining ceiling detail at Altamira.

The wonderfully painted caves, so full of interest, are spread along Spain's northern coastline like pearls on a string, each possessing its own particular charm and character. Twenty miles west of Santander, I stayed at the excellent Parador Gil Blas (a government hotel) in the small town of Santillana while I worked in the cave of Altamira, just a mile away.

Why is it, I wonder, that when people meet in places of great and lasting interest, they become somehow bonded? The act of sharing a strong emotional experience—such as viewing the Altamira ceiling—with one or two other humans seems foundation enough for the growth of a permanent friendship. Two strangers and I entered the large, silent cave; three good companions came away.

Visitors were few at this time of year, and on many occasions I found myself the only occupant of the cave. Working conditions were ideal. On entering, I would stand still for a few moments with my eyes closed, a little ceremony that was enacted on each occasion. Opening my eyes a minute or so later, I could see much more clearly and was able to avoid possible obstacles. The painted ceiling of the cave is about twenty-five yards from the small, modest entrance, and dim electric lamps faintly illuminate the rectangular hall.

The sheer beauty of color and form is breathtaking. The low ceiling is covered with strange protuberances; bulges and projections are everywhere, and upon these natural shapes the prehistoric artist painted the

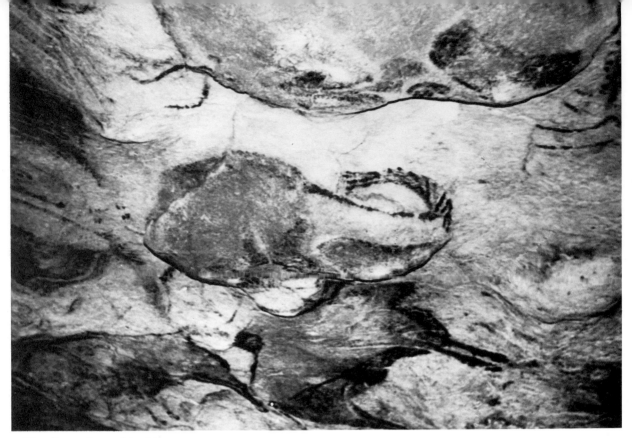

Standing and crouching bisons at Altamira.

many bison, horses, deer, and wild boars. The shape of each outcrop dictated the contour lines of the animals, so they are portrayed in various natural attitudes: sitting, crouching, walking, and standing. The three-dimensional effect that the bulges provide is most remarkable. When a photograph of the ceiling is inverted, the impression of a field full of resting animals is even more striking. Some twenty-five beasts varying in size between four and six feet long cover the area right up to the vertical walls. Close examination of the cave wall reveals many layers of earth and rock. There is a strong possibility that other open areas, probably containing more painted animals, have long since been filled by ancient landslides.

As already mentioned, many paintings are found only in certain parts of caves, perhaps sanctuaries set aside for religious rites and ceremonies. Altamira is no exception, for the hall containing the large paintings is just a small part of an enormous cavern that twists and turns for four hundred yards before the walls close in to prevent further exploration.

I spent a great deal of time lying on my back on the damp earth of the cave floor, by far the best position in which to photograph, with flash equipment, the colorful paintings. Unfortunately, the method presented certain hazards. Visitors gazing at the ceiling in the semidarkness would sometimes trip over my prone body, letting loose a torrent of unintelligible words in a variety of languages.

I remember how terribly scared two elderly German ladies were. They talked together as they approached my working area, and to prevent my

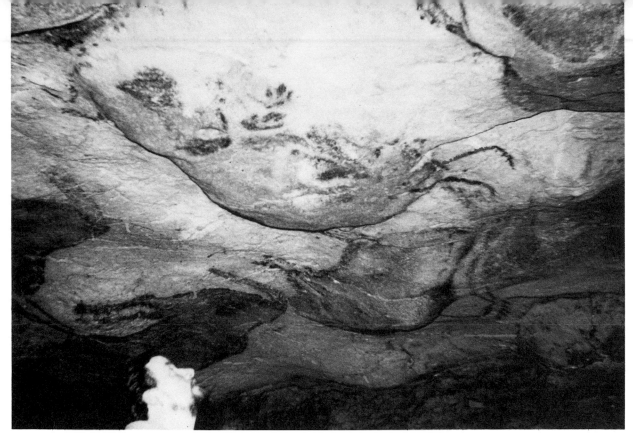

Paintings covering the natural rock outcrops, Altamira.

head from receiving a kick, I suddenly called out the only two words of warning I could remember from wartime Germany:

"*Achtung! Minen!*"

At that precise moment my camera clicked and flashed.

Little wonder they screamed. A phantom voice in the dark cavern informing them that they were about to tread on a mine had the obvious effect. When peace reigned once again, my German vocabulary had increased by at least two words which were used a great deal: *mein Gott!*

The longer I worked at Altamira, the more I appreciated the great beauty of its paintings. There was a subtleness to this art that one did not feel at Lascaux, where the animated animals charged and stampeded. Here at Altamira the static beasts appeared to possess a great hidden strength that was almost tangible in the infinite stillness of the cave.

On close examination of the ceiling, it appears that the prehistoric artist, after carefully choosing and cleaning a particular rock projection, first engraved the outline and details of the animal. Then red, brown, and ocher colors were applied to the body areas, which were finally outlined in a heavy black pigment—probably manganese or carbon.

It is quite possible that some of these animal figures represent a single composition. Most of the cow bisons are shown in the center of the group, crouched with tails raised (about to bear young?), whereas the bull bisons appear to be protecting the herd, for they are shown standing and facing outward. In some instances the paintings and engravings are superimposed

on one another, and it is believed that at least four styles are represented, from the earliest finger drawings and mysterious symbols to the realistic animal paintings. This would indicate the cave's use over a long period of time.

It was in the Altamira cave that the very first discovery of prehistoric art was made, and the story is worth relating in detail.

The year was 1866. A man and his dog were walking along a hillcrest when suddenly the animal set off in pursuit of a fox and disappeared into a copse. The hunter followed and found the dog trapped between large boulders. On removing the rocks to free the animal, the entrance to a large cave was exposed. Underground caverns are commonplace in this region of Spain, so the discovery caused little or no concern.

In 1875 a local archaeologist named Don Marcelino Sautuola decided to examine the cave in the hope of finding something of historical interest. From time to time his excavations brought to light animal bones and worked flints. During the year 1879 he intensified his searches, and on one occasion he took along his twelve-year-old daughter, Maria.

Bored with watching her father dig, she wandered off alone to explore another part of the cave. Her sudden cry of "Look, Papa! Look at the painted bulls!" was the first indication of the existence of prehistoric art.

Sautuola spent some time in pondering over the mystery of his find. The painted animals, so accurately portrayed, had been extinct for many thousands of years before. If the artist had possessed such an intimate knowledge, then surely he must have lived during that same period.

Today, cave art is an accepted fact, but it was not so a hundred years ago. The authorities scorned Sautuola's statement, and even accused him of perpetrating a forgery. Although he was a famous historian and well-

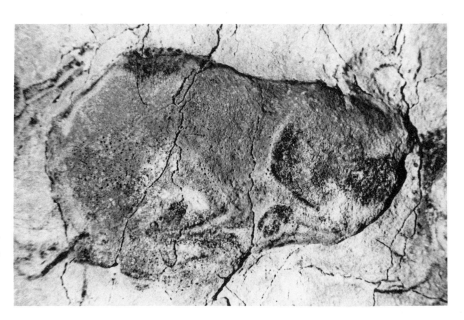

Bison painted over an oval-shaped protuberance, Altamira.

known archaeologist, his discovery of early art was rejected as nonsense by all but a few of the world's prehistorians. Arguments against the existence of prehistoric paintings were loud, and the list long. Three points were highlighted:

1. It was inconceivable that prehistoric man, with his primitive, apelike intelligence, could produce such masterly work. The fine paintings, viewed beside early man's crude tools and hunting weapons, appeared completely foreign and out of place. There existed no affinity between them. Excavated artifacts, crudely made, clearly reflected the hypothetical image of our early ancestors; the paintings definitely did not!

2. What pigment existed in those far-off days that would survive the vast lapse of time? The freshness of the colors suggested a modern work. To assume that Upper Paleolithic man possessed a paint capable of withstanding 15,000 years and more was unthinkable!

3. Saultuola himself would readily testify that no traces of human occupation were found in the painted chamber. In every excavated cave, the pattern was the same. Prehistoric man lived only near the entrances, not deep inside, and it was around the cave mouth that his kitchen refuse lay buried. So why should he so carefully decorate the ceilings and walls of an isolated chamber, a place unlived in and never visited? The tirade continued unabated.

Don Marcelino had one learned friend on his side, a Señor Juan de Vilanova y Piera, but those two voices were drowned by the throng of disbelievers. In 1886 (during the sixth year of their struggles), an eminent authority stated: "Such paintings do not have the character of Stone Age art . . . nor the Assyrian, nor the Phoenician . . . only an expression that an average disciple of the modern school would impart."

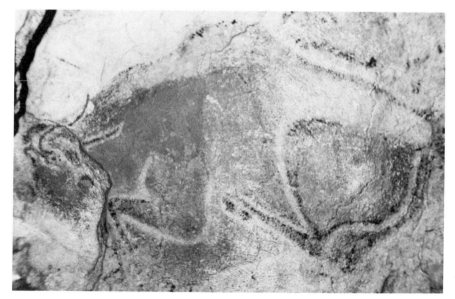

Bison looking back; the head has been painted over a rock outcrop, Altamira.

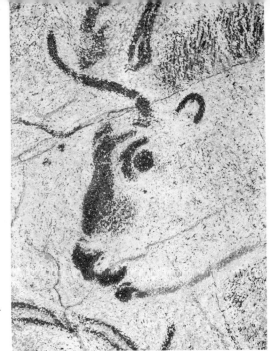

Head of an ox, Altamira.
*(36 × 23 in.)**

The one-sided battle continued to rage. Then, fifteen years after little Maria's find, paintings and engravings were discovered tightly sealed in the French caves of La Mouthe, Les Combarelles, and Font de Gaume. During excavations at these prehistoric sites, fine wall engravings were found below datable occupation levels, thus leaving no doubt whatsoever as to their great age and authenticity.

It was then that the great painted ceiling at Altamira was fully recognized, and appropriately called (by a former disbeliever) the "Sistine Chapel of Quaternary Art."

In the meantime, however, both Sautuola and Vilanova had died—two very disappointed and embittered men.

During the years that followed, every known cave in southern France and northern Spain was reexamined for traces of prehistoric art, and many fine works were brought to light in caverns hitherto considered barren. Fresh cave discoveries were made, and an entirely new conception of the artistic abilities of our earliest ancestors was initiated. It was also time for archaeologists to reexamine their earlier objections.

It is my belief that an ancient or primitive race is more capable of great and lasting art than is modern man. Motivation is the all-important factor; in primitives it is strong and on it may depend illness or health, a time of plenty or famine, even life or death. Every mark assumes an importance, yet it is made spontaneously, stemming directly from heart and mind.

If abstraction is the singling out and retention of special characteristics while ignoring the irrelevant, then prehistoric man was indeed a true abstract artist, but with one difference: for him the irrelevant was not ignored, it just did not exist.

In the cave's almost total darkness he was able to paint, engrave, and drag his fingertips through the wet clay. Each line and brushstroke took on

a deep religious meaning and was executed with great sincerity. For us, his mysterious reasons may remain inexplicable forever. For him, they may have been simple enough—as simple as the design of his weapons and tools.

This may answer the first objection voiced by the cynical critics, but what of the durability of the colors used?

While searching in the earth for suitable stones and flints, early man discovered large quantities of colored clay soils of yellow, red, and black. Using a binding agent, he made his pigments, then daubed the cave wall— and perhaps his body—with the color.

He had not posterity in mind when he utilized mineral powders for his palette, yet the fact is that these oxides are the most permanent colors yet known to man—a lucky accident that has proved fortunate for us.

So one by one the earlier questions were answered and many of the problems solved. While I worked at Altamira I began to understand and appreciate how the discovery of such superb paintings could so easily cause confusion and doubt.

But it was time to leave, and with much hand-shaking and back-slapping I reluctantly said my farewells to the Altamira guides, and nosed my little car southeast. There were many more caves in northern Spain for me to visit, and my next stop was the little town of Puente Viesgo, twenty miles from Santander.

The hill overlooking the town contains four finely painted caves: El Castillo, Las Chimeneas, La Pasiega, and Las Monedas.

Driving up the steep but well-made road, I contemplated the dozens of sealed caves still undiscovered. Deep underground, in silent darkness, could be many more caves like Altamira and Lascaux, many more thousands of wonderful paintings lying in safe storage awaiting the arrival of an inquisitive mind.

The high Pyrenees, where many caves await discovery.

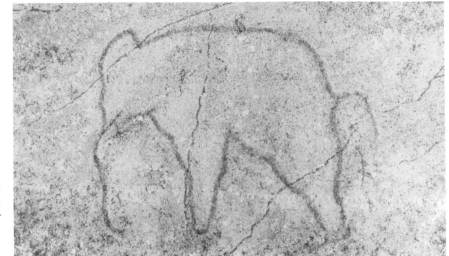

*Elephant or mammoth in faint red outline, El Castillo, Puente Viesgo. (18 × 24 in.)**

The guides were housed in a small stone building, and again I proffered my documents. All was well and the cave of Castillo would be examined first. Named after the hill in which it was found, the cave consists of one large hall near the entrance and a series of difficult twisting passages that wind for hundreds of yards into the hillside. Movement is assisted by a few strategically placed electric lights, but my gas lamp was a most welcome addition.

The first paintings occur not far from the entrance; they are of stags and horses. I stopped to examine some rather fine goats' heads carved in the rock on the low ceiling under the entrance steps. Farther on was an incomplete painting of a large bison, and just above it a horse, both in red pigment. Closer to the cave floor the wall seemed covered with small paintings and engravings, many superimposed one upon another. A frieze of stenciled hands intrigued me, and brought back memories of Gargas cave and its gruesome contents.

What prompted this type of painting was indeed common to many prehistoric peoples. No doubt there is a simple explanation but one that we may never discover.

As we moved carefully through the cave, the guide pointed to many strange symbols painted in red on the walls of crevices in the rock where it seemed no hand could possibly reach. He raised his lamp aloft to illuminate a beautifully painted bison in red. Then he turned to the opposite wall and crouched low to show me the drawing of a pitiful horse, with head and ears lowered, and a swollen underbelly pierced by arrows.

On our way to the furthermost reaches of this large cavern, we stopped to admire a strangely shaped stalagmite. A prehistoric artist had cleverly added to the bulges of calcite—with a few deft strokes of his brush—the hind legs and horns of a bison, thus transforming the lump of calcite into a realistic three-dimensional animal.

As we progressed, the path narrowed and led upward. We were nearing the end of our three-hundred-yard penetration, the last of the many interesting and assorted paintings. Here, about eight feet from ground level, was a small elephant delicately painted in a faint red outline upon a pale blue-gray section of the cave wall, a modest, charming work of art that has aroused much conflict of opinions. Is it an elephant (*Elephas antiquus*) or a young mammoth? A positive answer would assist in dating this beautiful painting, for although many hundreds of elephant remains have been unearthed in central and northern Spain, it is thought that the animal became extinct long before early man began to paint and engrave. The argument continues.

Slowly retracing our steps, we emerged from the dark cave out into the bright spring sunshine. While I replaced the film in my camera, the guide, Don Felipe Puente, told me a little of the history of this group of four important caves. Our next call was close by, in the cavern called La Pasiega (the passage), where we saw paintings and engravings of horses, deer, and bison. The cave was discovered in 1911 and subsequent excavations have brought to light many interesting artifacts now on display at the Museum of Prehistory at Santander.

Horse in black line, Las Monedas, Puente Viesgo.

We rested, talked and ate before continuing along the path that led to the cave of Las Monedas, so called because of the hoard of fifteenth-century coins found there when the cave and its paintings were first examined in 1952. A number of cave bear skeletons were also discovered, one still containing the flintstone spearhead of a Paleolithic hunter.

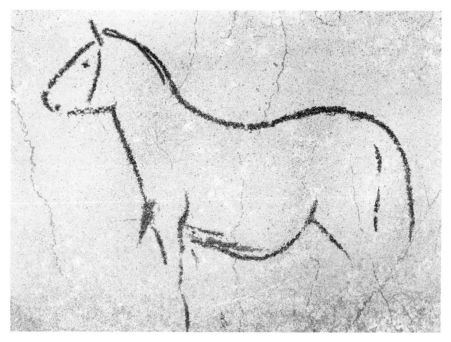

Horse in outline, La Pasiega, Puente Viesgo. (18 × 24 in.)

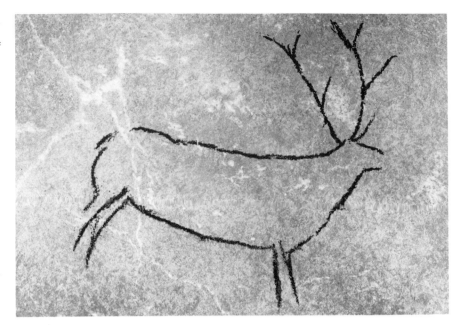

*Stag in black outline, Las Chimeneas, Puente Viesgo.
(24 × 32 in.)**

Then, finally, there was Las Chimeneas, a cave consisting of a number of chimneylike descents from which its name is derived. Discovered in 1953, it contains paintings in black outline, the finest of these being a stag with its antlers drawn in the twisted perspective position.

It was a very full day, and with so much to see one could spend a week or more at the Puente Viesgo site. The friendly, knowledgeable guides, who derive such enjoyment from showing off the treasures, dislike hurrying through the caverns prodded on by visitors who can spare but little time.

By now I had amassed a great deal of material: hundreds of photographs, copious notes, measurements, and color-matching samples. Yet there were more caves and many dozens of paintings still to see. The following day I drove east for thirty miles, reaching the small town of Ramales de la Victoria shortly after 10 A.M. It was Easter Sunday and the inhabitants were in festive mood. I had been directed to go to the inn at the main crossroads in the center of town, for the owner was also guide and custodian of the cave called Covalanas a mile or so farther south.

A boisterous crowd packed the inn to capacity. Gallons of rich red wine were being poured, drunk, and spilled, accompanied by a babble of loud voices. The air was thick with tobacco smoke and the strong smell of fish. I edged my way to the bar, inquiring, *"El guía—pinturas rupestres?"* Eventually reaching the wine-soaked counter, I was confronted by the innkeeper/guide, a man of florid countenance and massive proportions.

"Qué pasa?" he asked.

"Pinturas rupestres," I replied.

"Imposible," he said, folding his bare arms.

"Sí! Sí!" I insisted, coming to the end of my vocabulary. Then I

produced letters bearing the all-important rubber stamps and flourishing signatures. Frowning, he went through the motion of reading them while pouring a large tumbler of wine. He returned the letters, handed me the wine, and began to explain why he couldn't possibly leave his inn. It took me some time to grasp the story.

For a hostelry such as this, the time between Christmas and Easter was a cold, miserable, unprofitable, fiesta-starved period that shouldn't be wished upon a dog—blank months that grew even worse with the approach of Lent, when hardly a soul entered the bar.

Early this morning, he continued, everyone assembled at the church to attend Easter Mass. Now the fasting was over, now was the time of celebration, now was the time for drinking and feasting. Now was *not* the time to leave his bar and climb the hill to look at cave paintings. His wife and daughter were busy cooking. His sons were laying tables. Tending the bar was his personal responsibility—surely the señor could understand his predicament?

The señor could, of course. I took a room at the inn to await a lull in the proceedings that would afford an opportunity to visit the cave and its paintings.

The next morning I again pleaded with the owner.

"*Pinturas rupestres?*" I inquired.

"*Sí, sí, señor, pero mas tarde, tengo mucho trabajo!*"

I should wait until he was less busy, so I sat outside in the sunshine. Later I entered the bar, only to see the proprieter lurching around and spilling wine from his glass. He reached behind the inn door for a large bunch of keys, and slurred:

"*Venga! Vamos!*" and staggered into the yard. The road to the cave was steep and boulder-strewn. I hesitated.

"*Venga! Venga!*" he urged. So with large stones scraping the car's undercarriage I carefully advanced up the hillside until the cave was reached.

*Cave entrance, Covalanas,
Ramales de la Victoria, Spain.*

Looking at the walled-in entrance with its padlocked steel door, I breathed a sigh of relief; at last we were here. I left the car and walked toward the cave. The guide made no move. I returned to the car—he was fast asleep. He grunted a little when I shook him, but he managed to stagger toward the cave. From behind a rock he produced a carbide gas lamp which he lit, dropped, and relit. He tried several keys in the padlock without success. I took the lamp from him and placed it on the ground, then took the keys from him and opened the door. I placed the lamp in his hand and nudged him into the cave. He fell headlong and sent the lamp flying, but matters improved with time and eventually he showed me all the paintings that were to be seen in Covalanas and the smaller cave of La Haza, situated further along the mountainside.

His lamp revealed fine fingertip paintings characteristic of the two caves. I admired particularly a group of three deer apparently interrupted in their grazing by a sudden noise. They are looking up, and the deer on the right has its head turned toward the sound. There were horses, bulls, and deer, all executed in red ocher with a tentatively dotted outline, which had, in places, been smudged to add strength to the lines. The paintings, though discovered back in 1903, are still in an excellent state of preservation.

The next painting of importance is one of an ox, four feet long and partly executed in the fingertip technique. Its back is untouched, for it is formed by a natural fold in the rock surface—yet another perfect example of the artist enlisting the aid of nature to enhance his work and provide a third dimension.

La Haza is a smaller cave with fewer paintings, in the same style as those at Covalanas, and evidently the two sites are archaeologically linked.

Then a longer drive, due west along the northern coast to the city of Oviedo, and on to see the cave of La Peña de Candamo six miles from the town of San Román de Candamo. The entrance is high upon the hillside and

Horse in red ocher dots, La Haza, Ramales de la Victoria.

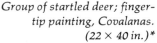

*Group of startled deer; fingertip painting, Covalanas. (22 × 40 in.)**

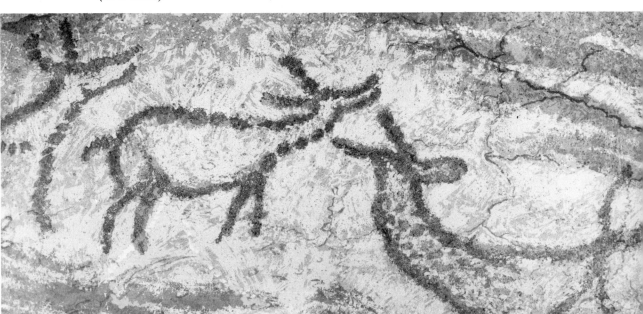

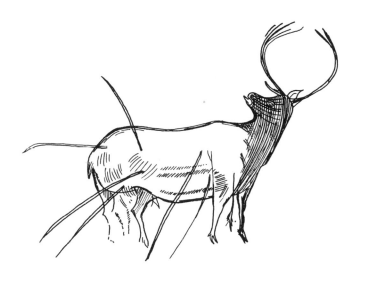

Wounded deer: engraving, La Peña de Candamo, San Román de Candamo, Spain.

is reached by a steep winding track. The guide was old, and instead of pointing out the paintings, he derived much pleasure from making me find them unaided and cackled loudly whenever I discovered a fresh one. He would lead me to a certain spot, hold his lamp high, and with extreme difficulty control his merriment until I had pointed with amazement at a particular painting. Then his pent-up laughter would be suddenly released to echo and reecho around the great cavern.

The most charming painting at Candamo is of a little sturdy mare lined in light brown on the calcite wall of an alcove high in the ceiling. The animal, about twenty-four inches long, is framed on all sides by stalactite formations and, in this great hushed hall, resembles an altarpiece.

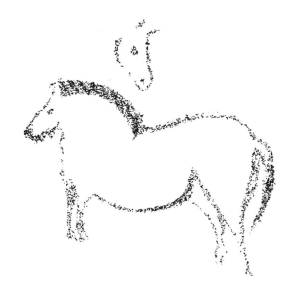

Horse in light brown, La Peña de Candamo.

Again time was running short, and as I still had at least two more important caves to visit before returning to England, I could spare no time for general sightseeing. On my homeward journey I stopped at Pindal, a beautifully situated cave on the edge of the ocean. Here I saw the second painting of what appears to be an elephant; the only other one had been at El Castillo. This animal is also quite small, barely sixteen inches long and again portrayed in a light red ocher line. In the center of its body there is a patch of red color, often referred to as its "heart."

Then I took a look at the cave of Buxu, with the nearby wooden houses mounted upon mushroomlike pedestals of stone, free from damp and vermin.

Except for an old woman who pointed directions to the cave, the village appeared to be deserted. I left my car, and in the drizzling rain climbed up to the entrance where an unlocked door of metal swung squeaking on its hinges. There were no guides or electric light, and the atmosphere of neglect was disappointing and vaguely disturbing.

I made my way back to the car and collected a camping gas lamp and matches. On my return to the cave it began to rain harder while thunder rolled above the heavy gray clouds. Thankful to be within the sanctuary of the dark cave, I lit the lamp and entered the narrow corridor.

There was not a great deal to see—some engraved horses and stags, and a bison painted in black over an incised outline. Beneath the animal drawings were a dozen or so engraved tectiforms, symbols and signs that remain a mystery.

I had progressed farther along the zigzag passage when the lamp began to dim and then quite suddenly went out. In the infinite blackness I slowly lowered the lamp to floor level and searched my pockets for matches. Where on earth were they? Perhaps, after lighting the lamp, I had left them at the entrance?

Frightened, and with my imagination running riot, I tried to suppress a surge of panic. This was my first experience of being in a cave completely alone, not knowing what pitfalls were below, or what loose rocks might come tumbling down from above. No one knew of my whereabouts. The

Elephant in red outline with red patch, often referred to as its heart, Pindal, Spain.

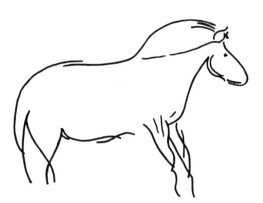

Horse, Buxu, Spain.

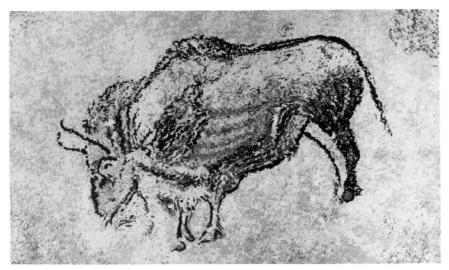

Bison in black line, Santimam-
iñe, Guernica, Spain.
(24 × 34 in.) *

cave was seldom visited and for some reason now abandoned. If some accident should occur it might be weeks or months before I was found. What a fool I'd been to come in alone!.

The matches were found in a top pocket. The small flame was reassuring, and with my hands full of matches and gas lamp, I made my way cautiously but quickly back to the entrance.

The cave of Santimamiñe was the last on my long list. It is situated on the hillside three miles from Guernica, and when I arrived at the farmhouse the guide was ploughing in a nearby field with a team of horses. His wife gave a lusty shout and he came running. A visitor to the cave at this time of year provided a welcome respite from the monotonous chores. Perhaps I was the first of the season, for I certainly received special treatment.

All the paintings were in black outline and all depicted the now familiar animals: bison, horses, and cave bear. There was one surprise however. A part of the cave floor had been partitioned off. Here, clearly marked in the mud, were the actual footprints of prehistoric man, undisturbed for many thousands of years.

Bear in black line,
Santimamiñe.

With a rich harvest of valuable material, I returned home. During the long drive up through France I thought of the many more paintings that existed in the rock shelters along Spain's eastern coast. These paintings differed from the ones in the caves—were more modern in fact: only 8,000 years old—and showed hunting and battle scenes that portrayed man for the first time. But the paintings were said to be badly damaged due to their exposed condition on the open canyon walls. I simply had to see them.

But the journeys from England were expensive even when planned on a shoestring budget such as mine. How much better it would be if we lived in Spain, amid this great wealth of prehistoric art. Would it be possible for us to leave everything behind and begin a new life in a strange country?

It was possible, and we did.

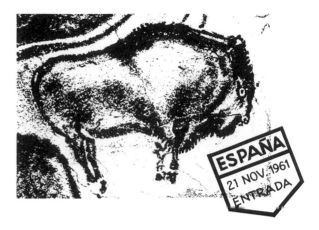

4

A Bison: Passport to Spain

Spain is different! So proclaim the travel posters and brochures, and, speaking from long experience, I heartily concur. Spain *is* different, as we were soon to discover.

Even long after my return from Altamira, its magnificent ceiling continued to haunt me. The wonderful paintings remained fresh in my memory and provided inspiration throughout the long working period spent on making the screenprinted panels. In copying the lines of the oldest masters I was absorbed completely. My trained hand would assume a turn to the left, but the prehistoric artist dictated a line that curved to the right, and right he was. I soon discovered that the work of my ancient predecessor was not governed by rules. No perspective, no light and shade, no rectangular limit to his canvas in which to place his composition, no background or landscape to decorate and enhance the animals he portrayed. No critics peered over *his* shoulder. He painted spontaneously without concern for space and time. A strong secret motivation deep within his mind guided his hand and so enabled him to produce these lifelike masterpieces.

As time passed, I slowly began to feel as one with the cave artist. I could now understand more fully his reasoning about why a line should swing to the right and not to the left. It was also important to portray accurately the background textures. This work alone was beset with many problems.

When I finally completed the "standing bison" print—a large panel measuring four by five feet—I realized at once that here was a screenprint of

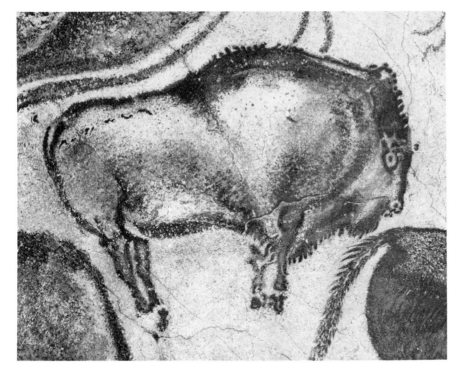

Standing bison: Altamira.
*(48 × 60 in.)**

a quality that I could never better. It was an exact copy of the original, in size and third-dimensional appearance; it mirrored the rock texture perfectly. It was as if the original artist had been present to provide a helping hand—a phenomenon I was ready to believe! Feeling very lucky and extremely pleased, I gave the print a name that later proved to be most appropriate: "Our Passport to Spain."

Working on the material that I had brought back from the caves occupied me for many months, and during this time my wife and I discussed our move to Spain. We were eager to escape into the sunshine and avoid another English winter of fog, dampness, and snow. So I suggested that late November should be the deadline for our departure—but where should be our place of arrival? Again we pored over the map of Spain. My main interest lay in the mountains that overlooked the eastern coast and the Mediterranean, for here I would find the important rock paintings of the Mesolithic era that were to be the subject of my next series.

The village should not be too far from a city. I must have access to a bank (our monthly check), post office (for the dispatch of prints), source of materials (paper, inks, etc.), and hopefully a library with books in English (for the long winter nights). We studied the map again, chose Barcelona as the city, drew a circle around it with a radius of thirty miles, and reached for a pin.

How comforting it would have been to lock up our home and safely venture forth, secure in the knowledge that we would always have a place to

return to if things went wrong! But we needed every penny we could muster for our new life in a strange land. We had to terminate the lease on our apartment, sell the furniture, find the best possible home for our lovable dog. Stop the telephone, papers, milk, bread, light, and heat. Inform all and sundry that the old address was void—new address unknown.

There was a great demand for a free pedigree poodle, but no offers at all for the purchase of our beautiful furniture and effects. But my prints were selling, and with a promise of a regular monthly allowance of £50 ($150) from the St. George's Gallery, we completed our plans.

It was arranged that I should travel alone by car, taking with me as much of our clothing and immediate needs as the little car would hold. I would find a place for us to live, and then meet my wife at Barcelona airport six days later. We packed the car with care: winter and summer clothes, blankets and bed linens, towels and household utensils, paints and books, typewriter, stationery, and a good selection of my screenprinted copies— ensuring that within easy reach was my "passport to Spain."

Crossing the Channel by air ferry, I reached Le Touquet and experienced my first brush with the French customs officials.

"Monsieur carries many items in such a small vehicle. Why?"

"Moving house, these things are my personal belongings."

"And these numerous sheets of paper with pictures on them?"

"My personal property—I'm an artist."

"Imported works of art are restricted, tax must be paid. What value do you place on your collection?"

"Only the price of the paper, until I can create a purchasing market for what is on it!"

"Come, come, monsieur, surely *this* print is worth something?" He held up a copy of my passport to Spain.

"How much would you offer?"

He hesitated and shook his head, now knowing. I took the print from him and began to tear it slowly.

"This is its present value," I added. He raised his hand.

"Monsieur has made his point—please proceed."

I gathered up the print and drove away.

Late the following day found me once again at a French customs checkpoint at the border with Spain. Once more I explained that the prints were my personal possessions, of no value until I could create a market, etc. I was allowed to cross the fifty yards or so that separated the border officials of France and Spain. The Spanish guard instructed me to enter a small building for document inspection. In the meantime he would examine the contents of the vehicle.

I emerged from the office to find a group of guards studying the standing bison copy. A soldier who spoke English looked up.

"This is your work, señor?"

"*Sí!*"—might as well air my limited vocabulary.

"It is a bison?"

"*Sí,* a copy I made from the Altamira cave—*pinturas rupestres.*"

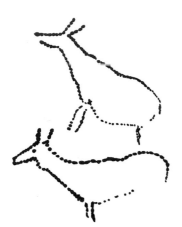

Two deer in red outline, Covalanas.

Engraved bull, La Peña de Candamo.

"Wait here, I must call the captain."

An officer and more soldiers emerged from the small building. I was surrounded. The captain gave me a polite salute and a hard glare, and asked, *"Qué pasa?"*

He was shown the large bison print, which he immediately recognized.

"Caramba! Why do you make copies of the Altamira paintings?"

"Simply because I want to show the world what wonderful works of prehistoric art exist in the caves of Spain. My work will attract many visitors to your charming country, for they will want to see for themselves these remarkable paintings."

"Señor, you are affording our country a great service. We are happy to have you with us. We wish you *mucho éxito y buena suerte!*—much success and good fortune!"

After more saluting and handshaking, I entered Spain for the second time. Heading for the road to Barcelona, I glanced at my now dog-eared passport to Spain.

"Bless you!" I murmured.

The awe-inspiring mountain range of the Pyrenees grew smaller in the rear-view mirror; the most tortuous and exhausting part of the journey was over. The tension eased and I began to relax. It was at this precise moment that I encountered the first road block.

A few weeks previously, the disaster area north of Barcelona had made worldwide headline news and I shuddered as I viewed the devastation. Spain had experienced its hottest and driest summer for many years; then suddenly, in late September, the storm broke, and for three days and nights the heavy downpour continued. During the third night the swollen rivers broke their banks and without warning the avalanche of water swept through villages and towns carrying before it houses, bridges, telephone and power cables, livestock, and humans. Thousands of homes were destroyed and many hundreds of people drowned. The night of horror left the survivors stunned and bewildered.

I found myself lost in a maze of mud-caked roads. Bridges were down and debris still blocked the roads. Detours would return me to villages I had passed through earlier in the day. Progress was painfully slow. In later years we were to experience the heavy rains and flash floods that came with autumn. The sudden volume of water that swept from the mountains down to the sea never failed to amaze us.

The clerk at the Barcelona office of information was most helpful. In good English he described the town of La Garriga, twenty-five miles north of the city, as being a pleasant mountain resort that would be ideal for our purpose. I wasted no time in getting there.

I found the small town situated on the main road that winds north from Barcelona to the frontier at Andorra in the Pyrenees. The hundreds of large empty houses that skirted the town looked promising, and as my car neared the main plaza I had already noted at least six of a size that would suit us best. Now to get the keys and make a choice; it seemed too easy.

At the town hall—a poky little room overcrowded by its three

Bison, engraved and painted, and symbols, Pindal.

Engraved fish, Pindal.

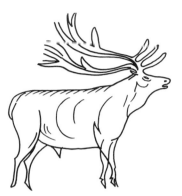

Engraved deer, Altamira.

occupants—a young man informed me that there was no accommodation of any kind available. No? But what about the hundreds of empty houses?

They were summer residences whose rich owners lived in Barcelona and occupied the houses during vacation months when the heat of the city became unbearable. There was absolutely nothing to be had, but he would make further inquiries.

Walking around the back streets of the town I noticed that the occupants of almost every house seemed engaged in furniture making. Through one doorway men and women were hammering chair legs together; bedsteads were being carved at another, and piles of wood, sawdust, and chips covered the floors.

Back at the office the young man had news. There was a small apartment that might do until something else could be found. Would I care to see it? It was in the Calle Baños, not far away. On reaching the apartment house we were met by a señora of ample proportions with a voice that matched. Leading off the dark corridor were two small windowless rooms, the first of which contained a table, three chairs and the largest chest of drawers I had ever seen. It was topped by several square feet of mirror, placed there to provide a feeling of spaciousness. This it failed to do, but it was successful in doubling the number of people that stood in the tiny room. A door had been removed and through the aperture was the bedroom. The double bed was centrally placed to allow an eighteen-inch gap between it and the wall on both sides. A curtained alcove hid the "kitchen," and a small lavatory with washbasin completed the accommodations.

"Impossible," I said. "Besides, there is no bathtub!"

The young man translated and the señora smiled. She took my arm and led me into the dark corridor. Pointing to a row of closed doors she said, "Take your pick; you have five to choose from."

She opened each door. The rooms were all alike: a bare stone floor, a stool, and an enormous metal bath supported at the corners by the feet of cast-iron lions.

Would it do? I tried to gather my thoughts. An apartment with no windows and yet five bathrooms. Really, it was all a little bewildering. Time was short; my wife would arrive at the airport tomorrow. I must be practical.

"The rooms have no windows and we must use electric light all day. Is the cost included in the rent?"

"*Sí, señor!*"

"Winter is almost here; are there adequate heating arrangements?"

"*Sí, sí,* central heating by hot water radiators—at no extra charge—have no fear of freezing, señor!"

The drive from Barcelona to La Garriga takes about an hour, time enough, I thought, to acclimatize my wife regarding our "apartment." But first she told me of the dreadful London fog and the delayed flight—then completed her story with a question that caught me unawares.

"Is it a large house?"

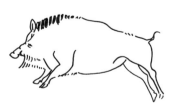

Running boar, Altamira.

"Not really large—not really a house—sort of an apartment."

"What do you mean 'sort of'? Has it a bathroom?"

"Yes, five."

"Five what?"

"Five bathrooms."

"Five bathrooms! The cleaning! How many other rooms are there to this apartment?"

"Don't worry, there are only two other rooms, quite small, bedroom and living room, and Señora Maria looks after the bathrooms."

"And who is Señora Maria?" There was an edge to her voice.

"Sort of a general caretaker, janitress, concierge, *you know.*"

"Is it quiet?"

"Seems to be—just this row of bathrooms on one side, and Pedro the fisherman on the other."

Lotti was silent for quite some time. Little wonder, she had enough to occupy her thoughts. Later I volunteered, "It's a nice little town."

I didn't mention the hundreds of wonderful houses, all empty. She would see them soon enough. I added, "I tried the coast, but it's hopeless unless you're a millionaire. This place will be all right until we can find something better. But please be warned, it doesn't look out over the deep blue Mediterranean."

"What does it look out over?" A fair question. Thank goodness we were getting close to La Garriga.

"Well, it's sort of quaint and doesn't look out over anything. You see, the apartment hasn't any windows." Happily our arrival prevented further dialogue. I stopped the car outside of No. 6 Calle de Baños, at La Garriga in the province of Barcelona.

It was a poor apartment right next to the village bathhouse. The rent was ridiculously high and we were being robbed, but without knowing the language, what choice had we? Happily, there was one great consolation. We had accomplished our move to Spain, and hidden among the rocks of those distant mountains were paintings—lots and lots of fascinating and valuable paintings.

Large deer, Altamira.

We spent Christmas in the "street of the baths." A dull time outside, totally lacking in spirit and atmosphere, with few decorations and no greeting cards or carols. Christmas morning came, yet the village children still played with last year's toys; it seemed like any other day of the year. But we were determined. Our little apartment was gaily decorated with candles, a tree, and silver bells hung from the broken chandelier. Outside nature was doing her best to cooperate. Snow began to fall late on Christmas Eve—the first for many years—and we hoped it wouldn't disappear before morning. The blizzard raged all night and the next day with no sign of ceasing. The bewildered villagers kept to their homes. They had never witnessed such a fall of snow—but surely it would soon stop?

It stopped, but not until the night of December 27th.

The bright morning sun brought no warmth, but it did illuminate a totally transformed scene. It was no longer a dusty Spanish town of ocher

and brown, but an Alpine village of golden sunlit crystals and deep cobalt blue shadows.

Wrapped warm in our English winter clothes, we stood at the front entrance and watched the scantily clad children wallowing in the deep drifts of snow, the first they had ever seen. Adults too plunged themselves into the soft mounds and scattered armfuls over one another, laughing and shouting.

Then quite suddenly the cold took effect. The children stared at their hands unbelieving as their fingers and ears began to sting. They ran home, crying with the pain and strangeness of it all.

More snow fell and roads were blocked. Everyone could now appreciate the seriousness of the situation. Trains were halted, pipes froze, and food was running low. How thankful we were for our warm, windowless rooms.

The New Year was heralded with firecrackers and bells, and we drank champagne with our neighbors. With the festivities over I wanted to begin work. We constantly inquired for a studio or workshop space but it seemed hopeless. There was a smaller village further up the valley where we went in search of a permanent home. The charming daughter of the local butcher spoke good English, and her efforts to help us were unstinting and in due course fruitful. She eventually found us accommodations, and we moved up the valley to the village of Ayguafreda.

At last I could work. The mayor kindly allowed me to use a large room in the new town hall for a studio, and I tracked down paints, paper, and the basic needs for screenprinting. Most of the equipment I made myself, using a corner in the village carpenter's workshop. Leaning over the bench, with longish hair and beard, I was soon given a nickname. They called me Joseph.

The nearest large town was Vich—pronounced "beak"—an ancient walled cathedral city nestling in the foothills of the snow-capped Pyrenees

Bison bellowing, Altamira.

Engraved symbols, Sabassona, Barcelona, Spain. (42 × 26 in.) *

*Figure engraved in stone, Sabassona. (42 × 26 in.)**

fifteen miles north of Ayguafreda. It was an excellent shopping center with a large open-air marketplace that filled with vendors and shoppers each Friday. Shoes, clothing, vegetables, meat, fish, and fine Spanish lace—everything imaginable was displayed under temporary canvas awnings.

At Vich I met Don Martín, head of the local archaeological society. We became good friends, and I spent many pleasant Sundays with the group, digging for prehistoric remains in a picturesque area called Sabassona, nine miles east of the city. My main interest was focused upon the large boulders that were scattered about the pine forest. On the largest of them we found deeply incised abstract symbols and drilled holes. Martín felled a tree and excavated the earth surrounding one large stone to discover an engraving of a man and a long-necked beast.

*Frieze of engraved symbols, Sabassona. (26 × 55 in.)**

It was an area well populated in Mesolithic times—about 6,000 years ago—for Martín and his colleagues worked hard and unearthed many dozens of pots, flint tools, and burial sites. The shelves of the local Museum of Prehistory were crammed to overflowing with their interesting and valuable finds.

Martín called at my studio one hot July morning and handed me the Barcelona newspaper. He pointed to a brief announcement which I read with interest. Although unable to understand it all, the names, dates, and places mentioned were enough. The director of the Spanish Institute of Prehistory, Madrid, was spending a few days at Ampurias in the province of Barcelona. He would be examining the results of the recent excavations made by an international group of student archaeologists.

I started to pack a few things together and questioned Martín.

"Where is Ampurias exactly?"

"On the Costa Brava, about fifty kilometers south of the French and Spanish border."

"Would it be difficult to locate the director?"

"No. Ampurias is the ancient Greek city that is being carefully excavated, and Dr. Almagro has summer quarters there."

He probably had summer quarters in other parts of Spain too. I hoped that he would stay a while longer at Ampurias, I *must* talk to him.

Driving toward the coast I remembered the advice given to me by my friend at the British Museum. He had stressed the importance of Dr. Almagro's position in Spain and advised me to make every effort to contact him and explain the work in which I was involved.

It took several hours of difficult driving over twisting mountainous roads to reach Ampurias, but I was there and it was still not too late in the day to make my call. I hurried to the museum. The person in charge of excavations shook his head. Dr. Almagro had already left and would not return this summer. I was too late.

Back at the parking lot the attendant told me there would be no charge for such a short stay—did I not wish to see the excavations? I was feeling very disappointed indeed.

"No! I only want to see Dr. Almagro."

"He is not here. He left early this morning."

"That I know."

"Come back *mañana,* señor, he will be here."

"Are you absolutely certain?"

"*Sí, señor.* This morning he asked me not to lock the parking lot gates as he would return at midnight."

"Where is the nearest hotel?"

The little coastal resort of La Escala is barely a mile away, but it was dark before I found a room. After dinner I walked to the water's edge and looked out across the Gulf of Roses to the line of night fishing vessels, their bobbing lights like diamonds on a string. I felt a little happier.

In the morning I was awakened by the boats returning to harbor, the

Engraved heads of deer, Altamira.

soft chug-chug-chug of their motors growing louder as they neared the shore.

The Costa Brava is surely the most picturesque coastline of all Spain. Appropriately called the "rugged coast," its miles of jutting red rocks protect small bays of silver sand. The tiled houses are lime-washed and resemble groups of red-topped mushrooms sprinkled around the crescent-shaped harbors.

At Ampurias, my knocking was answered by a young señorita. I explained (in poor Spanish) that I wished to speak with Dr. Almagro. She smiled and answered in perfect English.

"Please enter, I will tell my father you are here. What is your name?"

Don Martín Almagro listened while I described my interest in the rock art of eastern Spain.

"May I please see examples of your work?"

Moving some chairs to one side, I unrolled my passport to Spain print over the carpet. He looked impressed.

"Have you more? Which caves have you visited? How are these prints made? What is serigraphy?"

With his daughter's help I answered his many questions. Then he said, "I will arrange for you to have an exhibition in Madrid. October or November would be the best time. We must get catalogues printed and invitations sent out."

We also talked at length concerning the eastern Spanish rock art on which he is an expert, and he mentioned many of the more important sites, particularly the paintings at Albarracín in the province of Teruel. He also suggested that I should live closer to the rock art; the Valencia region would be much more suitable. It was a move I should carefully consider. In the meantime he would go ahead at once with the Madrid exhibition arrangements, and I could expect news from him within a few weeks.

Things were moving quickly—very quickly indeed!

The parking lot attendant could not believe his luck—a twenty-five peseta tip! For what? The señor was either mad or a millionaire! At that moment I felt like a little of both.

Hunter tracking, Valltorta.

5

A Setback

The Madrid exhibition was a great success. It attracted comments in the daily press. It was filmed for a television showing, featured in magazines and movie newsreels, and attended by a large number of people. As a result sales were very brisk indeed.

An artist's life is a precarious one. In periods of exaltation, success, excitement, and sales, the world has a rosy glow and the future is assured. Then the pendulum swings and one is suddenly beset by disappointment, bad luck, and feelings of doubt and depression.

But these are the occupational hazards of the free-lancer, and I am by no means alone. The greatest danger that exists is self-pity, or the possible loss of confidence. We each have a "guardian angel," but he is so darned lazy—there are times when I have to work desperately hard to make him lift just a finger in my direction.

Following the Madrid success, the pendulum described its arc. We received bad news from London. The gallery had closed and our monthly allowance, such as it was, would cease.

Our first thoughts were that we had the choice of two alternatives—to return to England and find a teaching job, or to continue with my work in Spain. On second thought however, we realized that there could be only one solution. Stay on.

It would mean a great deal of reorganization. There was obviously a market for my work through museums, universities, schools, and private

collectors in all parts of the world. I began to draw up a plan of campaign. It
went thus:

1. How to reach this potential market?
 By advertising my work in appropriate journals.
2. On receiving an inquiry, what action should be taken?
 Forward a well-illustrated catalogue and price list.
3. What other possibilities could be used to announce my work?
 Exhibitions, as many and as often as possible.

Well, I thought, there's a start. Three simple stages; just take them one by one, and see how the plan develops. I wrote for advertising estimates.

I was, of course, hopelessly wrong. Suppose my advertisement reaped a torrent of inquiries? I would need to have the catalogues printed and ready to send out without delay. To pay the cost of the catalogue, I must sell a large number of my prints by exhibiting them here in Spain.

I then discovered how expensive a full-page advertisement could be—far too high for my income. An idea struck me. I sat at my typewriter for a week and wrote a three-thousand-word article on "The Prehistoric Paintings of France and Spain," which ended with a note "interested readers may obtain fuller information by writing direct to" The article was sent, together with a selection of photographs to a prominent journal in the United States. The editor was pleased; it was printed and occupied nine full pages and featured fifteen illustrations. I was learning fast.

The weeks that elapsed between the article's acceptance and its appearance provided time to go ahead with the printing of the catalogue and also to hold an exhibition in Barcelona—the proceeds of the latter to pay the bills of the former. In compiling the catalogue contents, it was necessary to have all of my forty or so works photographed professionally.

The text followed, in English and Spanish, for the two separate editions, and finally all was ready to hand to the tiny printing house that had been recommended in Vich. The printer did not understand one word of the English text, and I admired his courage in accepting the job. Together we checked and rechecked the proofs, searching for the slightest error. I was well pleased with the result, and he of course was justly proud.

While finishing the catalogue, printing in my studio, visiting rock shelters, holding exhibitions, and giving English lessons to my Spanish friends, I received word from the editor requesting more articles. And one other thing; we decided to move our home from Barcelona to Valencia.

We had no wish to leave Ayguafreda. All the villagers were so friendly, helpful and kind, particularly the butcher Andres, his wife Maria, and daughter Margarita to whom we owe so very much. Our happy memories include wonderful springtime picnics in the mountains, lazy days of bathing on the Costa Brava, and sardana dancing in the village plaza during fiesta days. We shared with the villagers the gaiety of a wedding or the sadness of a death.

There had been, unfortunately, an unseen barrier in Ayguafreda—the language. This part of Spain is in Catalonia and everyone speaks Catalan. This is not a dialect but a language of its own, as is Basque on the north

coast. Therefore, our attempts to learn Spanish in an area where it is seldom spoken were abortive. Naturally we persevered and made some headway, and even learned to speak some words of Catalan.

In the schools only Spanish is taught and spoken. This is a government ruling strongly enforced, in hopes of bringing about a single tongue for all. But each region of Spain is steadfast in its desire to retain its own form of speech, and even after twenty-five years the "one-language" ruling has made no great impression in the villages. So most of the young people in Catalonia are virtually bilingual. They speak and read Spanish (Castilian) in school, but at home they talk and think in Catalan. Like most things Spanish, it is all a little confusing.

Though we were loathe to leave "our" village, my work called me south, and south we had to go. Again we chose a small village, in the mountains north of the city of Valencia. The sign, prominently displayed at the village limits, stated a population of 1,047, and an altitude of 516 meters. The main occupation of its inhabitants remained obscure. The crowded bars and local food shops made a living from the villagers' purchases, while the villagers themselves derived a living by supplying food and vegetables to the shops. The system operated smoothly and all appeared contented with the arrangement. In general, the people were far less industrious compared with their northern neighbors. Most probably the warmer climate is responsible. Also, the term *mañana* takes on a different meaning. It no longer indicates "tomorrow," but refers to a date somewhere in the distant future. Food was a little cheaper and of poorer quality, but everywhere—literally everywhere—were oranges. Through the winter months even the sky and mountains seemed to reflect the warm glow of the luscious fruit.

After a couple of false starts, we did find a suitable home. It was an antique villa that had been abandoned for many years. The owner lived in Paris and cared little about the near ruin that was pleasantly situated a ten-minute walk from the village. For a ridiculously low rent, we leased it for a period of four years. It was, of course, our responsibility to make it habitable.

With the help of a local builder, we replaced the roof, doors, windows, and the staircase that provided access to the rooms above.

Then we both spent almost two weeks systematically moving from room to room carrying out my strict order: "Kill anything that moves, and paint everything that doesn't." It worked well. Within a short time we had a comfortable home, with living quarters on ground level and my studio, library, office, and print store on the floor above.

In the large garden grew almond trees, grape vines, plums, oranges, and pears. The only animal life noted consisted of a semi-wild cat, millions of ants, flies, and a pair of magpies.

It was heaven.

The village of Naquera was ideally situated for reaching the painted rock shelters of eastern Spain, and I was able to gather together a great deal of material. At the many painted sites that I visited, a sharp rise in

Author's temporary home and studio near Valencia, Spain.

vandalism was evident, which obliged me to spend more time photographing and recording in the field than printing in my studio, but it was time well spent.

Of course, work at the actual sites was of great importance. Every incised and painted line demanded attention, but I could ill afford the time it consumed. Our sole income was from the sale of the screenprinted copies, for my few attempts to obtain a modest grant to help with the research work never met with success. As a free-lance artist, I hated asking for money, and hated refusals even more.

But my research work progressed at a rapid pace. Supplies of inks, paper, and other printing requirements were easily obtainable. The screenprinted editions were steadily increasing, and orders for my copies, particularly from the United States, were most encouraging.

At this time my articles in the American and English journals were attracting attention. The Smithsonian Institution in Washington, D.C., wrote to ask me if I would cooperate in forming a traveling exhibition. This was excellent news, and I sent them, at no charge, a copy of each of my French and Spanish reproductions. The mounted exhibit began to circulate in the United States and Canada in October 1966, and it was to continue without a break until 1972, when its well-worn condition made a replacement necessary. A similar traveling exhibition was mounted by the Arts Council of Great Britain, and from the Spanish government came a request for the purchase of copies of the Spanish cave and rock shelter paintings.

Our guardian angel was certainly pushing things along.

The house was perfect. My studio window looked out over the pine-covered mountains, and the sunny terrace was partially shaded by climbing vines. In winter we gathered pine logs from the forest, and the large open brick fireplace warmed the whole house. Summers were dry and water scarce, but the blue Mediterranean was only thirty minutes' drive away.

We lived in an isolated area with no television, no hot water system, no newspapers or radio. The primitive life suited me; we were extremely happy and utterly content. We stayed in the mountains north of Valencia for almost four years. It was the longest time we had ever spent in one place.

In fact, it took the combined forces of man and nature to move us.

Battle scene, Morella, Castellón.

6
Life amid the Rock Art

IN RURAL SPAIN, particularly in the south, life proceeds at two speeds: slow and stop. There is always *mañana*, time enough then to do the things that you had hoped to do today—that were put off yesterday.

In view of this philosophy, it is difficult, if not impossible, to make plans. Never once did I meet a Spaniard who would steadfastly conform to a routine. If he suddenly felt the urge to visit his cousin in the next village, or wished to examine his orange trees in the valley below, he would pull down the shutters, lock up his shop, and go.

We were quick to learn. I would leave home with the intention of walking to the village, having a haircut, and returning within forty-five minutes. Six hours later I would wander home, with the same length of hair, but laden with grapes after being cajoled and co-opted into helping with the harvest. At that time we had no telephone and lived in a remote region of the mountains, yet news traveled mysteriously fast, and my wife invariably knew my whereabouts.

This unpredictable state of affairs was magnified a hundred times when I went on my frequent journeys to the rock paintings in the surrounding provinces. For a day-long trip, I would load my car with all necessary equipment, then add the unnecessary items such as blanket, canteen of water, loaf of bread, fruit, wineskin, bathing trunks, cigarettes (I don't smoke), flashlight, caramels, etc. Bidding my wife good-bye with the usual words: "See you when I see you—don't worry," I would head the car in the general direction of my destination, and move forward with hope in my heart, but a feeling of trepidation in my mind.

Distribution of Rock Art in Eastern Spain

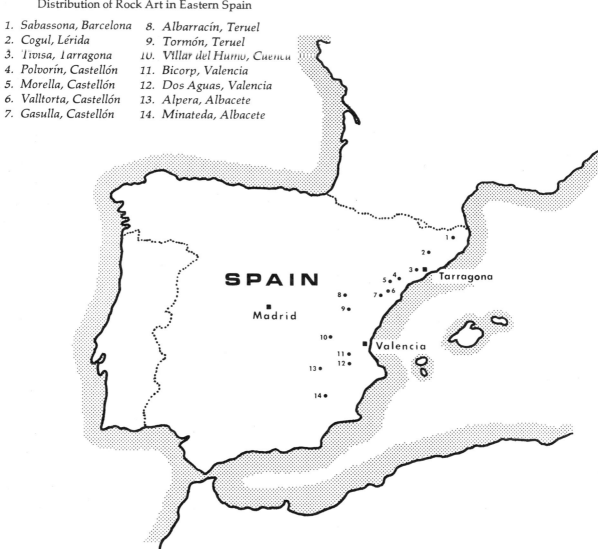

Painted rock shelter named Araña, Valencia.

Spain's treasure trove of prehistoric rock shelter art extends from the Pyrenees in the north to Malaga in the south. The multitude of paintings tells the story of the Stone Age hunters who lived in the mountains and fertile valleys of eastern Spain thousands of years ago.

Domestic and ritual scenes, styles and methods of hunting, carefully drawn animals, fighting groups of archers, and mysterious signs and symbols are all painted with meticulous care on the walls of shallow rock shelters under overhanging cliffs. Each year brings to light more paintings, and there is little doubt that many decorated *abrigos* still await discovery.

Yet outside of Spain—and inside for that matter—very little is known of these important paintings that contribute so much to the history of art.

The cave paintings of northern Spain cover a period from 25,000 to 10,000 B.C. In the shelter art of eastern Spain we observe a continuance of early man's artistic endeavors. The oldest of the rock paintings date back about 10,000 years, and the slowly changing styles bring us finally to around 2000 B.C., when the custom of rock painting ceased.

Due to the exposed state of the paintings, they have faded to such an extent that many were unnoticed until recently. But it must be remembered that the shelters are not caves but mere cavities in the cliff face and open to climatic changes. Most of the paintings are difficult to see, for the red oxide pigment has faded considerably. Many have been mutilated, and others have been soaked with water from the nearest stream in attempts to darken

the pigment. To see the paintings clearly it is necessary to dampen the rock surface slightly, and each guide has his own particular way of achieving this. A small fly-spray type of hand pump is used at one site, and if distilled water is used, this is by far the best method and the least likely to cause damage. In other shelters the water is poured, flicked, or even dabbed on with pieces of rag. The constant use of hard water from mountain streams leaves a deposit of calcite on the paintings and erodes the rock surface, thus accelerating deterioration.

During my visits I noted that less than half of the shelters were shielded by stone walls and locked doors. These are the ones easily reached by track or road. The others, though access to them is often difficult, are not protected and suffer damage from souvenir hunters. During recent years, visitors have chipped rock surfaces in vain attempts to take away painted figures, and brave hunters bored and vexed with an abortive day's work in the area have fired shots at some of the painted animals.

This vandalism has taken its toll and it is only in the shelters that are difficult to reach that the paintings remain in fairly good condition. With the general interest in prehistoric art on the increase, it is doubtful whether the paintings will survive many more years without the security of adequate

Typical Mesolithic rock shelter, Santolea, Teruel, Spain.

*Vandalism: portion of painted
rock removed, Valltorta.*

protection. It is sad to contemplate the rapid disintegration that is now
taking place after the lapse of so many thousands of years during which the
paintings were unnoticed.

And so my journeys to the sites to record what was left became more
urgent. To copy them all was an impossible task, but I carefully
photographed everything visible.

During this time I cannot recall one day's work pattern ever being
duplicated by another. Unlikely happenings and situations were common,
but in general the days would pass as follows:

Having discovered that a painted shelter was to be found in a certain
area, I would drive to the nearest village and make my way directly to the
main source of information—the place where marriages are arranged, and
property deals discussed and settled; the nerve center of the populace where
all news is received, digested, graded for importance, and relayed quickly
to interested parties; the one and only place to go for help, information, and
advice.

The village bar.

Early in the day the place is empty, but a bearded stranger excites
comment and within seconds the first interrogators arrive. As all able-

bodied men are working on the land, the advance guard of reporters are either old men hard of hearing and with failing sight, or very young children terrified out of their wits.

I explain that I need a guide to show me where the paintings are situated. They all move closer; the stranger speaks a kind of Spanish—let us listen to him! I repeat my request a few more times while passing caramels to the children and cigarettes to the ancient ones. A few members of each age group leave the bar and return shortly with one or more of the town's dignitaries: the mayor, his secretary, or the *alguacil*, whose activities include village policeman, town crier, and guide to the shelter sites.

They shake my hand and find chairs. What exactly do I want?—as if they didn't know! I explain, and show them my Madrid permit. The mayor reads it aloud and passes it down the line. In brief, the document requests that all civil and military personnel should aid me in every way possible. Its impact is immediate. They have no intention of letting me leave their village without accepting the hospitality due to a person possessing such a warrant.

A guide will be provided of course, but first a little drink, coffee laced with cognac? a beer, perhaps? a long gin and vermouth? Thanking them, I ask if I might first see the paintings, after which a little refreshment would be excellent before returning home.

This plea is completely ignored; drinks are ordered, together with roasted prawns, crisply fried octopus, potato chips, and mussels. I occasionally interrupt the drinking, eating, and talking, to ask for the guide. He will be along they say, just as soon as he has eaten, possibly in less than an hour. In the meantime we will have another drink before starting our meal, which is in preparation.

No?—But señor, we insist!

I have a great fondness for isolated Spanish villages.

Eventually, I do get to see the shelter and its paintings, but only when the greater part of the day has passed in eating and drinking. But having completed the necessary preliminaries and made contact with the powers that be, I can always return at a future date to spend more time in serious work and study. It is on my way home late at night that I may have need for the blanket, flashlight, and food. The dirt roads often damage my car, and it is easy to lose my way.

My home was ideally situated, for most of the paintings were to be found in the provinces of Teruel, Lérida, and Castellón to the north, in Valencia, and in Albacete and Alicante to the south. Some of the shelters are not easily accessible, and many are almost impossible to find without the aid of local guides. Unlike the caves of France, there are no signs, parking lots, admission fees, or souvenir stands. Unless one is in possession of some advance information, hours can be wasted searching and making fruitless inquiries, for even many of the inhabitants living in the area of the rock shelters are unaware of the existence of the paintings.

It is not easy to establish with certainty the age of Spanish rock art, but

Archer pierced by arrows, Valltorta.

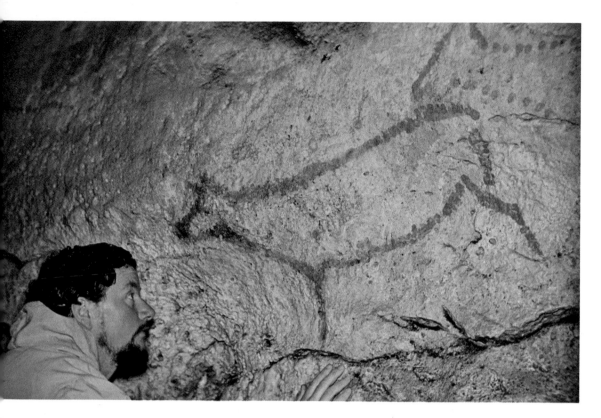

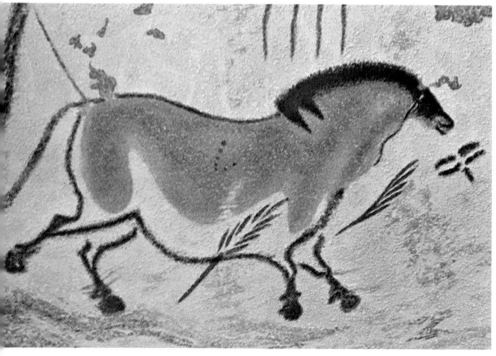

Author examining a
fingertip painting of a
deer, Covalanas,
Ramales de la Victoria,
Spain.

The so-called "Chinese
horse," Lascaux, France.
(47 x 57 in.)*

Bison in brown and black outline, La Pasiega, Spain.

*Standing bison, Altamira. (47 x 57 in.)**

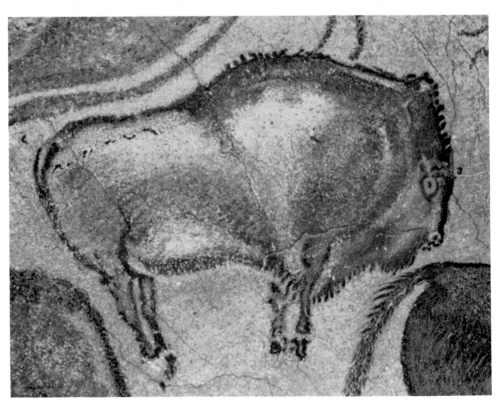

Climbing the third akba (center of picture), Tassili Plateau, Algeria.

Author and typical Tassilian landscape.

The painted ceiling at Altamira, Spain.

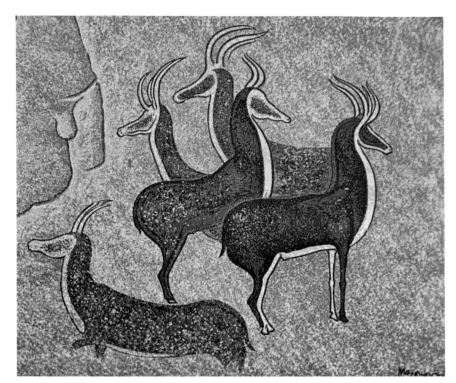

*Group of sable antelopes, Wadi Tamrit, Tassili. (24 x 34 in.)**

*Herd of piebald cattle, Tanzoumaitak. (22 x 34 in.)**

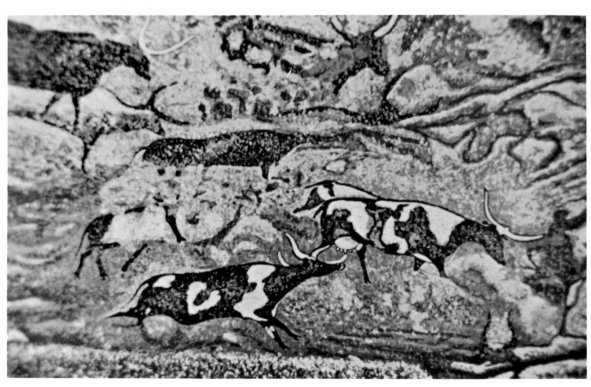

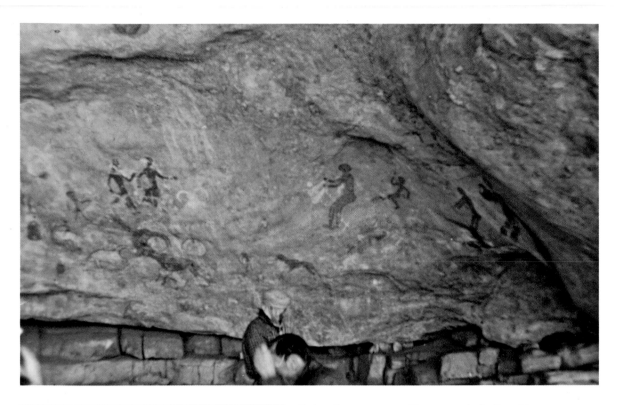

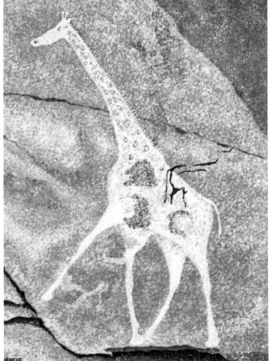

Painted sanctuary at Tanzoumaitak, Tassili.

*Giraffe in white, Timenzouzine, Tassili. (36 x 24 in.)**

Archers and cattle, Jabbaren, Tassili.

Family scene with figures superimposed, Tanzoumaitak.

Bowmen and hunter with lasso,
Polvorín, Castellón.

the extreme dates are likely to be between 8000 and 2000 B.C. Although the paintings are carried out in a highly stylized manner, men are depicted in numbers for the first time, and are shown alone or in groups hunting and tracking wild animals. Domestic scenes, though they exist, are few; hunting and battle scenes predominate. The animals are mostly wild boars, deer, bulls, and ibex—all shown in rapid movement, in sharp contrast to the more static Upper Paleolithic paintings in the caves along the north coast.

Following my long sojourn in the caverns of northern Spain, the difference in style between cave and rock shelter art was most striking. The cave art, older by some 10,000 years, was devoted almost entirely to individual animals—a kind of worship that concentrated upon each figure, whether it be mammoth, bison, bull, or deer. Although these animals are found painted side by side, they hardly ever form a composition or pattern.

But in the rock art of the Mesolithic period we witness a marked change. From the innermost sanctuaries of the caves, the art has risen to the walls of shelters high in the mountains. Very seldom do we see isolated animals; more often the figures form a composition or scene, with each figure—whether man or beast—playing its part in the story. Covering a period of perhaps four to six thousand years, the later stages become more abstract and, at times, almost impossible to interpret.

A detailed study reveals a marked deterioration in the quality of the paintings as the many hundreds of years pass. The most ancient paintings possess a realism and sureness of line and action that is obviously lacking in *Three figures, Valltorta.* the more recent works. The speed of life is already increasing. The hunt quickens, and the feeling of hurry is reflected in the paintings, which are becoming more and more symbolic. In the latest of the paintings we can detect the birth of an alphabet.

Animals were becoming scarce (there are no traces of bison or mammoth in any of the paintings), yet the human population had increased. Hunting had become a serious and difficult occupation.

*Hunters and women, Dos Aguas, Valencia. (36 × 24 in.)**

I studied the paintings closely, but could never determine for certain whether the scenes were painted before or after the events described. Do the hunting scenes, for example, tell us what has happened? Or were they meant to enlist the powers of magic and so assist in the success of some future hunt?

Why were the paintings made, and what do they mean?

There is no one simple and direct answer to these and other questions concerning the prehistoric cave and rock shelter art of France and Spain. Since the birth of art, more than 25,000 years ago, the style of painting and engraving has undergone many changes—at first slowly, on the walls of deep underground caves, then quickening, as seen in the more exposed rock paintings. Man's continually changing life pattern dictated the varying art styles. One word repeatedly springs to mind when contemplating the theories of motivation: *survival.*

By using his artistic powers, that unique gift he alone holds, man sought to influence nature and thus gain control over the animals he wished to hunt. Or perhaps his great art works, integrated with other ceremonies, were made to insure the continuance and abundant supply of the precious species. Possibly early man was conscious of his wasteful hunting methods and hoped that rituals would maintain a constant supply. Yet the overhunted bison, bulls, mammoths, and horses finally became extinct and are absent from his later paintings.

In the rock pictures his art is used for a different purpose. Gone are the majestic beasts featured in the caves. Now the emphasis rests upon the tracking and killing of the fewer fleet-footed animals that remain. Perhaps

the portrayal of a successful hunt in color, coupled again with dances, would instill a feeling of confidence and ensure a prosperous conclusion to this important activity.

Or were the scenes painted *after* such a happening, thereby recording for posterity a memorable incident? We may never know, yet when viewing the meticulous care and preciseness of the prehistoric painters, the former theory would seem by far the most probable.

A superficial study of Spain's rock art leaves one with the impression that all the paintings are alike in style and execution, and that a close examination of any one shelter would be sufficient to cover all the others in the region. This is not so. The famous shelter at Cogul, Lérida, depicts a peaceful domestic scene consisting of several women, cattle, deer, and one small male figure—probably a boy. At Valltorta in Castellón, 180 miles farther south, a most animated scene shows a violent battle taking place between two distinct groups of bowmen. In some shelters deer predominate, and in others bulls and archers are the main subjects.

There is one group of paintings that possesses all of the high qualities to be found in some measure at the other sites in the region. The shelter is situated two miles south of the village of Ares del Maestre in the province of Castellón. Its friendly guide, Federico Barreda, lives at a small inn called the Hostal de la Montalbana, with his wife, family, and tiny dog.

To reach the paintings it is necessary to climb up a steep winding track on the west side of the gorge or barranco of Gasulla. This journey must be made on foot and takes about forty-five minutes. The shelter, which faces southeast, is protected by a wall of stone, and the entrance is sealed by a locked metal door. The site is at an altitude of three thousand feet and like so many others in the region, commands a beautiful view of the country-

Painted rock shelter sites over-look the valley, Santolea.

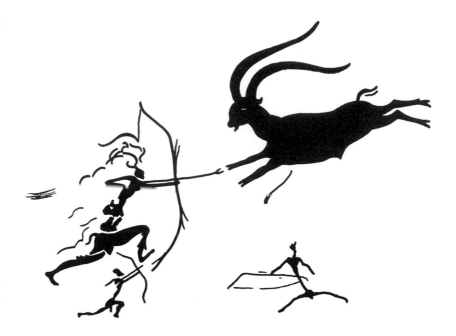

*Hunter and ibex, Gasulla, Cas-
tellón, Spain. (See also p. 106)*

side. It actually consists of two shelters, each containing many cavities, which are separated by an outcrop in the cliff face. The group is called Cueva Remigia and contains some of the finest examples of rock paintings to be found in Spain.

The well-executed "hunter and ibex" is an extremely lively detail consisting of three bowmen and a charging long-horned goat. The largest of the bowmen wears a headdress of tall feathers and appears to be dressed in a type of loincloth with tasseled tail. A sheaf of arrows lies nearby; the arrow about to be shot at the ibex has a sickle-shaped point, whereas the smaller archer is using the more usual arrowhead. The animal has been drawn particularly large compared with the hunters; it emphasizes the danger involved in encountering a wounded long-horned goat in a difficult terrain. (The steep hillsides that the ibex would frequent, are strewn with loose boulders and prickly scrub, and to move but a short distance requires the use of one or both hands.) It would appear that the animal was driven by the third archer toward the two bowmen waiting in ambush. This method of hunting appears time and again in many of the shelter paintings.

The largest print I have ever made is from a painting found in the fifth cavity at Remigia. The completed panel is actual size, measuring four by eight feet. This splendid scene is full of life and incident. The original painting is hardly visible, owing to the disintegration of the pigments and the dark color of the rock. To insure clarity, I was obliged to strengthen the colors in the screenprint and to some extent cover obvious mutilations with

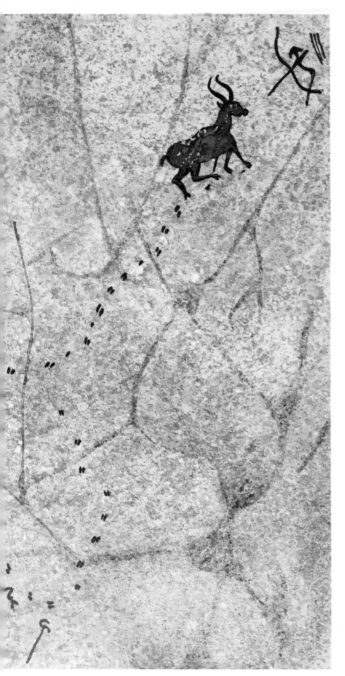

Bowmen and wounded ibex,
Gasulla.

Painting representing nest of
wild bees, Gasulla.

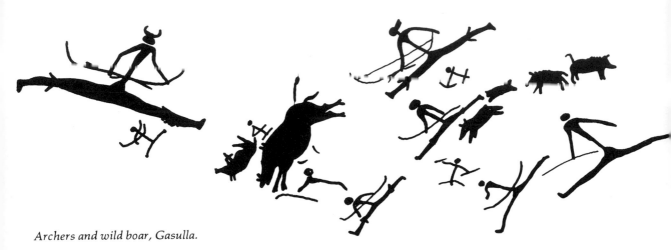

Archers and wild boar, Gasulla.

a light film of oxide to maintain the continuance of line. Thus the panel is more of a reconstruction of the original than a scientific copy of what is visible today. (See pages 104-105.)

The painting describes two events; the boar hunting composition on the left is possibly the finest to be seen in eastern Spain. Seven bowmen are converging on a herd of wild boar; the largest animal is wounded and runs to the left in an attempt to escape the hunters. Upside down above it is a smaller dead boar, and others in the herd have received arrows and lances in their backs. The bowmen are running at great speed, their legs open wide into a horizontal line to represent the characteristic "flying motion," *carrera al vuelo.* To protect their legs as they run through the undergrowth they wear fringed gaiters suspended just below the knee. The large figure on the extreme left wears a horned headdress and, like the others, is carrying his bow in a horizontal position to keep it clear of the ground while running toward the escaping boar. (See detail above.)

At top center is another figure. An archer with long strides is leaning forward while following the track of a wounded animal. It will be noted that

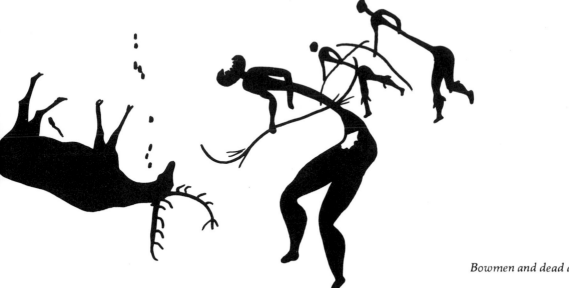

Bowmen and dead deer, Gasulla.

the track exists only *behind* the hunter and not in front. The painter assumed quite naturally that it was not possible to anticipate the direction of the spoor—he was limited to painting only what the hunter had already seen!

The group on the right of the panel shows a large, exceptionally well-drawn deer—upside down to indicate that it is dead. Near it is a large figure of a man bent forward, either to examine the deer or about to execute a dance. Two more bowmen in protective clothing are behind him. In all cases the human figures are the same: the heads are quite small and the uppermost parts of their bodies consist of little more than single brush strokes. Yet the legs are shown in much larger proportions to indicate the main asset of a great hunter. (See detail above.) Elsewhere in the picture there are many other figures engaged in various activities. The shelter has, sometime in the past, been used for the protection of sheep and goats whose hides have almost obliterated some of the figures near to the ground. This continual rubbing over the oxide pigment accounts for the warm background color along the whole lower half of the painting.

There is another cavity close by where five bowmen are seen marching along in unison. Four of them hold their bows high above their heads and are no doubt twanging the bowstrings as they file along behind their leader, who wears a tall helmet and holds his bow in a more vertical position. Several years later I examined, in the central Sahara, a rock painting almost identical to the scene just described. Perhaps, as was the custom of the early North American Indian, five bowmen were used by prehistoric races for conveying messages of great importance.

My repeated visits to the shelter sites established many friendships, and when I arrived in the villages, sometimes accompanied by a group of visiting American students or foreign museum and university authorities, we were invariably welcomed by the mayor and other dignitaries. The guide to the most important of the painted shelters, Valltorta, in Castellón, lives in the village of Tirig, and the events during one day there were most unexpected.

I arrived at 9:30 A.M. to find the streets deserted and everything closed. Even the hub of commerce (the local bar) was shuttered and surrounded by crates of empty bottles. Tattered, colorful bunting stretched from window

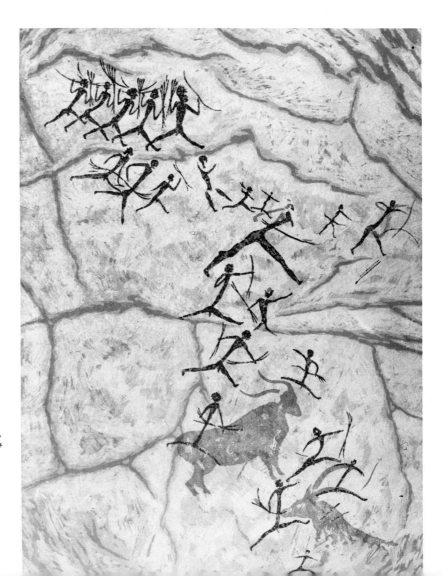

*Marching bowmen and hunters, Gasulla. (33 × 23 in.)**

Archer and stag, Gasulla.

to window explained the mystery. I had arrived in the middle of a seven-day fiesta, and the five hundred inhabitants were abed after dancing until dawn.

I made my way to the little plaza to park my car while searching for the guide, but here another surprise awaited me. Each narrow entrance to the main square was barricaded with enormous wine barrels, cart wheels, planks, and boards, all lashed together with thick ropes. Later in the morning my tired, sleepy-eyed guide told me that shortly after midday there were to be *los toros.* The young bulls, especially rented for the occasion, would be allowed to run loose in the plaza while the men and boys showed off their bravery and nimbleness by facing the charging animals and dodging away only at the very last moment. I watched the display with interest; from one such small village of Spain would emerge a future famous *torero.* So it was a day of noise and excitement and I returned home late in the evening without visiting a single shelter. Such is Spain—and who would want to change it?

But my previous visits to the paintings at Valltorta had been more fruitful, and resulted in screenprinted editons of two very fine examples. One panel contains a large composition which is apparently the work of a

Hunter pursued by a bull,
Gasulla.

single hand. This has every appearance of a battle scene; the figures are all alike—elongated, with narrow waists and large legs—and all are bowmen. Yet there is a marked absence of arrows in flight or held on bowstrings; the facing groups seem to be enacting a battle, without inflicting injury upon one another. The painting could possibly depict a show of strength, a

Battle scene detail, Valltorta.

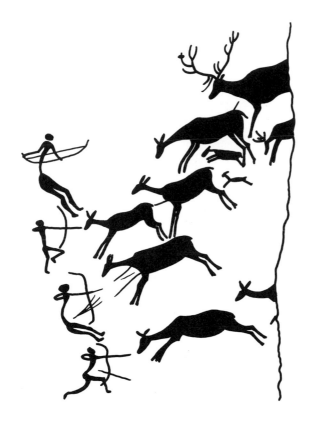

*Bowmen and deer detail,
Valltorta.*

periodical ceremony that decided group power without actually going to war. (See pages 108-109.)

Another painting, the extreme righthand portion of which is partly obscured by a thick layer of calcite which covers parts of the animals' flanks, illustrates a herd of ten deer being driven toward four waiting bowmen. The female deer is leading the herd, with the males taking up the rear. It is usual for the males to adopt the most vulnerable position when danger threatens, so at first glance, this scene appears to be a contradicton to the rules. But we must remember that the bowmen had been waiting in ambush, while their active colleagues were positioned behind the stampeding herd, using fire and noise to frighten their quarry. Therefore, to the animals, the danger lay at the rear—not in front—and the male deer were perfectly positioned to protect the herd. (See page 103.)

I have enjoyed long conversations about these paintings with modern deer hunters who use the longbow and arrows. They never fail to be amazed at the artists' accuracy.

The rock shelter at Cogul, Lérida, is situated on a dry, dusty plain that produces little else but cereals, almonds, and olives. The painting was discovered in 1896 by a village priest named Ramón Huguet, who took cover there during an uncommon and particularly heavy downpour. Perhaps he was trying to decipher the faint Iberic and Latin inscriptions

*Detail from domestic scene,
Cogul, Lérida, Spain.*

that are scratched in the rock close to the paintings, or possibly the damp atmosphere had darkened the colors sufficiently for an observant eye to detect.

The village postman is the keeper of the keys, and the small shelter lies just outside the village down a dusty track. When I first visited the site there was little or no protection. The guide filled a bucket from the nearby stream and liberally doused the painted wall with water, so that the colors would show a little more strongly. This action had been repeated over many years with the result that the painting is now very faded indeed.

Even so, it still provides a focal point for discussion. Is it purely a domestic scene, with women tending cattle and the wild deer and ibex grazing at a distance? Could it possibly be a wedding, or is the male figure, which is so prominent, a young boy receiving some kind of initiation? The faintly scratched letters afford no clue, for these are thought to be about 2,000 years old—much more recent than the painting. The inscription reads: *Hic non factvs est termvs* ("this was not done by Termus"). We may never know what the painting means; we shall certainly never know who the artist was. We can be sure of one fact only—it wasn't Termus! (See page 110.)

A year or so later, I held an exhibition of my copies in the city of Lérida, and my panel of the Cogul painting was prominently displayed. Attending the opening was the provincial governor, who expressed surprise and pride on learning that his province contained a prehistoric painting. I described the inadequacy of the protective arrangements and the misuse of water. He was genuinely concerned and promised to remedy the situation. He did, to good effect. Today the shelter is closely barred, the application of water no longer permitted. The floor is paved. A thick wall protects the area and displays an accurate but visible copy of the now faded painting.

Drawing of detail from domestic scene, Cogul.

If only these measures had been taken fifty years ago!

In the province of Tarragona, between the city of that name and the coastal town of Vinaroz, lies the shelter of Cabre Feixet. It is about eight miles inland and most of this journey must be made on foot, but the long walk that ends in a steep climb is rewarding. The painting, though quite small, is remarkably well preserved, and the figures can be made out at quite a distance from the shelter. This is an uncommon occurrence in Spain's rock shelter art except at sites difficult to reach and seldom visited. A deer and an ibex are shown in a running attitude while an archer with bow held horizontally approaches from the right.

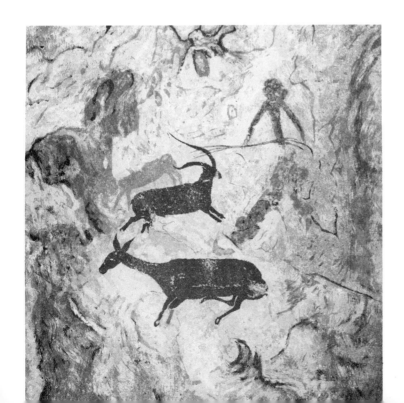

Archer, ibex, and deer, Tivisa, Tarragona, Spain.
*(34 × 24 in.)**

Bowman and wounded deer,
Albarracín, Teruel.

While searching Spain's eastern regions for traces of prehistoric man, I never quite knew in what circumstances I would find myself. One thing could usually be relied upon: the search would involve a long walk, a high climb, and finally a rock-strewn scramble to reach my goal.

But on arriving at Albarracín in the province of Teruel, things were different.

There are many fine and interesting paintings in this picturesque area. Tall pine forests stretch for many miles, and although the ground is uneven I don't recall any difficult climbs; but to be quite honest, I wouldn't have noticed them in this wonderland.

It was late September—sunny and warm with no heat. The high trees cast latticed shadows over the springy green turf. Large red rocks worn smooth with time jutted from the foliage, and sparkling streams bubbled along reflecting the sunlight.

My guide was dressed in the well-patched garments of the landworker, including a wide-brimmed straw hat and laced rope sandals. As we passed through this veritable paradise, walking across meadows carpeted with tiny blue and yellow flowers, I asked him his name. I wasn't the slightest bit surprised at his answer.

"Jesus," he said.

I was most interested to find that a white pigment had been used for several of the paintings. The natural color of the rock was such that the usual red oxide would be almost invisible, so our prehistoric artist had searched for a pigment—probably zinc or pipeclay—that would serve his purpose equally well.

The style of the paintings and the pigments used strongly resembles the rock paintings of the Tassili Plateau in Central Sahara that I had heard and read so much about. The Albarracín shelters could be placed with the ones at Tassili and not look out of place, particularly the bulls, for they have the same semicircular-shaped pointed horns and delicately painted cloven hooves.

I had planned to spend a few days at Albarracín, for the shelters were widely scattered, and I anticipated a lot of walking and climbing. The landscape was perfect and the paintings proved to be of a high quality.

There are three main styles, or phases, in eastern Spanish rock art, and I was now able to recognize them quickly:

PHASE I, the earliest paintings, the large well-drawn figures of animals, rather static and very realistic.

PHASE II, the hunting scenes that show such haste, with bowmen swiftly pursuing their quarry.

PHASE III, the figures of both men and animals highly stylized, sometimes made with mere vertical and horizontal strokes of the brush with no trace of naturalism.

All three styles were evident at Albarracín, and I later made screenprinted editions of the more important examples.

Most of the shelters were sealed off behind metal bars; this precaution does prevent visitors from actually touching the paintings, but unfortunately does not deter vandals from throwing sharp rocks, bottles, etc., through the bars and so causing irreparable damage.

The first shelter to be visited was called Del Navazo. It is a wide alcove, and the white-painted frieze of a dozen large bulls stretches for eleven feet across the dark-gray rock face. It is a most decorative composition, with the huge animals advancing majestically from the right and left of the frieze to converge on a small group of five animated archers, two of whom are firing their arrows from a crouching position. A small natural indentation of the rock near the center provides cover for a tiny hunter who appears to be hiding.

*Frieze of bulls, Albarracín. (24 × 64 in.)**

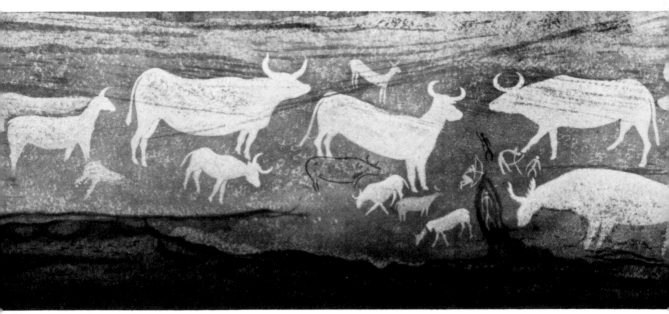

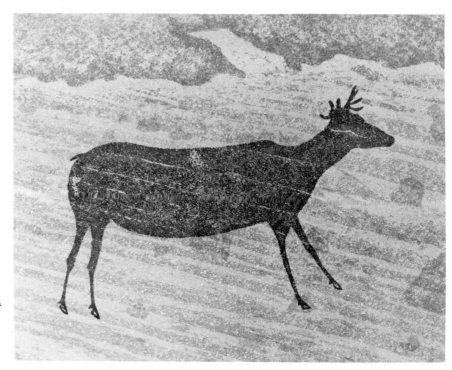

Deer in red, Albarracín.
*(22 × 30 in.)**

As I examined the painted frieze, my guide Jesus occupied himself in cleaning up the shelter floor of broken glass, stones, and small earthenware pots that had been thrown at the paintings. During our journey I had noticed that almost every large tree in that thick pine forest had been tapped, its bark scored vertically with a blade, and a small ceramic container attached to the base of the scar to catch the slowly dripping resin sap. These cups of liquid provided vandals with convenient missiles, and I was saddened to see tears of hardened resin covering many of the paintings.

Then on to the shelter named Olivanas, difficult to reach and therefore in a better state of preservation. Delicate deer in red and, surprisingly, a bull with six legs. Either the artist had second thoughts on the positioning of the front legs and altered them accordingly, or, more probably, his intention was to portray movement.

Close by was the painting of an archer carrying a bow and tracking the spoor of an animal which lay dying a yard or so away. Then more deer with feet and antlers painted in careful detail.

The figures in the shelter known as Doña Clotilde were rather strange. They appeared to be more recent than the others in the Albarracín region, probably Phase III, and featured highly stylized human forms drawn in long vertical lines with short horizontal strokes denoting arms and legs. In the center of the panel a tree or bush was shown, covered in foliage. This was the only occasion in my many travels where I saw vegetation of any description portrayed.

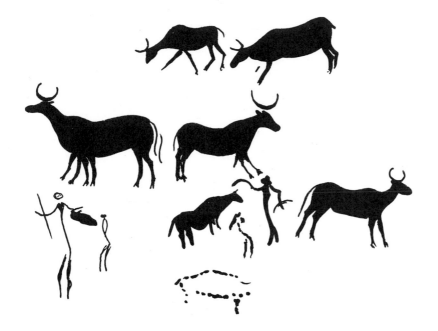

Herd of cattle, Albarracín.

I spent several days at Albarracín examining and photographing the dozen or so shelters that lie hidden in the thickly wooded region, and it was quite late on the final day when the guide and I reached the last of the paintings. As we approached the site I could see a very small cavity in the rock face, covered with a metal grille. Thinking that such a small recess could hold little of importance, I was agreeably surprised to find the most

Figures and tree, Doña Clotilde, Albarracín.

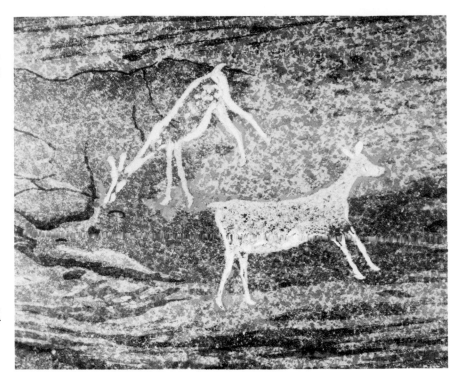

*Two deer in white pigment,
Albarracín. (24 × 26 in.)**

charming painting I had yet seen. Safe and secure behind the metal bars
was a delicate drawing in white of two deer. The young deer is grazing
while its mother stands on guard, alert and listening. The light pigment
stands out clearly on the warm soft gray shades of the natural background.

Every painted shelter in eastern Spain has a name, sometimes two. On
occasion it reflects the paintings it may contain, such as "the shelter of the
deer," etc. Or perhaps its name will date back over the centuries to a time
when the contents were either unknown or ignored, and the physical shape
of the rock formation inspired its title, like Uncle George's Eyebrow. A
strange happening or activity might also have supplied a name, and my
imagination runs riot when I think of a small painted alcove high in the
woods at Albarracín called the Bishop's Kitchen.

I then traveled farther north, following a winding dusty road that
conceals a fresh panoramic view around each bend, a drive that is slow but
full of beauty and interest.

The village of Santolea in Teruel is so antiquated that it is difficult to
negotiate the narrow cobbled streets, even in the smallest car. So,
accompanied by the young guide, one walks the four miles along the course
of the Rio Guadalupe and up into the cliffs that tower above its southern
side. Here, overlooking the fertile valley, is the "shelter of the archer," so-
called because of the small but exquisitely painted figure that is its main
attraction. (See page 107.) Forking right on the return journey one ascends
a boulder-strewn barranco to visit a shelter containing paintings of dozens
of animals that are, unfortunately, all in rather poor condition. This is aptly
called the "shelter of the herd of cows."

Tired and thirsty we made our way back to the village. The round trip had taken almost four hours, but the scenery from the high shelters had been magnificent. Inside the tiny house it was cool and dark. An old lady handed me a glass of water in which she emptied a folded packet of white powder. While the liquid bubbled noisily she told me to drink it down. It was the most refreshing drink I have ever tasted.

Not once during my eight years' stay in eastern Spain did I discover a painted bison or mammoth. These animals, like other species, had been overhunted by an increasing human population, and the three main phases of rock art clearly show a quickening of the hunt, improvement of weapons, a sense of urgency, and the decreasing number and species of animals.

We must remember, of course, that some 10,000 years had elapsed between the time of the earliest cave paintings and the first rock shelter pictures. To err is human, and prehistoric man was no exception. In his rock shelter paintings we see no sign of mammoth or horses; the animals that survived are deer, wild boar, and mountain goats. To kill these fleet-footed beasts, new hunting methods and weapons were devised, and the improved weapons depleted the herds at an even greater speed. Thus man's whole life-pattern changed, as the rock paintings so clearly demonstrate. The animal herds were fast decreasing, yet the human population continued to increase. A crisis was inevitable.

On the walls of cavities that were once the homes of these ancient people, we see battle scenes portrayed. What a tragedy that man should

*Archer in ceremonial dress, Santolea. (18 × 36 in.)**

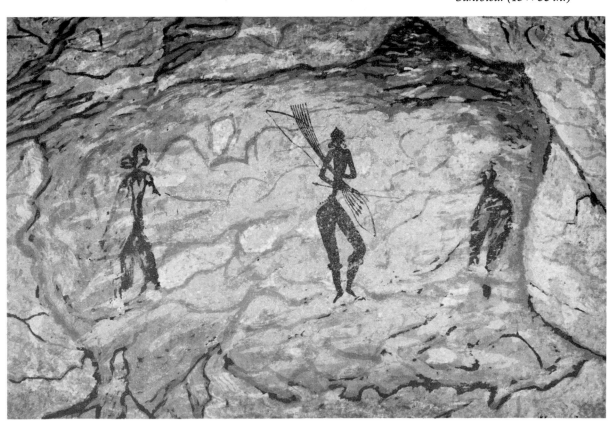

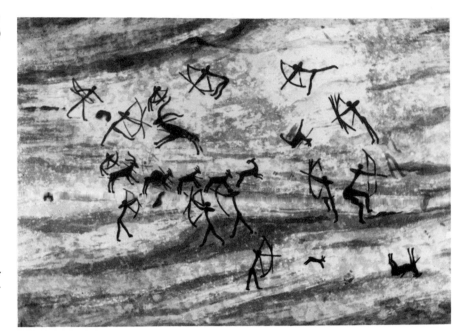

Detail of hunting scene, Araña, Valencia.

turn upon man and fight over an ever-decreasing food supply! It was the beginning of a pattern that has continued.

The worst was yet to come.

The ability to portray the animals realistically slowly disappeared. Over several thousands of years we can detect a marked deterioration in the quality of painting. Did man's urgent struggle for survival allow no time for painting? Did he cease to believe in the magical power the works might possess? Did starvation or plague strike the human population?

We may never know, but his art work ceased.

As already mentioned, it is difficult to date the paintings with any degree of accuracy. The almost bare rock floors contain little evidence of early man. No doubt the shelters were occupied on and off over several thousands of years, and fresh paintings added to the existing ones from time to time. This fact becomes apparent when studying the group of figures in the shelter known as La Araña ("the spider") near the sleepy village of Bicorp in the province of Valencia. As it was the nearest to my mountain home I have examined the site many times and find it one of the most interesting of all.

As a result of my articles published in the United States, we received at our home many visitors and serious students of rock and cave art. Sitting on the terrace in the shadow of the grape vines, we would sip a cool drink and discuss the earliest art of man. If time allowed, we arranged a visit to the shelter of La Araña for the following day, taking along a picnic basket of cold chicken, fruit, and wine. The map shows the site to be about fifty miles from where we lived, but in Spain maps are deceptive—one must talk in

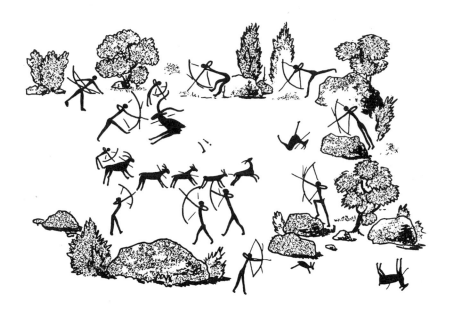

Reconstruction of Araña hunt-ing scene.

terms of time not distance. The journey to the shelter took three and a half hours, which included a fifty-minute hike.

The shallow alcove faces south and overlooks a deep gorge. It was once protected with metal bars and padlocked, but now the fence has been torn from the rock, and the broken gate swings idly on its hinges. As the new mountain road stretches closer to the shelter, the maltreatment of the paintings will increase. Quite soon there will be little left to see.

The center of the panel is of an early period (Phase I) and features four large deer, quite static and carefully painted. The two bowmen appear to be patiently following the herd, showing no haste or concern, so different from the remarkable hunting scene (Phase II) on the far left of the shelter. Twelve archers, with their bows and arrows in the firing position, surround a group of mountain goats. The bowmen on the right of the ambush have killed the two leading animals, which are in the inverted position and pierced by arrows and lances. An archer at the bottom of this animated scene is taking careful aim at an escaping ibex. Two of the figures are drawn in strange positions. One at the top appears to be falling backward, and near the bottom of the group an archer has one leg raised in the air while he takes aim.

It must be remembered that the prehistoric rock shelter artist never enhanced his scenes with trees, bushes, or boulders. He assumed that the observer would know instinctively exactly what was happening, and additional embellishments were not necessary. An artist today would be obliged to add such things to enable us to appreciate more fully the strangeness of the scene and the logic of its action.

At the right of the panel, small, crudely drawn animals are shown, together with a series of zigzag lines (Phase III). These are the most recent of the paintings, probably made by men obliged to grow their food as game became more scarce. As he lost his intimate contact with the animal, so we find man no longer capable of realistic portrayal. The symbol is replacing naturalism.

On the extreme right of the wall is a most interesting painting. Three long lines, representing cord, stretch from the lower portion of the shelter wall up over the rough surface to reach a small natural cavity in the rock face. This small hole has fine radiating lines painted around it to represent a hive of wild bees. Two figures are attached to the cord ladder: one at the bottom ascending, with a basket slung over his shoulder, the other figure at the top with one arm reaching into the cavity in the process of gathering wild honey. In his left hand is held a basket or jar, and a swarm of bees circle nearby. His work would provide a welcome and important addition to the food supply. (See pages 144-145.)

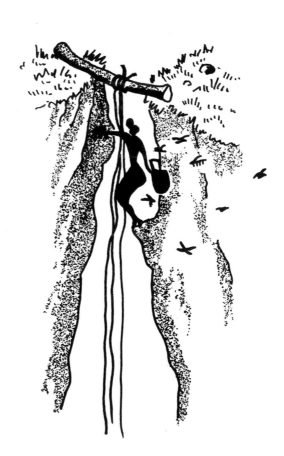

Reconstruction of honey-gathering scene, Araña.

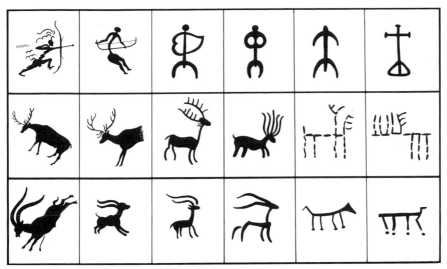

Evolution of figures in Spanish rock shelter art, dates approximate.

8,000 B.C. 7,000 B.C. 5,000 B.C. 4,000 B.C. 3,000 B.C. 2,000 B.C.

Back in the village of Bicorp I saw old women plaiting cord from strands of dried grasses. Ceramic jars are also made locally, and wild honey is gathered from mountain hives. The modest industry of prehistoric times that I had seen in the shelter painting still continues.

For how long, I wonder?

Wounded deer, Valltorta.

7
Recent Discoveries

ONE DAY I received a summons from the Director of Scientific Investigations in Madrid. Many rock paintings had been discovered deep inland in a remote, difficult-to-reach area in the province of Cuenca. Would I care to accompany him and his party to investigate the find? I readily agreed, and noted the time and place of our rendezvous. The paintings had been discovered further inland than any to date. "Eastern Spanish rock art" would obviously have to change its title and embrace a wider area.

The nearest habitation to the rock paintings was a village called Villar del Humo, a locality so remote that it couldn't be reached by ordinary car. It was possible to drive only to within fourteen miles of the village, then a four-wheel-drive vehicle was necessary to negotiate the remainder of the rough track. The trip started in an adventurous atmosphere and remained so.

The Land Rover that finally brought us to the village was sturdy and commodious; it had to be. Our party consisted of the director, his wife and two hefty sons, the museum curator from Cuenca, a driver, myself, and eventually the all-important guide. We had also to find room for our camera equipment, baggage, and food.

It was the absolute end of nowhere. There was no inn of any kind, no vehicles (except ours), and no paved streets. Several pigs meandered safely around unfenced houses built of boulders and clay. Mules transported heavy loads, and crowds of children fingered our transport excitedly. We were accommodated in a large two-storied building. The ground floor

Stylized figure holding circle, Villar del Humo, Cuenca, Spain.

housed the kitchen, stables, and dining room, and upstairs we were allocated our sleeping quarters.

My bare room contained two items of furniture: a bed with lumpy mattress, blanket, but no sheets, and a chair that supported an enamel washing bowl. I retired early, for a 6 A.M. start had been decreed for the following day. Protesting, the bedsprings lowered me into a shallow pit where I spent a most uncomfortable night.

Shortly before 4 A.M. I was awakened by the noise of much activity. Climbing out of my pit, I looked down into the heavy blackness that precedes dawn. Hurrying along the street was a procession of people and mules heading toward the open country. Where could they be going? Was the village being evacuated?

Deciding against returning to the discomfort of my bed, I went in search of water. The house was quiet but the squeaking floorboards betrayed my movements. Finding a full earthenware jug outside the door of the main bedroom, I took it with me and washed.

Feeling refreshed, I checked my camera equipment, prepared the plastic tracing sheets, sharpened the wax pencils, and was downstairs ready to go long before the scheduled 6 A.M.

In the stable, which was separated from the dining room by a narrow passage, a man was harnessing a mule. I asked him about the early exodus from the village and he explained.

Economically, this was a poor village. It tried to be self-supporting. In fact, a type of barter system prevailed that was most successful. Bread, the mainstay of life, was a problem. Worked to its full, the land was not rich enough to grow all the wheat required, and almost half the year's supply of flour had to be "imported." Now the wheat harvest was in full swing; it must be brought in and stored before even a stalk of it could be damaged by storms. The rules demanded that every able-bodied person, young or old, should work in the wheat fields from dawn to dusk.

I pointed out that 4 A.M. was long before dawn, and he agreed. He also added that it took the workers two hours to reach the wheat fields on the lower plain. They would arrive at dawn to begin their back-straining day of harvesting the crop by hand. When dusk fell, the heavy sheaves would be loaded onto the mules, and the four-hour return journey—strenuous and all uphill—would begin.

A twelve-hour hard working day, plus six hours of walking—it was incredible!

That night at 10 P.M. they returned, gaunt and tired. The smaller children sprawled asleep over the bales, yet all looked contented. They smiled as they passed. "Adios, señor—buenas noches!"

The harvest was a little better than last year.

During my stay at the village, I realized how hard people can, and do, work. The older folks were busy too: between nursing the youngest children, preparing meals, bottling preserves, and washing clothes, they scrubbed streets and animals, whitewashed the walls of the houses and

painted the woodwork—for Villar del Humo had entered for the national award presented annually to the prettiest and best-kept village. With thousands of other entrants throughout Spain hoping to win, the competition was strong.

That year, 1968, the village of Villar del Humo in the province of Cuenca, won the award hands down—pigs and all!

There must be a moral somewhere.

Our truck took the same route as the fieldworkers and in passing we called a greeting. They stood and waved their hats and sickles, snatching a moment to mop brows or refresh themselves from spherical ceramic containers, expertly squirting long jets of water between pursed lips.

We left the track and began jolting slowly over the stony surface toward the first group of paintings. Axle-deep, we forded streams; dismounting, we would all push to provide the extra momentum needed to climb a sandy slope. The towrope was used to remove a fallen tree that blocked our way; and so the hours passed.

During this time our young guide told us about himself and described how and when the paintings had been discovered. He was born and bred in the village and had left it only to complete his education. When he returned, he was appointed the village schoolmaster, a task to which he was entirely dedicated.

I have deep respect for a man who can, singlehanded, control and at the same time educate sixty or more children ranging in age from seven to fourteen—and actually *like* doing it.

But he did more. On weekends he would take them into the mountains to search for traces of prehistoric man. The children would scrutinize every

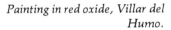

Painting in red oxide, Villar del Humo.

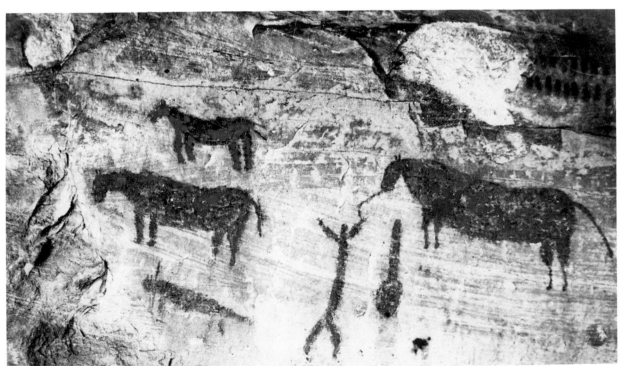

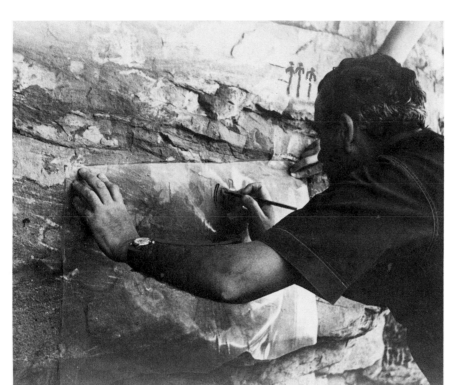

Author tracing painting at Villar del Humo.

foot of rock face and note any scratch or daub that appeared in the slightest way strange. This methodical and well-organized search brought its rewards, and over the months he and his enthusiastic team had compiled a report that had immediately aroused the interest of the Madrid authorities.

Thankfully we leaped from the rear of the truck and crawled up the short slope to the base of a vertical flat rock face. On this surface, exposed to sun and weather, were paintings in dark red oxide. Figures of reindeer, wild boar, bulls, mountain goats, and archers were encompassed in an area five feet high and ten feet long. (See pages 143, 146.)

The wall faced south, and as I worked the sun beat down upon my back and neck. The rock reflected the heat and I began to sweat profusely. The work was tedious and the conditions not at all favorable. I had first to dampen the wall to strengthen the color; then, placing a sheet of transparent plastic over the painting, I would trace the lines using a colored wax pencil. It sounds simple enough.

But the rock was so warm that the water dried almost immediately on contact. The plastic buckled with condensation and the wax pencils literally melted in the heat. I stripped off my shirt, and while our driver held it stretched aloft with both hands, I worked within the shadow it cast on the rock face. The camera work that followed was comparatively easy, and the whole surface was photographed section by section. The large five-by-ten-

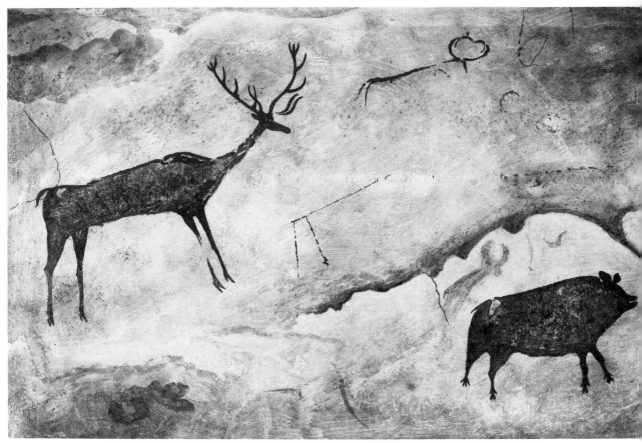

Stag and boar with later additions, Villar del Humo.

foot copy that I finally made from the material gathered at this site now hangs in the office of the director of the Spanish Institute of Prehistory, Madrid.

Work progressed well, but it was rather rushed—yet the hurry was understandable. These paintings were new discoveries not yet seen by anyone who could assess their value. We wanted to see everything as quickly as possible.

I have no wish to anticipate the director's future publications on the paintings that we saw and recorded, but I can reveal that what we did examine covered a long period of time, from the early period of the reindeer to the more recent symbolic paintings. The schoolboys had done their job well.

When we had authenticated the paintings, news of their finding was announced over Spanish TV during a specially arranged program. The whole group had a gala day in the Madrid television studios, a day the boys will always remember. Their example had been set, and I am certain that at this moment young imaginative minds are out scouring remote mountainous areas in search of man's earliest art.

I left the village of Villar del Humo with my mind full of memories, vivid pictures that have remained with me through the years: the time when, for instance, as we were eating our dinner, the mule was brought home and stood at the stable door across from where we were seated. Quick and nimble action by the director's sons saved our gear from being defecated upon by the animal, which showed not the slightest respect for Leica cameras and other valuable equipment.

And again in the village bar, where on Sunday evening a huge crowd assembled to watch the TV program. An old American film was showing. Scenes of luxury flitted across the screen, long luscious limousines, a dream world of gadgets and plenty. It had not the slightest effect on the assembly. Not a jealous thought entered a single mind. To these humble people who had to rise at 4 A.M. the following day, the pictures that they were viewing were of an abstract quality—something so remote as to be virtually nonexistent, a wonderland that could be enjoyed, but would cease to exist at the turn of a knob.

But I have recently learned that the long stretch of dirt road has now been paved and is passable to vehicles. No doubt an army of salesmen has descended upon the village, bringing to the populace all the things that are necessary to life, things that they have for so long been without. The luxuries seen on the television screen are now yours: just sign here, and work harder each day to make the payments—it's quite simple.

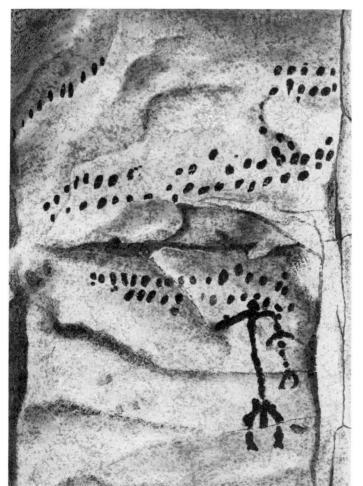

Fingertip dots and stylized figure, Villar del Humo.

When I last saw the people of Villar del Humo, they were strong and resolute, overcoming all difficulties easily and with a natural confidence. They possessed a philosophy on life that raised them above today's accepted standards of behavior and sense of duty.

I fervently hope that the paved road that has pierced the heart of the village will not drain it of its strength.

The search for and recording of Spain's rock art treasure took me to many isolated regions. I traveled the provinces of Tarragona, Teruel, Lérida, Castellón, Valencia, Cuenca, and Albacete. Years later, I retraced my steps to look once again upon the paintings that hold for me such fascination, but vandalism increases and the visits were sad.

Although kept secret from the general public, fresh discoveries of rock art do not, unfortunately, keep pace with the vandalism and damage now inflicted by unthinking and malicious visitors to the decorated sites. Large pieces of painted rock have been removed by hammer and chisel; gates with broken locks swing idly in the wind; and new mountain paths siphon motorists from the highways into the hills, where the once isolated shelter sites have become picnic grounds. I am indeed thankful that my recordings and researches originated many years ago, at a time when the artistic genius of our prehistoric ancestors was revered and respected by the few aficionados who knew of their existence and whereabouts.

If you wish to see some of the drawings I have described, do so now, for the time is short. There is not much left to look at. But soon—quite soon —there may be nothing.

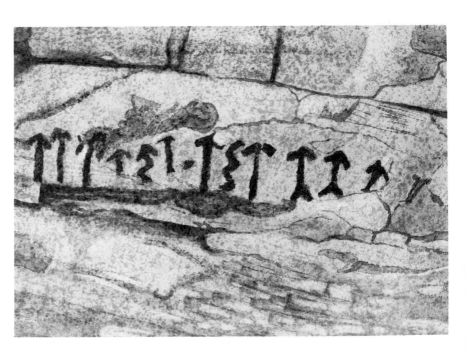

Row of stylized figures, Villar del Humo.

Tassili N'Ajjer

8
Journey to Tassili

IN A BITTERLY COLD gale-force wind, the tent flaps machine-gunned through the January night. A beam from my flashlight informed me that it was 2 A.M. and the temperature 20° F.—twelve degrees below freezing. Although desperately tired, sleep was impossible with inadequate clothing and just one solitary blanket for protection against the intense and unexpected cold.

A few days previously I had basked in warm sunshine on the beautiful island of Majorca, fifteen hundred miles to the north. I had thought that by traveling south the climate would become warmer, particularly in this region of the world. Before setting out on the journey I had tried to recall all I had read or seen concerning the area. Stories of the French Foreign Legion told of sand, perpetual heat, excitement, and romance. It was indeed difficult to believe that this was one and the same place.

The middle of the great Sahara Desert.

Yet here we were, a small group of shivering humans perched high upon a massive tableland called the Tassili Plateau, a mountainous region that rises steeply and majestically five thousand feet above the surrounding barren sea of sand.

Running archer, Jabbaren, Tassili N'Ajjer Plateau, Algeria.

My teeth chattered and my aching body shook as I recalled the circumstances that had brought me in mid-winter deep into the heart of the Sahara, over a thousand sand-strewn miles south of the Algerian coastline.

It was one day in November 1966 when, without the slightest warning, there came an unexpected invitation to join a group of Americans in Algiers

and accompany them to Tassili. The letter was quite definite: all expenses paid from my home in Valencia, Spain, to Tassili, Africa, and return. My only obligation would be to describe the rock paintings that I already knew so well, and compare them with the ones that we should see. Perhaps I would also supply background information on prehistoric paintings in general: dates, pigments used, etc. The letter explained that the Archaeological Institute of America was sponsoring a tour of North Africa for several of its members and a visit to the painted shelters on the Tassili Plateau was to be the highlight of the trip. Would I be free to go along with them?

Would I!

Taking the letter with me, I set out for a long walk into the pine-covered hills, frequently stopping to reread its contents and to contemplate my sudden, surprising, and unbelievably good fortune.

When the immediate excitement abated, I gave careful thought to the clothing and equipment that would be needed. Service in North Africa during World War II had provided me with memories of acute discomfort in the freezing conditions that prevail in the mountains during the winter months, but we would be much farther south. I began to look forward to the journey, a journey that proved to be the most remarkable I have ever made.

. . . And the first night on the plateau the most uncomfortable.

My tent companion was a Paris travel agency representative, responsible for the employment of guides and transport arrangements during the tour of North Africa. He too lay shaking with the cold, unable to sleep.

"All this way to look at some paintings," he stuttered. "Why not visit the Louvre? It has thousands of works of art, and Paris is more comfortable than this God-forsaken region."

I smiled and said, "Because the paintings here are more important than those at the Louvre."

"Ah, no! More important? Will we see a Mona Lisa tomorrow?" he asked.

"I think there is every possibility—a Mona Lisa painted six thousand years ago, and other art works that will tell a strange story."

"Could I hear something of this story, Doug?" he inquired. "It would help a lot to have a reason for suffering like this."

Group of women making a fire,
Sefar, Tassili.

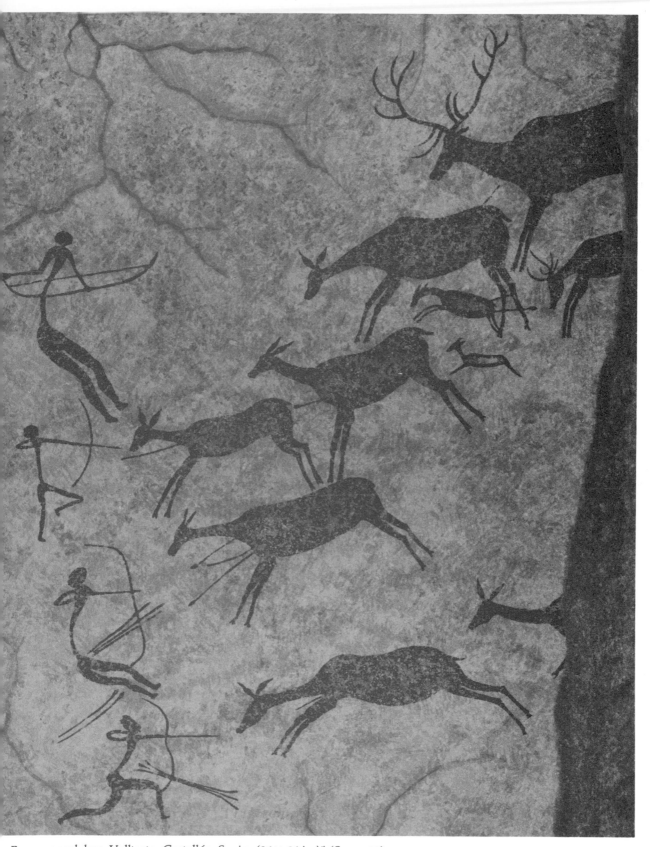

Bowmen and deer, Valltorta, Castellón, Spain. (36 × 24 in.) (See p. 81)*

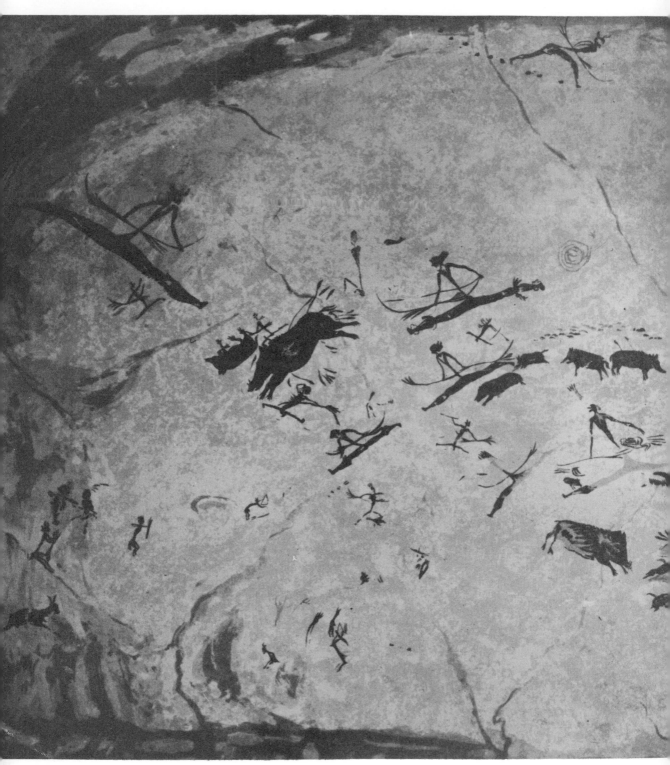

Boar hunt scene, Gasulla, Castellón. (46 × 86 in.) (See pp. 76-77)*

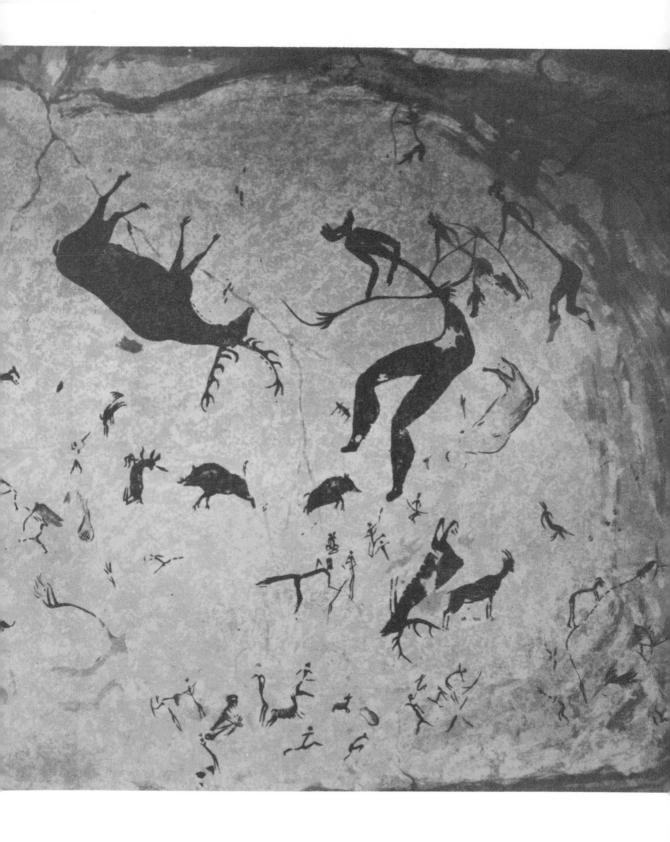

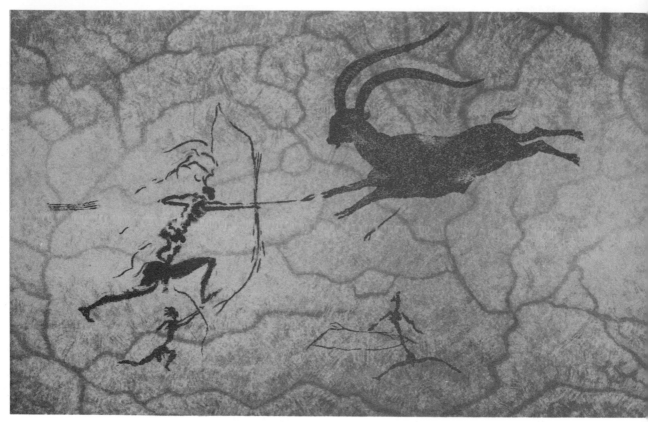

Hunter and ibex, Gasulla.
(24 × 36 in.) (See p. 74)*

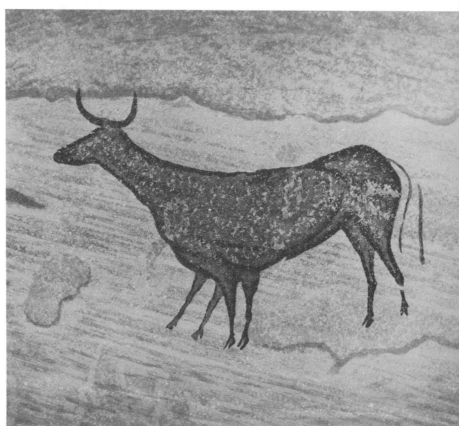

Bull with six legs and two tails,
Albarracín, Teruel, Spain.
(22 × 30 in.) (See p. 86)*

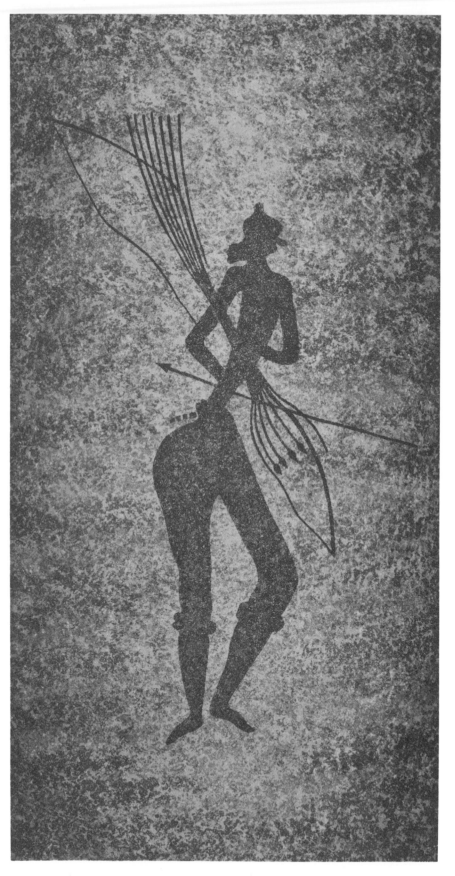

*Detail of archer in full regalia, Santolea, Teruel. (36 × 18 in.)**
(See p. 88)

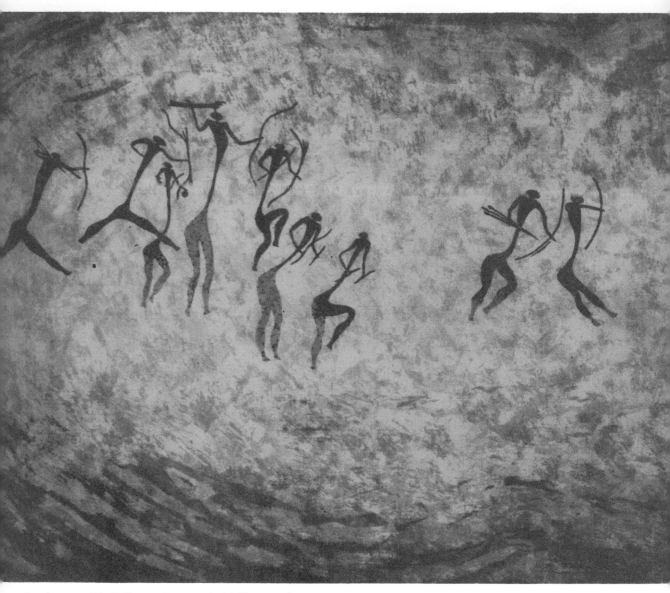

Battle scene (?), Valltorta. (22 × 52 in.) (See p. 80)*

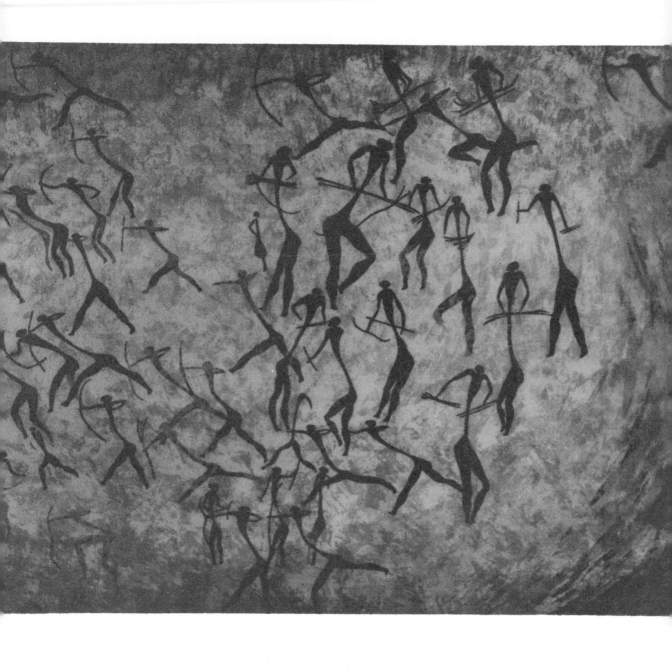

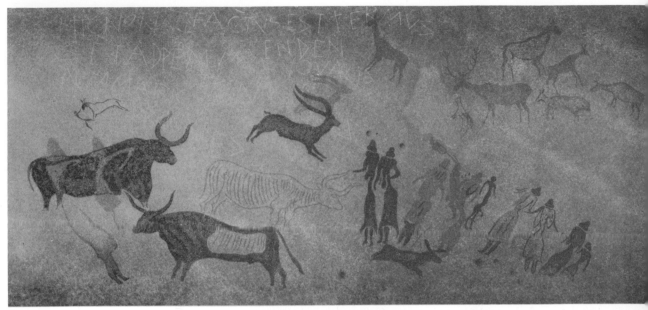

Domestic scene, Cogul, Lérida, Spain. (32 × 65 in.) (See p. 82)*

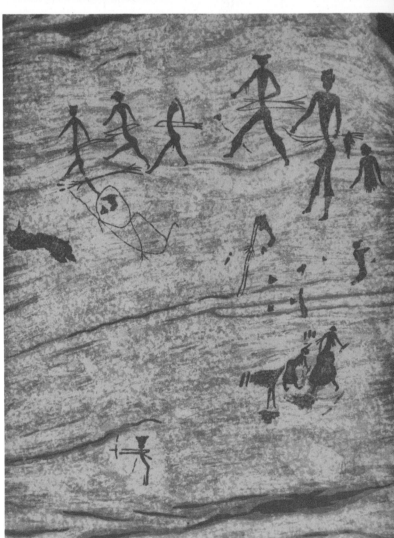

*Hunters and women, Dos Aguas, Valencia, Spain. (36 × 24 in.)**

Frieze of moufflons, Sefar.

The roar of the sand-sprayed wind continued unabated while I told him a little of what was known about the mysterious rock paintings of the Tassili Plateau.

A French army officer, patrolling the region in 1909, was shown several shelter paintings in the area of Tassili by the Arabs; he was interested and even took the trouble to make a few simple copies of some that he examined. When he finally returned to Paris he reported his discovery to the authorities, who were quick to realize the great importance of the find. Here was proof that the Sahara had, at some time in the distant past, been populated by a large number of humans. From examination of the hunting scenes, it was logical to assume that the great Sahara Desert was once green, with deep rivers alive with fish, flowing through fertile valleys that supported animals of all kinds. Even the name Tassili N'Ajjer means "plateau of the rivers," the driest region in the whole world today.

"Later today, the paintings will show us—more clearly than any words

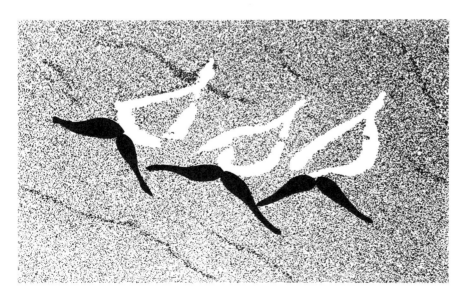

Ostriches in white and red pigment, Jabbaren.

—how prehistoric man lived, loved, hunted, and died in this once veritable paradise," I said.

We lay in the darkness for a while without speaking; perhaps my friend had gone to sleep while I was talking? Finally he said, "This trip sounds exciting. To think that these paintings have survived thousands of winters such as this—and the same number of scorching summers! How is it possible? How soon can we start out? What time is sunrise?"

Prehistoric art had captured another ardent admirer.

During the weeks that followed the letter of invitation, I was kept fully occupied. My first priority was to acquaint myself with what was already known about the paintings. I wrote to everyone I knew in the field of prehistory, but their replies were negative. Apart from envying my wonderful opportunity, they were unable to help. They did, however, advise me to read Professor Henri Lhote's excellent book, *Search for the Tassili Frescoes.* This I had done several years previously and had already refreshed my memory from that and other detailed reports housed in the Valencia Museum of Prehistory.

Fortune lent a helping hand. A week or so later I was invited to attend an international symposium on prehistoric art to be held in Barcelona. Many important and well-known authorities would be attending, and there seemed every possibility of acquiring information and advice.

A taxi from Barcelona airport took me directly to the museum where I talked with its chief, Dr. Eduardo Ripoll. Yes, certainly someone could help me. Professor Henri Lhote himself would be arriving from Paris the very next day.

He and his charming wife were most helpful, but upon hearing that the trip was planned for January, advised us to stay at home. The weather and conditions would be unbearable: cold days and long, freezing nights. I explained that a change in program was impossible—it was to be January or probably never. They frowned, but gave me lots of useful suggestions. When we parted they wished me "Good luck," and added, "You'll need lots of it!"

Traveling via Palma Majorca, I arrived in Algiers on January 12, and allowed myself a whole day in which to contact and talk with authorities before the main group arrived. But the Arab holiday festivities were in full swing and offices would be closed for days. In the chilly wet weather I made a brief, disappointing exploration of the Casbah and returned to my hotel to await the arrival of the group.

Next day the scheduled flight arrived, but without the party of Americans! Urgent phone calls told a sad story. They had missed the plane at Casablanca. With only one flight a week to Tassili—the next day—it seemed unlikely that I would reach the plateau after all. This was a bitter disappointment.

It was Friday the 13th.

However, by some miracle a special plane had been chartered, and towards midnight the party arrived, tired and in an ill mood. I received a

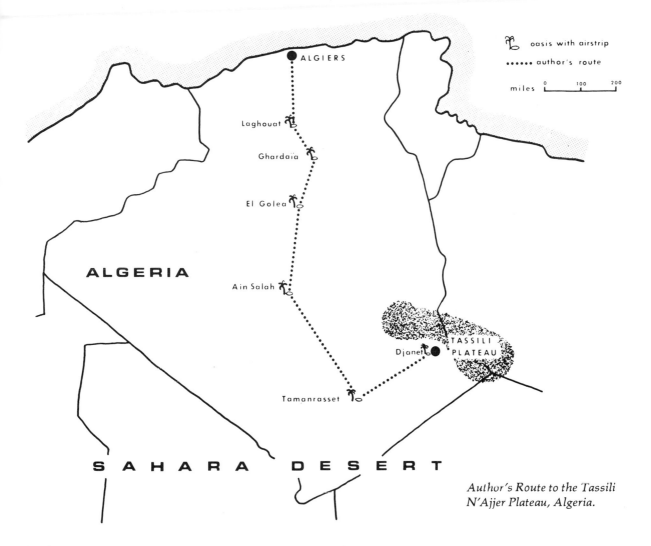

oasis with airstrip
...... author's route

miles 0 100 200

ALGIERS

Laghouat

Ghardaïa

El Golea

Ain Salah

ALGERIA

TASSILI PLATEAU

Djanet

Tamanrasset

SAHARA DESERT

Author's Route to the Tassili N'Ajjer Plateau, Algeria.

shock as they entered the hotel lounge. Most were lightly dressed, some wearing straw Panama hats and one elderly gentleman sporting a white sunhelmet. They came well prepared for intense heat!

Early next morning, crates of bottled and canned drinking water were loaded into the plane, and we left Algiers, flying due south and following the direction of the tarmac road below. While the twisting ribbon pointed the way, the pilot kept a sharp lookout for any stranded vehicles that might be aided by his radio reports.

Far below, the green oases appeared like emeralds threaded on a gray string, and our plane, like a giant dragon fly, glided from one to another, exchanging mail sacks, parcels, and passengers. We halted at the strange-sounding names of Laghouat, Ghardaïa, El Golea, and Ain Salah. One of these stops provided time enough to board an ancient bus and visit a nearby village.

White-walled houses sprang like mushrooms amidst stately palms, and well-stocked shops were piled high with hand-woven rugs and jelabs,

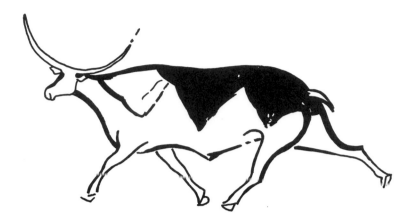

Running bull, Sefar.

the warm hooded garment of the Arab. Several of the near-freezing group members purchased this warm clothing before returning to the plane.

The passengers were of a mixed variety. The light-skinned Algerians from the coast and the darker occupants of the Sahara nodded and grinned at the friendly American, French, and English travelers in an attempt to make contact. Clothing varied from bare feet to combat boots, and from golf caps to turbans. Many Arabs shivered in Western-style suits, while several Americans sat warm and comfortable in their newly purchased desert cloaks.

Hours passed as we penetrated deeper and deeper into the remote and barren landscape. Nothing, not even the horizon, could be seen from either side of the plane. An infinity of flat desert and sky merged to make a blinding whiteness all around us.

As the sun slowly set into the desert, we touched down at the large oasis of Tamanrasset. Here, passengers and aircrew spent the night at a small inn, ill-equipped to cater for such a large party. But the day-long excitement had made us weary and we snatched a few hours of welcome sleep before the 4 A.M. call next morning.

By candlelight we breakfasted on coffee and rolls before being crowded into an ancient bus and driven at an amazing speed to the airstrip. Our group was diminishing, as some members had decided to stay at Tamanrasset to look at engravings in the Ahaggar region, and the main party now consisted of twenty-five persons. Included in this number were an officer of the U.S. Embassy at Algiers, a cameraman from Télévision Algérie, and my friend the travel representative from Paris, whose excellent French and English proved invaluable during the long and sometimes heated discussions with the guides. The rest, and main body, of the party were all from various parts of the United States—from Arizona to New Hampshire.

Another three hundred miles by plane would bring us to the small oasis

of Djanet—the end of the line—but in the meantime we stared down in amazement.

Far below the scene had changed and the landscape grew stranger. Out of the sea of sand tall columns of red sandstone pointed their fingers to the sky. Deep gorges left by long dried up rivers crisscrossed the ruined cliffs that supported towers and domes eroded into masses like wax spilled from a giant candle. Suddenly we saw a wide expanse of sand that became the airstrip. Tiny Land Rovers were lined up to receive us, but apart from a stack of metal fuel drums there was nothing else to be seen but sand, sky, and mountains.

Throughout the long journey the pilot and crew of the plane had been most helpful and informative. Now the former gave us a pleasant surprise. Instead of landing immediately, he swung the plane around and took us for a short trip over the Tassili Plateau. This bird's-eye view of our ultimate destination made us gasp. Here, in this desolate wilderness, desiccated by heat and carved by wind-driven sand, we would find traces of the early occupants of the once green Sahara.

We turned around and landed. While we unloaded our equipment and precious drinking water the pilot and his crew wished us luck and remarked that they would rather fly than walk over the terrain we had just seen from the air. A few weeks after my return home I recalled those words as I read the sad news that "our" plane had crashed on leaving Tamanrasset, with all lives lost.

With loaded trucks we set off for Djanet. As there was only one plane a week, almost all of the two hundred inhabitants of this picturesque oasis

Female figures, Sefar.

Children of the oasis, Djanet, Tassili.

had turned out to greet us. Against the deep blue sky, thousands of slender palm trees raised their foliage to form a galaxy of exploding emeralds. Brightly dressed women and children moved gracefully between white-washed huts and gardens bounded by shoulder-high fences of platted palm leaves. In English, Djanet means "paradise." The oasis is aptly named.

Here in the middle of the Sahara the silence was noticeable. Apart from the few dust-covered vehicles of the Algerian Touring Club, the only means of transport was by camel, by donkey, or on foot, and the only means of contact with the outside world was by radio. Fourteen miles away from Djanet loomed the mountains that form the Tassili Plateau, and amid the labyrinths of the lunarlike landscape were to be found the paintings of prehistoric man.

We were all most anxious to begin, but the guide protested that arrangements weren't complete and suggested we should stay the night in Djanet. Since this would have seriously shortened our visit, we insisted on starting as soon as possible. The guide complained that our arrival was unexpected, nothing had been prepared, there were no donkeys to carry our equipment, food, and water. He was also astonished to find so many elderly members in the group. When he realized that we were adamant in our determination to reach the top of the plateau that same evening, he shrugged his shoulders.

"Then there is not a moment to lose," he said. "If the camp isn't reached by sunset, you will all perish on the mountain."

This blunt but true statement accelerated our movements. We boarded open trucks, and with little ceremony were trundled and jolted across fifteen miles of loose sand and dumped at the foot of the *akba*, or mountain pass. The transport returned to Djanet, and we ate a quick snack while preparing ourselves for the stiff climb.

By a stroke of luck, Arabs with donkeys suddenly appeared, having just completed the difficult descent. These were persuaded, very much against their wishes, to carry our equipment, food, and water, using a long roundabout route, back to the mountain-top camp.

We started the ascent encumbered only by our cameras and The Elderly Gentleman's (T.E.G.) fragile white sun helmet, which, wrapped in a plastic bag, he insisted on carrying everywhere. This useless item of apparel soon became a nuisance. Both hands were required to negotiate the more difficult stretches, so the helmet was continually being passed from person to person through these awkward climbs. There were three *akbas* that led to the top, each separated by a small flat plain of sand and stones that provided a welcome relief from the strenuous climbs involved. The first *akba* wound snakelike around the large rocks and boulders, up into the mountains towering above. Then came a restful walk across the flat region before commencing the much steeper and more difficult climbs through the second and third *akbas*.

The Paris agent and I took up the rear to assist stragglers. Our first casualty was T.E.G., who, though determined to reach the top unaided, was physically unable to do so. We allowed him frequent halts, but as the sun dipped and the going became rougher, we recalled the guide's warning. It was clear that between us, T.E.G. would have to be carried. He hated being assisted, and his repeated but ignored cries of "Put me down!" echoed through the mountains.

As the hours passed the climb became more difficult. We were literally racing against time, and the exertion of manhandling T.E.G. made me sweat profusely—yet at the infrequent rest stops I found myself freezing. The feeling of exhaustion came and went, but there was simply no choice—

Mask, Sefar.

Ascending the third akba, *Tassili.*

we *must* press on. At one point, the sheer cliff face could be negotiated only with the aid of knotted ropes impaled into the rock. In getting T.E.G. up and over, we seemed to achieve the impossible.

There were two guides; the senior one led the party while the other, a young Tuareg, stood constantly on watch. He flitted about the mountain first here, then there, like a mother eagle watching her young learning to fly, inconspicuous but always on hand and ready to assist whenever necessary.

The long climb ended abruptly. We were on top of the plateau, but far behind the main party. With no time now for rest, we stumbled on across the strange moonlike surface, trying desperately to keep the group in sight, and constantly misinforming T.E.G. regarding the whereabouts of the camp—of which we had not the remotest idea. I would tell him that I could see the tents—only five minutes away—please keep going. Ten minutes later it was necessary to conjure up another mental stimulant that would bring us closer. Just as T.E.G. was about to pass out completely, I really did see the camp. I let go of his arm and pointed to the little yellow tent spires. He fell headlong and stayed down.

We could now afford a moment's rest; then darkness fell suddenly and the cold wind rose as we reached the tents and dropped, exhausted, onto stools. Our six-hour torment was at an end. The few blankets were distributed, and as already described, our first terrible night on the plateau began.

By dawn the wind had lessened, but the ordeal of the previous twenty-four hours had split the group into two factions. The more elderly members wished to return to Djanet immediately (who could blame them?), while the remainder elected to stay on and examine as many paintings as time or drinking water would permit.

Although loathe to do so, Ali the guide allowed the group to separate. Before parting, however, we discovered that a decorated shelter was close by the camp at Tamrit, so all of us enjoyed examining a very delicate painting of a herd of antelopes. It is a particularly well drawn group, extremely decorative, and one of the classics of Tassili. No other paintings have yet been discovered in the immediate area, so this gem stands alone. It is in varying shades of red oxide on a natural ocher background, the average length of each antelope being twelve inches. This composition was the first full-size screenprint copy I made on my return from Tassili. The rocking rhythm of the design is masterly. Though slightly faded, the lines are still distinct—but it must be remembered that the paintings are in the open and have been exposed to severe climatic changes over thousands of years. That they are still discernable at all is miraculous.

Our group was now reduced to nine and able to move with greater speed. We were to visit the area known as Timenzouzine, which lay southeast of our camp at Tamrit, and, as if by magic, camels appeared with the promptness of a first-class rent-a-car organization.

We quickly discovered that mounting and riding camels was a hazardous procedure, and it took me some little while to learn. The camel

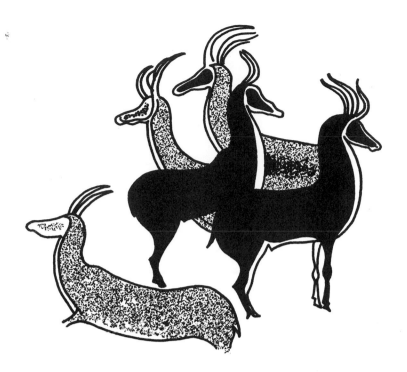

Antelope, Wadi Tamrit.
*(24 × 34 in.)**

was made to squat down to permit mounting, then with the rider's left hand firmly holding the front of the saddle, and the right reaching for the long hair of its back behind the saddle, and with stockinged feet crossed on the U of the long neck, the animal was told to rise.

My unpredictable steed never once obeyed an order without using delaying tactics and objecting in the noisiest terms, while its owner used a small stick and many Arab obscenities in an attempt to enforce his will. The grunts and smell that emanated from the beast during this time were loud and strong, and the suspense of not knowing exactly how or when the camel would react was quite nerve-wracking. Also this species had but one hump —not two—so instead of being safely ensconced between a pair of hillocks, I was perched precariously on top of a high dome in a saddle that constantly slid to one side.

Suddenly, I quickly ascended in three distinct lurching movements; first thrown backward to stare at a wide expanse of sky, then forward to view the sand and stony ground, then miraculously equilibrium was restored, and the animal moved forward at a seemingly dead slow pace which was, in fact, much faster than walking. It was explained to me that by touching certain parts of the camel or saddle equipment, the animal would react in different ways. It did, always contrary to my intentions. My beast didn't like me, or I him, and its owner wasn't happy with either of us, but we made good headway.

Certain areas of the terrain were unfit for camels, and we were obliged to scramble over large boulders to reach the shelters in the dried-up wadi at Timenzouzine. The narrow gorge was lined on either side with numerous

alcoves, and each one contained paintings. Cries of "Doug! Come and look at this!" came from all quarters as we hurried from one shelter to another. There were bulls, antelopes, and crouching hunters dressed in zebra skins. An almost invisible giraffe in faint white pigment walked with dignity among herds of cows and strange symbols of a later period. Some paintings were found in the most unexpected nooks and crannies. On one occasion I had to lie on my back and wriggle along a narrow shelf. On the ceiling two feet above my head was painted a group of women apparently floating in space. Photography in this light and position was difficult but I was well pleased with the result.

We grew more and more excited as new groups of paintings were found. We hurried from one wall to another and cameras clicked at each fresh subject. The light was adequate for taking photographs as the shelters are not dark. Most are only a few yards long and a few feet deep, with overhanging projections. We soon learned not to ignore walls that looked barren, for close inspection invariably revealed paintings of some kind.

Several of us were examining a small incomplete drawing of a bull when we suddenly realized that the background of white streaks represented a perfectly drawn giraffe—an amusing, Disney-like painting that captured the awkward stance of the animal. As we stared, several more details emerged: the small horns and ears, then dozens of curling strokes down one edge of the neck portraying the mane, and small carefully placed shapes in light brown covered parts of the animal. I made a quick sketch on

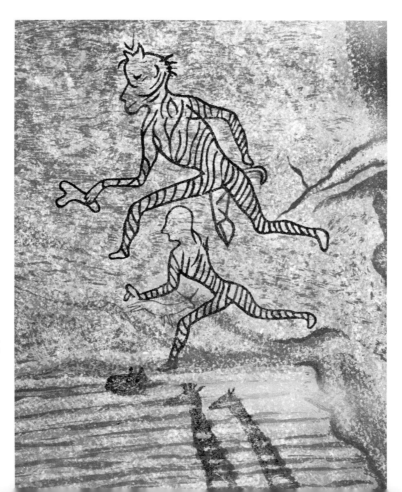

*Hunters in camouflage, Timen-zouzine, Tassili. (36 × 24 in.)**

*Giraffe, Timenzouzine. (36 × 24 in.)**

the spot and took measurements and photographs. In my studio when I began work on the copies, the projected color slide would assist me to obtain accuracy of background, color, and details of the figure.

We returned to our camp at Tamrit. The few wind-torn tents were pitched close to an ancient cypress tree. Many hundreds of years old, this tall, isolated survivor provided a valuable landmark should any of us lose our bearings while searching the endless labyrinth of eroded rock. One had only to climb a high point, look for a tree, and there would lie the way back to camp.

At night, the flickering campfires of the Tuareg guides animated the grotesque rock formations surrounding the camp. We sat with them, and in a mixture of French and Arabic, punctuated with shrieks of laughter, they answered our many questions.

This vast plateau is inhabited now by only a few Tuareg families, nomads of the desert who manage to survive by grazing small herds of goats on the scant pastureland and drinking from the few permanent unclean water holes. The gifts most valued by them are the cast-off clothing of the occasional visitor and precious aspirin tablets. They appear to have cures for all ills except migraine. Little wonder that the Tuareg will gladly exchange prehistoric arrowheads for aspirin!

They never washed, and the lower parts of their faces were always bound with a length of cloth well smeared with goat fat. This served several purposes, two of which were immediately apparent: the wind-blown sand was prevented from entering the nose and mouth and they never suffered from skin soreness. We also found that grease, or thickly applied Chapstick, gave relief to our cracked and bleeding lips caused by the dry, sand-laden wind.

Typical Tassilian landscape.

Small leather pouches suspended from thongs around their necks contained the Tuaregs' most valued possessions—tiny trinkets, small pieces of folded paper, and other items that they would not disclose. While they talked, a type of dough was mixed and buried in the sand beneath the hot coals. An hour later their freshly baked bread was ready for eating.

They sang for us while we joined them in clapping hands in time with their chanting. The Tuareg possesses an acute sense of tone, and my rendering of a song was remembered by our guide, who hummed the exact tune the following day while we picked our way across the apricot-colored sand and through the fantastic scenery toward Tanzoumaitak.

Here we were able to examine one of the most famous sanctuaries in the whole region. Paintings of several different phases were evident; well-drawn figures were mixed with crudely painted camels and weird horned beasts. Henri Lhote has listed sixteen art phases and at least thirty styles, so the paintings and engravings offer a great variety, but also much confusion. In this large shelter the most remarkable painting is of two stately figures measuring almost thirty inches high. Their hair is decorated and double stripes come down from high foreheads. They are accoutered

with bracelets, loincloths, necklaces, and body markings of white spots or studs. At a later stage moufflons, the big-horned sheep of the desert, and other figures have been superimposed in white around the base of the painting, which gives the figures the appearance of rising above a sea of minor creatures. (See page 147.)

A large moufflon with patterned horns moves to the left and faces a weird horned beast, drawn in profile yet showing two eyes. A man sits astride a camel and rides between two dark shapes that may represent huts. Dotted about are dozens of horned animals and semicircular objects reminiscent of jellyfish.

One could spend a great deal of time disentangling the jumble of paintings that overlap each other. In this type of sanctuary the earliest work would attract later artistic efforts, so we see several styles quite clearly. Mysterious shapes and symbols appear everywhere. It is not easy—and in most cases impossible—to explain their meaning. Only a minute portion of this great plateau has so far been examined, and hundreds of thousands of paintings await discovery. It may be many years before we are able to piece together the story and solve the mystery of the once green Sahara and its occupants.

To tear one's eyes away from the decorated shelters is almost impossible, but a glance lowered to the soil brings its rewards. On the surface of the ground near the shelters we found many pieces of painted pottery. With more time to spare we would have discovered lots of implements and articles of adornment, for the Tuaregs showed us small boxes full of tiny arrowheads, beads, and other interesting artifacts that lie

*Moufflon and enigmatic figures, Tanzoumaitak, Tassili. (31 × 51 in.)**

in profusion all over the Tassili Plateau. Here, reposing undisturbed beneath the stony surface of the wilderness, another civilization awaits discovery.

A few of us vowed solemnly that we would one day return, at a more suitable time of year, to spend a longer period in looking at the treasures that the high mountains protected. Perhaps on the next occasion, fate would be kinder to us.

During the remainder of our short stay on the plateau I felt very ill. A fever shook my body but it did not subdue my spirit. We saw as many paintings as our short stay would allow. We discussed them until my voice faded completely. Our return to Djanet was by a long, roundabout route which also included painted caverns. Other members of the party were, by now, feeling exhausted and ill, but we still staggered from shelter to shelter examining and photographing all that was possible. On my return home pneumonia kept me bed-ridden for over two weeks.

Every night I dreamed of Tassili, but the nightmares were never so bad as that painful, indescribable descent down the *akbas* into the welcome oasis of Djanet. Although my headaches continued for many weeks, the vivid memories of the most remarkable journey of my life will remain forever.

Two female figures with children, Sefar.

Tassili N'Ajjer

9
Interlude for Questions

NORMAL LIFE cannot possibly be resumed immediately following a visit to the Tassili Plateau. There are photographs to be processed or exchanged, screenprinted copies to be made, and articles to be written. In short, the pervading atmosphere of the plateau lingers on, interweaving its magic into more mundane activities.

An article describing my first trip to the Tassili prompted many inquiries regarding the copies I was then making of the Saharan rock art. Several institutions, particularly those that had already shown the traveling exhibition, asked if they could be included in any U.S. lecture program that I might contemplate.

A lecture tour? This was something I had never seriously considered, but the suggestion set me thinking. A carefully planned tour of the United States would certainly be of great help in promoting interest in my work. It would also present an excellent opportunity for me to visit various places and meet many people.

Mammoth, Pech-Merle.

The Archaeological Institute of America expressed interest in my inquiry, and eventually listed some twelve places where my lecture would be presented. There was no difficulty in arranging a further eight privately, making in all twenty to cover in a period of five weeks.

Carefully and thoroughly I reexamined my slide collection and selected about three dozen of the most suitable to illustrate a lecture on the "Prehistoric Art of Europe and Africa." It would last an hour—begin with a

Hunter chasing boar, Valltorta.

talk, followed by color slides, and end with a question-and-answer period.

The flight from Madrid was comfortable and uneventful. The rush at Kennedy Airport confirmed my earlier suspicions: in New York everyone moved at top speed. A bus took me to the city terminal where I lined up for a taxi. I hadn't long to wait. Never before had I seen people whisked away so quickly. A flash of yellow screeched to a halt, a door slammed, and the taxi leaped forward as if sprung from a trap. I stood waiting with a suitcase in one hand, a smaller case in the other, and a large roll of prints under my arm.

Brakes squealed and I opened the door. I placed my suitcase on the floor of the cab, my smaller case on the seat, and the roll of prints on top. This left me no room to get in; I would have to enter by the other side.

I slammed the door and hurried round the rear of the vehicle, but I was too late. On hearing the door close, the driver took off like a rocket and was immediately lost in the traffic. I stood in the street stupefied. This was a brilliant start! Would I ever see the cab and my belongings again? Within seven minutes the taxi was back, the driver glaring at me mystified.

From New York to Kansas, Iowa, Illinois, Indiana, Michigan, Ohio, and Pennsylvania; from the smog of Los Angeles to the clear brightness of Santa Barbara; on to San Francisco, the charming city that has borrowed a little atmosphere and architecture from every capital of Europe.

At each lecture site the audience expressed a keen interest in the paintings and prehistoric man's way of life. Students of anthropology,

archaeology, sociology, and art all thirsted for more answers to questions that somehow seemed urgent. Why was this?

It could be that modern man is destroying himself. Overpopulation and pollution of air, land, and water may very soon reap a grim harvest. During my lecture series I realized that many of our young people are aware of what is happening and are anxious to see a change. Perhaps we have "progressed" too quickly, ignoring the obvious signs. Prehistoric man— and the early Indian, for that matter—knew how to live at one with nature. But with the rape of the land and the disappearance of ancient races, the secret has been covered and lost. Perhaps, by digging into the past, we may find a solution for the future.

Knowing of my several treks to the paintings of the central Sahara, many members of the audience raised serious questions as to whether the ancient paintings could portray the arrival of beings from outer space, whether our planet was, in the remote past, visited by "Martians" and if their stay, however brief, was perhaps recorded upon the walls of shelters and caves by prehistoric artists.

Questions of this nature arise continually during my frequent lectures, and perhaps this is as good a moment as any to air my views concerning a subject that is rapidly gaining momentum.

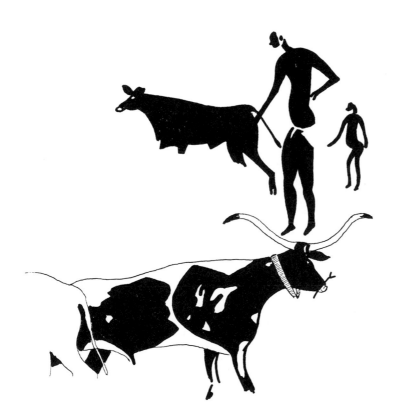

Cattle and herder, Sefar.

Figures with "halos" *Canada* *Hawaii* *Algeria*

It is, of course, the secret wish of many of us that beings do exist in outer space, and that sooner or later they will visit the planet Earth. Such a "coming" would immediately solve many of our present problems; if they should prove friendly, their knowledge might save us all. Alternatively, our petty international quarrels would need to be instantly reconciled. The great powers would seek to combine resources to combat a threat to our universe. Political differences would hastily diminish if the very survival of the world's population should ever be threatened. I feel sure that deep within the minds of many people lies the thought, "If God doesn't come, maybe a Martian will."

The world needs a savior, I willingly admit.

But in my opinion there exists in prehistoric paintings no evidence whatsoever that such visitations ever took place in the past. I agree that many of the strange drawings and paintings resemble our imagined version of beings from outer space—helmeted creatures with antennae attachments. But our present hopes about such beings prevailed, with a slight variation, thousands of years ago. Then the ultimate answer to all problems was held by the shaman, or witch doctor, who had received a halo from heaven and held the secret power of healing, and of sunshine and rain. In the art and folklore of all primitive races from every corner of the earth we see this person depicted time and again, from the headdresses of prehistory to the halo of Jesus. This is no being from outer space. We must look elsewhere for our salvation.

Inward perhaps?

I soon learned the success of my talk depended on how lively the

Italy *Sweden* *Australia*

Helmeted figures, Tassili.

question-and-answer period happened to be. It went on invariably for much longer than the prescribed ten minutes. I personally enjoyed this part of the evening. It was stimulating; sometimes it was a question of talking *to* my audience and sometimes of talking *with* them. I much preferred the latter, and the questions were always varied and challenging:

(From a musician) *Have you ever found indications that pre-historic men possessed musical instruments of any kind? If so, of what type were they?*

Two paintings from the eastern Spanish group show archers walking along in step with bows held high above their heads, possibly twanging the strings as they march. In Tassili, I saw a painting of two dancers, one plucking a bowstring, the other tapping two pieces of wood together.

Archers twanging bowstrings, Gasulla.

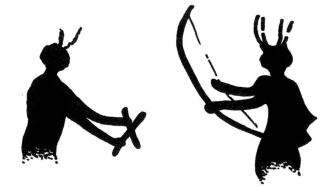

Percussion and string musicians, Tassili.

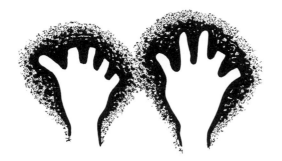

Stenciled hands showing deformities, Gargas, France.

(From a doctor) *In the paintings, have you detected signs of illness or disease?*

Only in the stenciled hand imprints that appear so frequently in the cave art of France and northern Spain. These positive and negative prints show joints missing from the fingers. This might be sacrificial mutilation, but it is possible that a disease such as leprosy may have been commonplace at that time.

(From a tall lady with a loud voice, dressed in brogues and tweeds) *You have described to us the high artistic ability of prehistoric man. My question is, Couldn't the paintings have been made by prehistoric women?*

Er—um, yes, madam!

I traveled in jumbo jets and small commuter planes, by rail and bus, sunbathed in southern California and shivered in the snow at Pittsburgh. My audiences were varied, and on one occasion the front rows were filled with young children. Their questions were, as usual, concerned with welfare:

Did prehistoric children go to school? What did people eat when there were no bison or bulls to hunt? Did they have a doctor to go to when they were ill? Where did they get medicine from?

They most certainly had classes, for there was much to learn. How to make arrow and spearheads from stones and flints. How to hunt and track the animals, and how to find edible berries and roots. How to make fires and build shelters. How to make tools and ornaments from antler and bone.

There were many days when food was scarce. Bones have been discovered of many small animals that were eaten by the early hunters—squirrels, rabbits and foxes. They weren't always lucky enough to have deer or bison meat.

Almost certainly one man in the group would be better than the others in recognizing symptoms of illness. He would also know the best plants and herbs to use as a cure.

Each day the pattern would be repeated: an early start to the airport, the flight to my next destination, the afternoon check of the lecture hall and visual-aid equipment, the early evening cocktail party, dinner, lecture, and reception that followed. Always more and more questions:

What illumination did the artist use while working in the dark cave?

Small, shallow cups have been found near the paintings. These simple lamps held fats or oils which would provide a small flame. Perhaps also a smokeless torch of birch bark was used.

Why are paintings and engravings found only in certain areas and not in others?

Prehistoric races needed to have their magical art near at hand. If they lived in a very fertile region where vegetation and animal herds abounded, their homes were static, and nearby caves and rock shelters became religious sanctuaries.

Other, less fortunate nomadic groups, which lived on the plains and pursued their quarry over vast distances, would be obliged to carry their ceremonial artifacts with them, probably taking the form of masks, totems, figurines, dances, etc. Thus we find the static art in the most fertile regions of northern and eastern Spain, and southern France.

Do prehistoric paintings exist in the United States?

Most certainly. There are many examples of early Indian paintings and engravings to be found in the southwestern states—southern California, Arizona, New Mexico, Nevada, Utah, and Texas. Although most of this rock art may be comparatively recent, I am certain that some of the works are several thousands of years old, particularly examples I have seen in southeastern Utah.

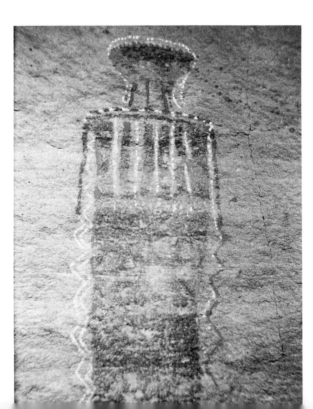

Canyon painting, Horse Canyon, Utah, United States.

What is being done to preseve the paintings?

Unfortunately very little. But a great deal is being done to harm them. Names are scratched and scribbled over the painted surfaces, and sections of rock have been chipped away by vandals. Paintings inside caves can be adequately protected by simply sealing off the entrance with a locked door, but the rock art of Spain, Africa, and other regions presents a great problem. The most effective method is to build a high wall around the decorated shelter and install a metal door with padlock. This is an expensive operation, and, in some areas, a difficult one to accomplish.

One day the aircraft touched down on a dusty plain in Texas. For a hundred miles in each direction the low landscape stretched out flat and wide. I was met at the airport and driven into the city where we had lunch. As we chatted, my hosts told me that arrangements had been made with the local television network to program an interview—would I mind?

Of course not. I rather enjoyed these impromptu five- or ten-minute chats, and the apparent confusion of people and equipment always fascinated me—how everything came out so smooth and right I shall never understand. We were a little late in arriving and things got rushed. Had I some slides that could be used? Yes. The prints that I had brought with me, could they be pinned to a screen? Yes.

The smart young lady interviewer pointed to a table and two chairs.

"That's where we will sit," she said. "There are three cameras; one for us, one to show the prints, and the last to show the slides. The monitor screen is in that corner so you will be able to see when the producer changes cameras, and we can vary our conversation accordingly. We shall be on in two or three minutes."

Quite a few cameras, I thought, to do a lot of jumping around for a short interview. I asked how many minutes the program would last, and was surprised at the answer.

"Half an hour," she said.

"Look here," I protested. "We ought to rehearse this a little. What questions are you going to ask me? In what rotation will the copies and slides appear on the screen?"

"I really don't know, but we will manage somehow," she said with calm confidence. "I've been checking up on the subject a little, and I've a whole lot of interesting questions. Please sit down, we're on in a few seconds."

I tried to avoid the cyclopean eye of the camera as it crept in close. Looking away to one side, the studio lights were blinding. On the other stood the monitor screen. It showed the interviewer smiling blandly, but I wore a worried expression. I changed it to a "say cheese" look and prepared myself for the first broadside.

The young lady was experienced, and the interview went surprisingly well. Within minutes we seemed to be deep inside caves discussing the paintings that flashed periodically onto the screen.

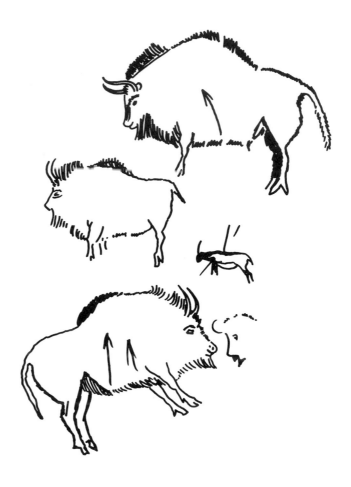

Bison, with pierced hides,
Niaux.

The slides were hopelessly mixed. The Tassili paintings and the eastern Spanish were jumbled together with the French and northern Spanish cave art, and yet no confusion was apparent. There was a strong resemblance between them all. Though thousands of years—and miles—separated the various groups, they all had a common theme: the animals, the hunt, the kill, and survival. I had never discussed the subject in this manner before: now I was learning something new. The hurry and confusion had produced food for thought.

As the tour neared its end, I began to feel a little exhausted, mentally and physically. But what an experience it had been! Most people I met envied me my home in Europe, and I in turn wished to live in the United States, where every conceivable type of countryside and terrain could be reached within hours: the high, white-capped mountains of Colorado, the flat hot deserts of Arizona, the "Spain" of southern California, thick forests bordering the Great Lakes, the canyon mazes of Utah, the list is endless.

"But ours is a new country," they say, "Europe has so many *old* things to offer; the cathedrals of France and Italy, the castles of England, and everywhere the quaint villages."

But of course America is an old country too, created at the same time as Europe. It has a known prehistory dating back to 6000 B.C. and almost certainly a prehistory yet to be discovered that will show an even earlier occupation.

What I find so fascinating about America's prehistory is that it is so recent one can almost touch it. Just a few hundred years ago its occupants were living in much the same manner as men in eastern Spain thousands of years ago. The early Indian (what a pity he should have been given this name!) has left behind tangible proof of his way of life, but how much longer the remnants of his culture will survive is debatable. What is left should be examined today—tomorrow may be too late.

In Kerrville, Texas, I talked to a small group of people who had banded themselves into a modest local archaeological society. On Saturdays and Sundays they would dig the surrounding areas for proof of early man. The membership included housewives, schoolteachers, senior citizens, bankers, and storekeepers. All worked diligently and well under the expert guidance of their president and program chairman. They derived a great deal of pleasure and fulfillment from their labors, which had proved positive and well rewarding.

And so I left America wanting to return, vowing that sometime in the future I should travel the southwest in search of the early Indian rock art that is scattered among the last remnants of real wilderness in the United States. Seated comfortably in a jet, I gazed down on the country that I wished to explore: the high desert with its maze of deeply etched canyons,

Two deer and ibex, Araña, Valencia.

the brick red spires and domes that cast long cobalt blue shadows—a mellow background for the bright yellows and greens of cottonwoods and desert holly. Down there, in the nooks, crannies, and crevices of rock would be the paintings and engravings. How old would they be? What stories would they tell?

As the panoramic beauty of the sculptured wilderness unfolded, I was warmed by a greater respect and understanding for the early occupants of this vast, forbidding region. It was but a glimpse—yet sufficient to set me longing.

During my return flight across the Atlantic I cast my mind back over the previous weeks: the dozens of new friends I had made; the thousands of people who had shown such marked interest in the subject of prehistoric art; the incredible size of the country, the beauty of its lakes, forests, prairies, and mountains; the small but energetic groups of people fighting to keep their country beautiful—making their voices heard; the speed and coldness of the large cities, and the slow tempo and friendliness of the villages and towns; the high level of education with crammed schools, colleges, and universities. A service for every need—for those able to afford it. An answer to every problem—yet many baffled and bewildered citizens.

But the greatest impression of all was the overwhelming sense of freedom, and the strong feeling that one was traveling across a country still in the making.

While the great jet sped toward Europe, I was already thinking of our next move. It was time to leave Spain and explore other prehistoric sites. There was no doubt at all in my mind regarding the whereabouts of our next home. Mentally, the decision had already been made.

It had to be somewhere in the United States of America.

Cattle and herders, Sefar, Tassili.

Tassili N'Ajjer

10
Sahara's Secret Art Gallery

"Nigla! Nigla! Tinaboteka!"

From a deep pool of sleep I rose to the surface. It was not yet light, but
the sky was warming in the east, dimming the stars that had shone so
brightly through the night. Comfortable in my sleeping bag, I stared for a
while at the heavens, awaiting another dawn and the strange thrill that it
would bring—no two sunrises were ever the same. I stretched, closed my
eyes, and began to float once more.

"Nigla! Nigla! Tinaboteka!" The call was more urgent.

Unzipping and rising from a soft downy mummy-style sleeping bag
may have every appearance of a flower opening, but the odor belies the
appearance. It was to be yet another day without washing. I rubbed sleep
from my eyes with a wash-'n-dry tissue and glanced at my watch. Time: 5
A.M. on a mild March morning in 1967. Place: high on the Tassili Plateau
once again.

I laced up my boots, removed a fair amount of dirt from my fingernails,
and tried unsuccessfully to comb my sand-filled hair. As I completed my
preening the cry of our Tuareg guide was chorused by the other members of
our little band.

*Two figures in conversation,
Inaouanrhat, Tassili.*

"Nigla! Nigla! Tinaboteka!"

It took only minutes to pack my duffel bag and place it with the others
in readiness for loading onto the donkeys. I then went in search of coffee. I
hoped to be earlier than the insects, and was, for a short while. As soon as I
had buttered a hunk of the hard bread and spread it with jelly, the sky

Floating figures, Inaouanrhat.

brightened and with the dawn the flies came. These persistent and annoying creatures covered everything. One had to be most wary, for they would stay on the food and be consumed unless carefully brushed away.

I spooned powdered instant coffee into a mug and swamped it with boiling water from a blackened kettle idling on the hot ashes. Finding an isolated rock on which to sit, I ate, sipped the coffee, and let my mind wander. I am wretchedly antisocial until my third cup.

How different, I thought, was this trip from our first experience! A few months previously my American friends had written to me inquiring if I would be interested in another journey to Tassili. They had suggested late March and I had quickly agreed. Spring comes quickly to the Sahara, and I was most anxious to return.

This was a trek we had had to arrange ourselves, and after a great deal of correspondence with the Algerian authorities—most of which was frustrating to say the least—we eventually found ourselves all present and correct at the St. George Hotel, Algiers, ready and eager to go.

I had reached our rendezvous via Valencia and Palma Majorca, but my friends—a husband and wife with two grown sons—had traveled from New Hampshire, thus demonstrating a great affection for the region that had been so unkind to us the preceding year. Our last, but by no means least important, member was a lady from the U.S. diplomatic service, a senior secretary who spoke fluent French.

Warm sunny weather greeted us at Algiers, and the garden of the hotel was carpeted with white lilies. The familiar sounds of a tennis game softly penetrated the venetian blinds while I marred the delicate decor of the room with my rough equipment. We had a 4 A.M. call for the morning and I wished to be prepared.

Well-worn jeans and rucksack, strong boots and windbreaker, camera and notebook, wide-brimmed hat, sunglasses, and packed duffel bag—all

was ready. My more civilized clothing would be left at the hotel to await our return. We would also leave behind us all contact with the outside world; for the members of our small group, time would stand still.

In the early hours of the morning we assembled in the lobby and waited for the cars to take us to the airport. Changed into desert clothes, the transformation was complete. I hardly recognized my friends.

We used several modes of transport to reach the high plateau deep in the Sahara, but by far the most dangerous and frightening part of the journey was our drive from the hotel to the Algiers airport. We had plenty of time, yet our Arab drivers sped through the dark empty streets as if being pursued by the devil. At a breakneck pace they screeched and skidded around corners and over sidewalks. Completely ignoring traffic lights and stop signs, with the right foot pressed hard upon the floorboards, they rushed headlong toward the airport. Had someone informed them that time bombs were ticking away in our baggage? Most probably the two car drivers had wagered fifty dinars on the outcome of this death-or-glory race. Or perhaps the sheer delight of being able to drive through the empty Algiers streets unmolested provoked this suicidal and terrifying escapade.

Trembling but thankful, we reached the airport with an hour or so to wait before takeoff. In the comfortless domestic flights area we stood around and talked. We were hoping that Ali Guerdjou, our well-informed guide from the previous trip, would meet us at Djanet. In our correspondence we had particularly asked for him but had received no reply.

Then our Arab (Touring Club) drivers joined us again, accompanied by a limping, pitiful-looking youth in dire need of a bath, a good meal, and adequate clothing. They explained in French that he would be traveling with us, and that one of the lad's many accomplishments was his excellent knowledge of English. We questioned him and discovered his vocabulary was limited indeed, with "no" being the most used word.

Hut and cattle, Sefar.

Had he been to Djanet before?

"No."

He knew the Tassili Plateau?

"No."

Had he ever before traveled by plane?

"No."

We also discovered that he hated walking, climbing, the desert, and all its inhabitants. His only possession was a broken watch and a dirty crumpled handkerchief.

As the two drivers moved away to their cars, they provided us with our second fright in a day that had barely started. We asked them who this poor lost soul was.

"His name is Megros, he is your guide," they replied.

Our ancient DC-4 took off at dawn and began its oasis hopping. Having experienced the journey before, we felt and acted like veterans. When other passengers wondered aloud, we were able to help them by supplying valuable information. Yes, we would be allowed to leave the plane at the next airstrip. No, it would not be possible to obtain food there. Yes, it did have a restroom of sorts, etc.

Later that day we reached Tamanrasset. Here we would spend the night and continue our journey to Djanet the next morning. Megros, our "guide," was convinced that his duty lay in attaching himself to our group like a leech, and following us closely wherever we went.

Next day we were breakfasting a little after 4 A.M. all ready to leave for the airstrip, when I suddenly remembered Megros. I hurried to his room

Detail of battle scene, Sefar.

and shook him as he lay snoring. He woke with a start, leaped from his bed fully clothed, and began hammering on the doors of the corridor shouting, "Wake up! Wake up!"

I took him firmly by the arm and led him to the dining room, where we were all assembled.

At first light the plane rose again and climbed quickly and steeply to fly over the Ahaggar mountains that surround Tamanrasset. We looked down and saw the wreckage of the plane that a year previously had not been able to clear the treacherous rocks. The next few hours soon passed while we gazed at the natural splendor of the mountains below. Then, as they fell away to be replaced by sand, we saw the airstrip of Djanet. At last we were there!

Standing under the belly of the plane waiting for our gear to be unloaded, we looked over to where the rugged trucks were drawn up in line. There was no sign of Ali Guerdjou. Disappointed, we grabbed our duffel bags and walked slowly toward the vehicles. Someone would be here to meet us, no doubt. From behind the third truck Ali suddenly appeared, his strong white teeth gleaming in a big smile, and a hand held out in greeting. He talked rapidly in French, first serious, then laughing. I was impatient to hear the news.

Hyena and child, Tanzoumai-tak.

He was now in complete charge of the Algerian Touring Club administration at Djanet. A team of expert guides was under his command, and we should be given the best one he had. We pleaded. We didn't want his best guide, we wanted *him*, Ali Guerdjou! He promised to see what could be arranged.

Later, he freely admitted that he had purposely hidden behind the motor transport so as to view, in private, the members of our party as we deplaned. He also had vivid memories of our last visit, and if we had brought the elderly gentleman along with us again, I'm certain Ali would have swiftly and promptly taken to the hills.

Djanet looked wonderful in the clear bright air, and we made ourselves comfortable in the straw and cane huts equipped with metal beds and clean white sheets. How warm and leisurely it felt—it was hard to believe that ten weeks later in the year could make such a difference; no hurry, no cold, and no rush. We would spend the night here and tackle the long climb early next morning before the sun grew too hot.

We talked with Ali concerning the places we wished to visit during our stay on the plateau. The area known as Sefar was a must, and perhaps Tinaboteka too? He nodded and assured us that we should see many wonderful and strange paintings, for he had decided to take us personally. He added a rider though; the new guide would have to come along with us, for Megros had been sent from the head office in Algiers to supplement the overworked guides centered at Djanet. On this trip he was to be tested, and Ali's report would determine whether he stayed on or was dismissed. I personally hadn't the slightest doubt about the outcome.

Shell-like figure, Inaouanrhat.

We spent a most pleasant afternoon exploring Djanet. Penetrating deep into the palm trees, we came upon several families and hosts of

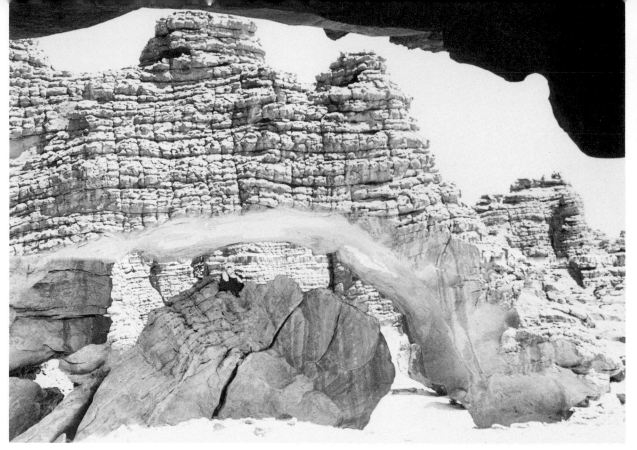

Rock formation, Tassili.

giggling children gaily dressed in brightly colored fabrics. Heavily ear-ringed and with the tightest of curls, they scampered along with us jabbering away like flocks of exotic birds. They looked healthy and well-nourished, and their quick reactions to our sign language showed bright intelligence. Diseases of the eye appeared to be prevalent, particularly in adults, caused and spread no doubt by the flies that crawled everywhere. We watched the women washing clothes by beating their wet bundles with large rocks, and noted that communal watering places were shared by man and beast alike.

Before the evening meal, we reached into our duffel bags and brought out our own particular, and well-protected, bottles of aperitif—thus we established our "cheers hour," a relaxing period at the end of each day when we would recount our adventures and relive once again those valuable moments we were loathe to lose. We were fit, contented, and brimful of anticipation.

Early next morning we started our dread climb, but the plateau opened its arms to us. The grim ascent had dissolved into nothing but an invigorating walk. I remember asking Ali when we would encounter the really nasty section that was such a nightmare last year. He answered that we had passed it twenty minutes ago.

We reached the top and halted for an orange and gingerbreak snack, a combination I heartily recommend. Then across the plain to Tamrit—a

Charging bull, Villar del Humo, Cuenca, Spain. (See p. 97)

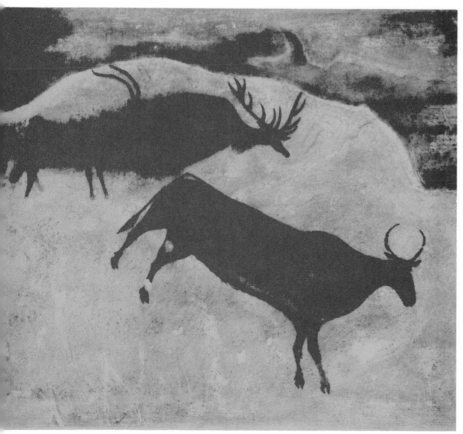

Deer, ibex, and bull—a recent discovery, Villar del Humo. (See p. 97)

Hunting scenes and figure collecting honey (upper right), Araña, Valencia. (30 × 53 in.) (See pp. 91-92)*

Panel of archers and animals—a recent discovery, Villar del Humo. (See p. 97)

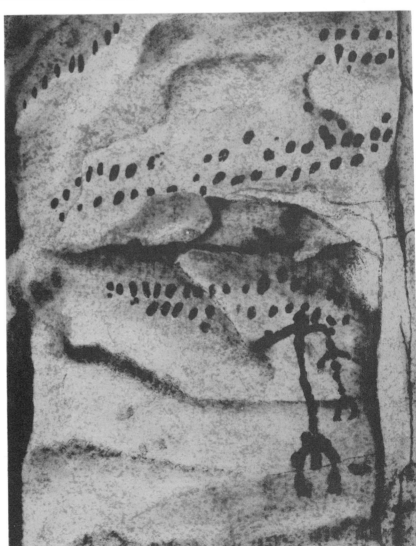

Fingertip dots and stylized figure, Villar del Humo. (See p. 97)

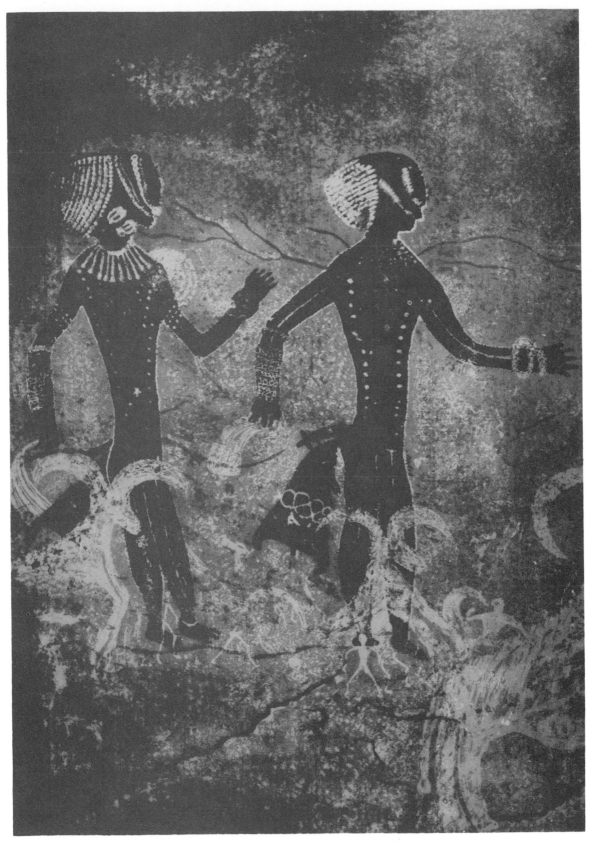

Two figures in finery, Tassili N'Ajjer, Algeria. (47 × 31 in.) (See p. 123)*

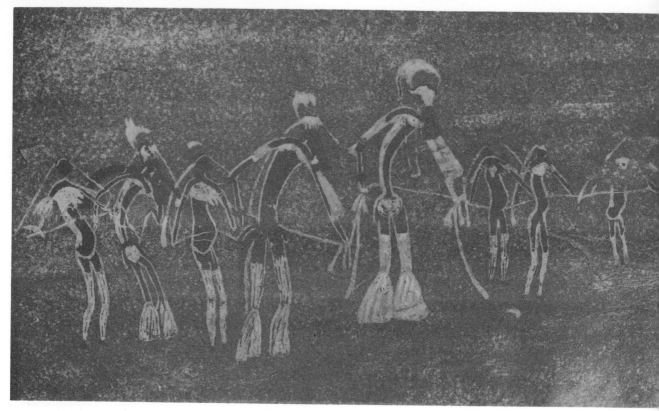

Masked dancers, Sefar, Tassili. (22 × 34 in.) (See p. 158)*

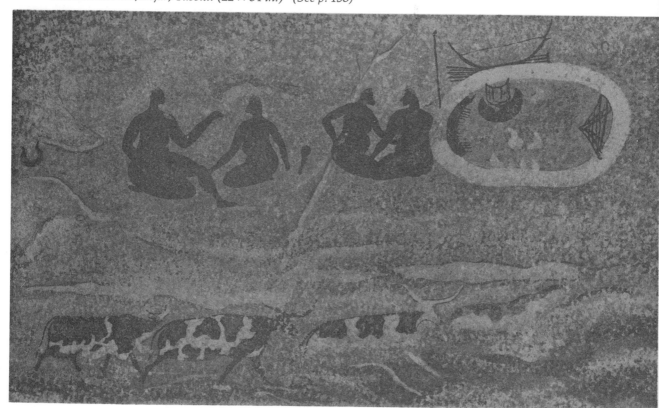

Seated figures beside a hut, Sefar. (22 × 34 in.) (See p. 158)*

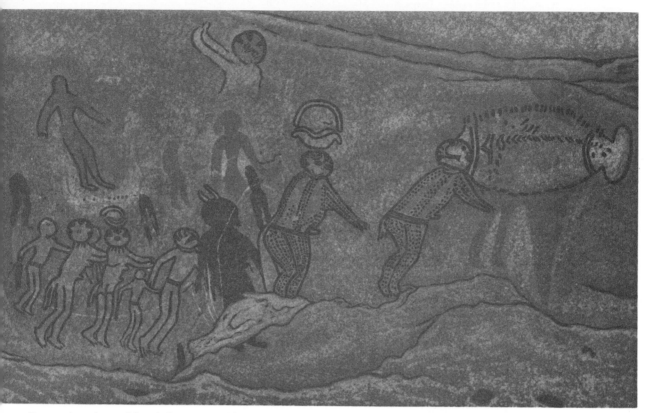

Procession of round-headed figures, Jabbaren, Tassili. (24 × 34 in.) (See p. 164)*

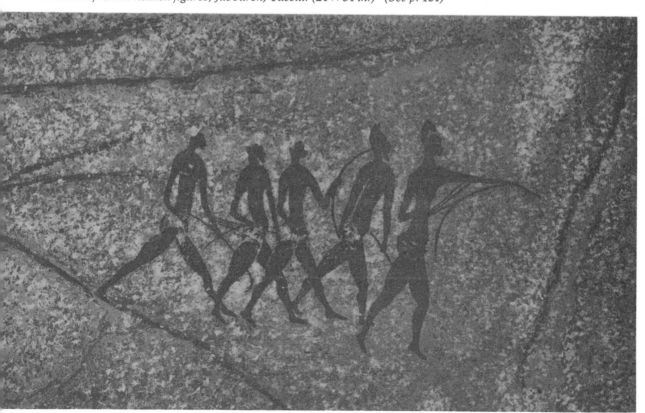

*Archers in file, Jabbaren. (17 × 23 in.)**

Helmeted warrior,
*Sefar. (34 × 22 in.)**
(See p. 158)

walk that seemed nothing. It must be admitted, though, that we had all been in strict training prior to the trip. The year before we had learned a hard lesson!

So here we were, hiking across the plateau with determination, under the expert guidance of Ali and his valuable Tuareg assistant named Candelouise. We had taught the Tuareg several words of English which he delighted in repeating, and in turn we had learned a few words of his tongue that we used as often as possible. One of them was *nigla* which meant "come on—hurry up." As we were currently heading toward an area known as Tinaboteka which lies west of Sefar, the cry that brought me back to earth was appropriate enough.

"*Nigla! Nigla!* Tinaboteka!" The donkeys were loaded; we were on our way.

With the possible exception of The Maze in southeast Utah, the scenery of the Tassili Plateau is unlike that anywhere else in the world. The twisted, tortured rocks soar vertically to form withered fingers, some capped like mushrooms with domes ready to fall. The disintegrating formations resemble ruined cities with broad avenues and narrow passages intersecting at regular intervals, sometimes even forming large squares which would make natural meeting places, and where we found the most interesting of the paintings.

The once fast-flowing rivers of prehistory ate hollows and shallow caves into the base of the towering rocks. Now strong prevailing winds continue the erosion by sandblasting the volcanic stone into grotesque and beautiful shapes. We felt like ants wandering in the waste of a candlemaker's tray. In this land of no water, the rocks appeared as waves, or a raging gale suddenly petrified.

We traveled many miles a day, encouraged and stimulated by our curiosity to know what lay around the next corner. Each turning brought

Petrified rocks, Tassili.

gasps of surprise as we looked up at the wind-sculpted monuments jostling one another for space to corkscrew or sprawl. Scaly-skinned monsters, ruined cathedrals, bridges and spires—the list was endless.

This enchantment was increased tenfold by the thousands and thousands of paintings which adorn the walls of Tassili's vast secret art gallery. Countless pictures in black, red, white, and golden ocher reveal vividly the plateau's glorious past.

Among my most interesting possessions is a large-scale map showing the area of the plateau over which we traveled. At the top lefthand corner in tiny print it lists the names of the French army surveyors who were responsible for drawing it up in the year 1932. Each time I examine the map I think of what exciting stories of adventure Lieutenant Melia and Adjutant Renard could tell of their arduous activities. The large sheet simply bristles with strange names as my pencil retraces the routes we trod: Tamrit, Timenzouzine, Tanzoumaitak (on the first trip); Titeras N'Elias, In Itinen, In Etouami, Sefar, Tin Teferiest, Tin Tazarift, Tin Abotéka (on the second); and Jabbaren, Inaouanrhat, Tabarakat, Ozaneare, Rayaye, Alanedoumen and Tin Kani (on the third and last trip).

These are all place names. To this long list can be added the titles given to each *akba* (mountain pass), *wadi* (gorge), *erg* (sand dune), *guelta* (water hole), *oued* (water course), etc.

To the uninitiated, the map appears to be seething with towns, villages, and thousands of inhabitants, and one can visualize a rural bus service efficiently linking the strange-sounding names together.

But what a silent, isolated place it is. There is not the slightest indication that one is about to leave the area of Tin Teferiest and enter Tin Tazarift, and no apparent change in the scenery affords a clue.

Yet it is vitally necessary to name each group of rocks, or how would one give directions? or pass on the last sighting of a stray camel to its pursuing owner?

Following my first journey to the plateau, I was of the firm conviction that nothing could possibly live or grow in the cruel climate, but our second visit proved me wrong. My sole interest lay in the paintings, but fortunately our younger members cast their glances in other directions, and I am grateful to them for observing flora and fauna that I would have otherwise missed.

We were privileged to catch sight of a moufflon, but the shy, quick creature refused to be photographed. On another occasion a single rabbit scampered between the rocks, though there must have been others that kept out of sight. The third and last of the furry species we saw resembled a marmot; he was quick and we weren't sure.

Our feathered friends were present but few in number: doves were noted at Sefar, crows at Tamrit, also small black and white birds of sparrow size, and one that remained out of sight but sang beautifully—we named it the "desert lark."

Lizards were quite numerous; they came in all sizes and colors. One type was of particular interest to our Tuareg guides and donkey drivers. It

Spotted giraffe, Sefar.

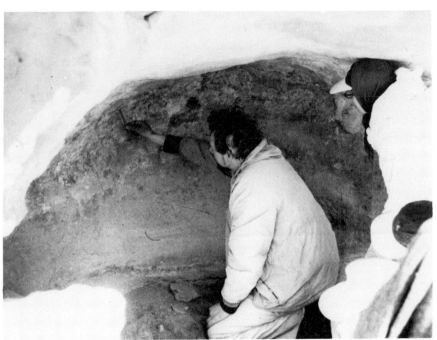

Author examining a rock painting, Sefar.

was a large jet-black reptile with a ridged tail and scaly hide. Candelouise spotted one as it scurried under a flat stone, but the poor thing left its tail exposed. This was grabbed tightly by our guide and the protesting animal pulled from its lair. It was not immediately killed, but was carried back to camp carefully ham-strung. Given an opportunity, its sharp teeth would have bitten painfully deep, not to let go until killed. It provided an unexpected addition to their evening stew, a delicacy that tasted like chicken and was much prized by the Tuaregs.

Snakes were not too active, but we did see the dreaded horned viper of the Tassili—the creature that occupied my thoughts if I awakened during the night. I was afraid that one would come gliding slowly to investigate my warm sleeping bag. One of our group carried the necessary serum and first-aid and we were thankful that it was never put into use. The equally deadly but less common small, black scorpion was also seen and prudently put to death. Ali told us that a good price was paid for live specimens at the Pasteur Institute in Algiers, but we had no suitable container, and no one cared to carry it loose in a pocket.

Insects. Thousands of flies, identical to, but smaller, than the common house fly. They would settle on our backs in the morning and stay with us all day, not too bothersome but rather unpleasant. The plateau is spotlessly clean with nothing for the flies to live on. They must have been brought up from the oasis by the donkeys. A few ants, several small cobalt-blue beetles, a spider or two, and to complete the census, an occasional dragonfly darted across the water holes.

On the Tassili, a pair of stout walking boots can be reduced to shreds in a comparatively short time. The ground surface is covered with sharp-edged rocks mixed with smooth, round boulders. In short, movement is difficult and can best be accomplished with both eyes firmly focused on the ground a yard or so ahead of intended footsteps. While complying with this rule I was able to observe the scant vegetation that obviously supported what little animal life we had seen.

It was surprisingly plentiful considering the lack of water. Bright wild flowers of many species forced their tiny blooms through the jagged rocks to greet the sun, and white, yellow, and blue blossoms of fragrant lavender provided pleasant surprises. Some plants had roots several feet long, reaching deep beneath the soil for hidden water courses that must still exist. Oleander that reminded me of my home in eastern Spain stood proudly, as well as camel thorn, wild olive, and of course the few but magnificent cypress trees. The one at Wadi Tamrit that provided us with such welcome shade measured twenty-two feet in circumference and was certainly many hundreds of years old.

All these things were noted as we made our way from Tamrit and headed northeast. The greatest concentration of the Tassili paintings is to be found at Sefar, where we made camp and stayed for a few nights. Decorated shelters and rock walls abounded in every direction, but our knowledgeable guides methodically led us through this confusing labyrinth ensuring that we missed nothing. Our tall Tuareg guide seemed to be well-

Proceeding to Sefar through a natural tunnel.

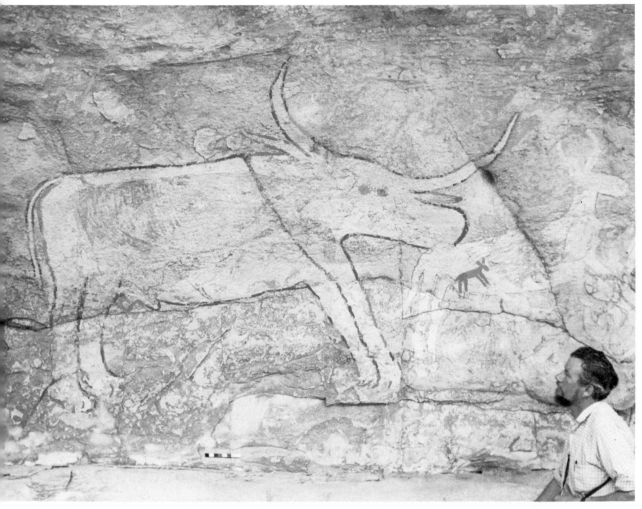

Large horned beast, Sefar.

acquainted with every inch of the plateau. He was handsome, and one of the very few who would allow himself to be photographed—in fact, he delighted in it. He would stride ahead of the group and station himself beside an impressive painting or on a high picturesque perch, knowing full well we were unable to resist.

It was exciting to find this vast number of paintings in such an excellent state of preservation. The marked difference of the various styles was particularly striking. Many of the paintings reminded me of the eastern Spanish group. Others seemed exact replicas of Australian aboriginal rock art, while some resembled those of the African bushmen and even the early Indian paintings of North America. In addition to the styles already mentioned, we saw large paintings in outline peculiar to Tassili alone towering above a seething mass of smaller creatures covering the rock shelters at Sefar.

In general, prehistoric man painted what he saw, and his perfectly proportioned animals are easily identified. Yet at Sefar we examined the

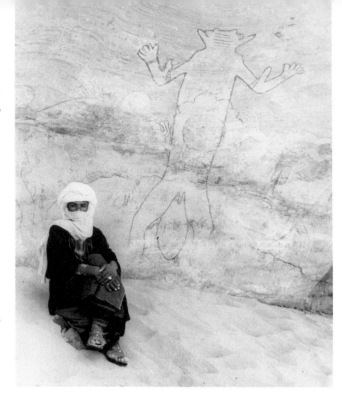

"The Monster" at Sefar.

strangest of men and creatures, usually painted with a white pigment and surrounded with a contour line of dark red oxide. Dozens of bloated female figures with round heads hold up their arms in a praying attitude to the central figure, an enormous monster with strange protuberances growing from head and arms. There are at least three such scenes at Sefar, and in each case the face of the male figure is covered with a mask or grille consisting of five distinct parallel lines. Obviously the scenes describe a ritual—but of what kind? When were they painted? I searched for some clue, but the mass of superpositioning makes the riddle hard to solve. In some cases the classical and realistic figures have been painted over roundheads, and then suddenly we observe exactly the opposite.

As in France and Spain, the prehistoric artist of Tassili used mineral oxides to make his colors. These he ground to fine powder before mixing in a binding liquid of animal or vegetable fats. It is difficult to determine the exact age of the paintings; they appear to cover many different periods, but the extreme dates are estimated to be between 6000 and 2000 B.C. At this time in prehistory, Tassili N'Ajjer lived up to its name of plateau of the rivers, for some of the paintings feature fish, and in one case a hippopotamus. Domestic scenes are common, as are the great groups of cattle tended by herdsmen. Also plentiful are the jungle creatures: antelopes, bulls, giraffes, and ostriches.

To the keen observer, the paintings supply a continual and visual description of daily life in prehistoric times. We see portrayed the struggle of life from the cradle to the grave: quiet family scenes, dances and strange ceremonies, fleet-footed archers pursuing herds of stampeding game, and hundreds of bowmen engaged in violent battle.

Who were these people? Why did they paint the walls of their homes? What strange happening occurred to transform a veritable paradise into such an arid wilderness? Was the desiccation sudden, or spread over a long period of time?

These and many more questions concerning the Tassili N'Ajjer Plateau remain unanswered. The paintings show the people to have been hunters, fighters, and, surprisingly, dairy farmers. Many of the cattle wear collars around their necks, and the pastoral paintings show herders and even milking scenes.

Serious scientific study in the area had barely commenced when the conflict between the French and Arabs (1954–1962) brought an end to the intense researches of Henri Lhote, and the possibility of further exploration in the near future appear remote. Such expeditions are costly, and no doubt the Algerian government feels that more important decisions await attention.

Yet the paintings show us a great deal. Apart from the occasional battle scene, we can observe a feeling of pride in the carefully drawn figures, and a great serenity, punctuated here and there by dancing sorcerers, pervades the atmosphere.

Our daily routine remained constant throughout our stay on the plateau. We rose at 5 A.M. and carefully packed our sleeping bags and belongings for loading onto the donkeys. Then we breakfasted before setting out on a four-hour survey of the painted shelters. At midday we rested and ate Ali's perfectly prepared and always satisfying meals. With the sun at its highest, we dozed in the shelters and homes of prehistoric man, surrounded by his strange and mysterious paintings. Then at 3 P.M. we would set off once more, searching for and finding many hundreds of paintings that told the story of the once densely populated and fertile plateau.

In the evening we looked for comfortable nooks and shelters in which to spread our air beds and sleeping bags before the sun dipped quickly

Hut interior and family group, Sefar.

behind the tall grotesque silhouettes of our strange surroundings. The evening meal that followed "cheers hour" was always a gay affair and the only time when we could eat in comfort, completely free from flies, which disappeared during the hours of darkness.

With our hunger more than satisfied, we would sit and talk quietly, not wishing to disturb the great peace and silence that was tangible in the darkness. And so to bed, to look up at the bright stars for a while before slipping gently into sleep.

My greatest problem was to decide which of the paintings to feature in my screenprinted editions. These must be photographed more carefully, copious notes made, and measurements taken to ensure accuracy in the final copy. Having found a "must," I would complete the work—only to find a much better example later in the day.

There were ten or more different styles, and it was my intention to choose the best examples I could find from each of them for my print editions. Masked dancers, herds of cattle, domestic scenes, roundheaded "Martians," groups of hunters—all claimed my attention.

At Sefar, a well-painted group stood alone. Three masked male dancers with long, narrow waists, wearing plumed headdresses and wide-bottomed leg coverings, shuffled along in line with five females, with their breasts painted white and wearing striped legwear. All the dancers were linked together by a long tasseled cord. (See page 148.)

Then in sharp contrast is a peaceful scene showing two groups of figures seated beside a white, oval hut. A lance and bow with arrows lie to the right of the doorway, which is sealed with woven straw. A line of piebald cattle nearby completes the domestic picture. (See page 148.)

A tall, dark warrior, uniformed in helmet and epaulets, carries a spear, his purposeful stride along the rock face held still forever. (See page 150.)

Battle scene, Sefar.

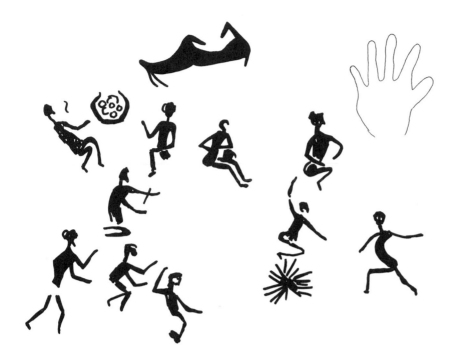

Feast scene, Sefar.

One charming composition was full of incident. In the center, a pile of sticks burned and around the fire several figures were engaged in domestic chores. At top left, two seated females prepared food for a pot that stood between them while above lay the reason for the activity—a large dead animal with legs pointing upward waited to be skinned, cut up, and put into the pot. Friends were arriving from the left with hands upraised in greeting. This indeed would be a grand feast.

A dramatic and animated battle scene: two groups of bowmen confront one another; the large army of archers from the left runs swiftly toward the enemy, firing their bows as they advance. The other group retreats under the heavy barrage. One can almost hear the cries of the warriors and the whistle of the arrow shafts.

In the afternoon we made a visit to the nearby permanent water hole, one of the precious few that exist on the otherwise completely dry plateau. It was about the size of a small swimming pool and covered in several places with an unattractive green slime. Ali filtered the water through muslin to remove the largest of the clearly visible swimming creatures: black ones that swam up and down, and a red type that moved from side to side. He added special purifying tablets, for the unseen microbes are apt to cause more harm than the larger visible organisms. It was the only water available for drinking. We were lucky to have it, and after a day or so we forgot to concern ourselves about the possible ill effects.

Megros was of no use whatsoever; he was, in fact, a burden. With little

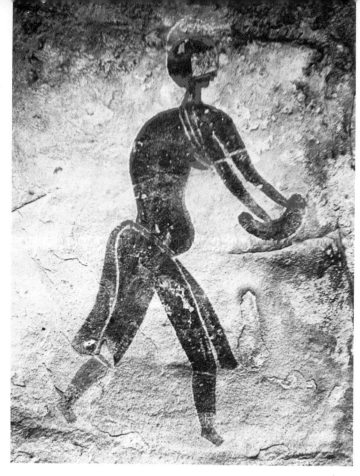

Masked lady of Sefar.

or no effort he managed to do most things wrong. While marching, our communal source of drinking water was carried by Ali. It was a soft leather skin with a plastic cap which, when unscrewed, exposed a nipple. It is a simple matter to hold the container high, point toward the mouth, press, and guide the stream of water through pursed lips. Such skins are common in Spain and are most hygienic. But Megros would ask for water early in the day, and we were never able to break him of his nasty habit of sucking noisily at the nipple like a baby goat.

He touched the paintings, and for some unknown reason constantly inquired what time of day it was. He would then adjust his broken watch, shake it, hold it to his ear, and then repeat the question and little ceremony half an hour later.

We consumed vast amounts of water; six to eight pints a day were usual. Very little was passed in the normal way, and I don't remember sweating to any great extent. On reaching the body surface the liquid immediately evaporated in the arid air. Ali often sprinkled a few drops of aniseed into the drinking water to kill any unpleasant taste. Though very tired, thirst would awake me during the night and further sleep was impossible without gulping down some of the precious liquid. To die of thirst must surely be the most torturous and agonizing way of departing from this world.

One evening in Spain I dined with Henri Lhote and his charming wife, Irene (who speaks English fluently). While we talked of the plateau, Madame Lhote described a visit to Paris that was arranged for a small party of Tuaregs who had been helpful during her husband's earlier expeditions. I could imagine the last "Gentlemen of the Desert" being confronted with civilization for the first time, and how confused they must have been. I was surprised when Madame Lhote explained.

The Tuaregs were shown factories, machinery, modern farming methods, the Eiffel Tower, and Notre Dame. Through all this they appeared unimpressed; yet they reacted immediately while standing on a bridge overlooking the river Seine. Terribly shocked, they expressed the deepest concern that so much water should be allowed to escape and flow away from the city!

No Tuareg ever carried water on his person as a hiker or campaigning soldier would do, but he would always ensure that there was an adequate supply within reasonable reach.

I clearly remember Ali's consternation when we arrived at Djanet for our third and last trip to the Tassili. We had informed the head office in Algiers of our wish to go to the seldom visited Jabbaren area of the plateau. To this they had agreed—after raising the charges considerably. Ali accepted that the paintings there were magnificent, the scenery quite

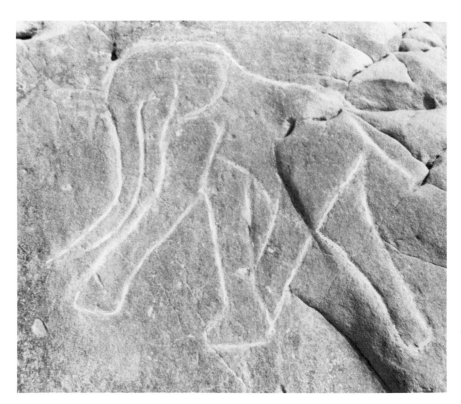

Engraved elephant, Sefar.

extraordinary, the area comparatively unknown—but did we realize that there was *no water*? We would have to carry every drop, and to stay in an area with no water hole would be tempting the devil. It was an unlucky region; the guides and donkey drivers hated it. *Must* we go there?

Yes, we must.

Resignedly, Ali made the arrangements. He ordered extra donkeys to carry the water, purchased a large straggly beast that seemed neither sheep nor goat, and we set off. As usual he was proved right: ill luck dogged us from the start.

To reach Jabbaren we ascended the plateau by the Akba Aroum, a different route than the previous trips. It was longer but slightly more gradual. The donkeys, their drivers, and the goat were strung out far behind us. It took a day's march to reach the Jabbaren site, where we awaited the arrival of our food, water, and sleeping bags. We waited in vain; darkness fell and still there was no sign of the donkeys.

Ali, then suffering from a terrible bout of flu, called his young Tuareg assistant, and together they departed in search of the transport. Left to our own devices, we first rested and then searched our minds to find a way of passing the time. As the hours went by we grew hungry and anxious.

Water hole at Sefar.

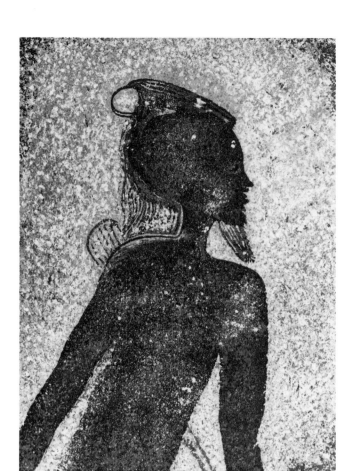

Bearded archer, Jabbaren.
*(23 × 17 in.)**

Finally Ali returned with most of the donkeys and supplies. The delay had been caused by the loss of one animal and its aged driver, who had no knowledge of the region. With luck he would find his way, and the young Tuareg was continuing the search. The poor man had no water, only solid rations. If he failed to appear after three days, there would be no hope at all. Ali was ill and worried.

Often during the night, when awakened by the bleating and belching of the goat, I thought of the old man out on the plateau searching in vain for a shape he would recognize silhouetted against the starry sky.

We spent two uncomfortable days at Jabbaren, looking at its fantastic paintings but visualizing the old man's sorry plight. The fresh meat supply was slaughtered by our one-eyed cook, and during dinner that evening we were still unable to reach any conclusion regarding its origin. The meat was awful, but the night was quiet.

Ali's illness reached a climax and he was obliged to roll into his blanket where he sweated heavily for several hours. Later he rose, drank a little brandy, smoked a cigarette, and pronounced his thin, wiry frame alive and well.

*Mysterious symbols: wind or water? Inaouanrhat. (24 × 34 in.)**

Many of the paintings at Jabbaren are quite mysterious. One shows a carefully drawn circle with four strokes radiating from it. Urn shapes are positioned on the end of each straight line, with interiors crisscrossed like a net. It is the only painting of its kind, and one that may remain an enigma forever. I tried hard to unravel the mystery.

I sat before the painting for a long while and tried the trick again: watching the late afternoon shadows and listening to the silence, letting my mind be led away—then suddenly returning to the problem as a cat pounces on a mouse after pretending disinterest. But there was no answer. There never has been.

A procession of uniformed roundheads crosses one wall, with two of the figures carrying basketlike objects upon their heads. A fish is nearby, providing the scene with an underwater atmosphere. Masked sorcerers leap and dance, and a shameless erotic group disport themselves, ignored by the herds of cattle that move silently forward.

But there were many more rock pictures to be seen at Inaouanrhat and Tabarakat. We left the Jabbaren area with Ali's countenance showing nothing but pleasure and relief.

We were crossing an *erg* on the approach to Ozaneare when we met an elderly Tuareg guiding two young Frenchmen over the plateau. For several

minutes Ali spoke earnestly with him, then he made the introductions. We were highly honored for this was the renowned Jebrin, the man who led Henri Lhote's famous expedition back in 1956. Now aged over eighty, he still darted up, down, and across the plateau like a mountain goat. When we shook hands, his skin felt like that of a tortoise, wrinkled and hard. While he smoked and chatted, his eagle eye caught a movement of color a mile distant.

"Here comes the old one!" he said. "Who did you send to find him?"

We saw old man Jebrin heighten a little as Ali smiled his answer.

"Your son," he replied.

Then north along the *reg* to Rayaye we went, with a tall cypress standing proudly in the distance pointing the way to another totally unexpected surprise. Approaching the tree we saw a long reed mat anchored to the sand in a U shape, then another a little farther away. Ali recognized it at once and instructed us to keep our distance while he went ahead. It was a Tuareg camp he explained, and it wouldn't be right to go barging in uninvited. He took with him chocolate and aspirin, small gifts that would be much appreciated. Soon he was waving for us to join him. I was crestfallen when he said quietly, "Please! No photographs."

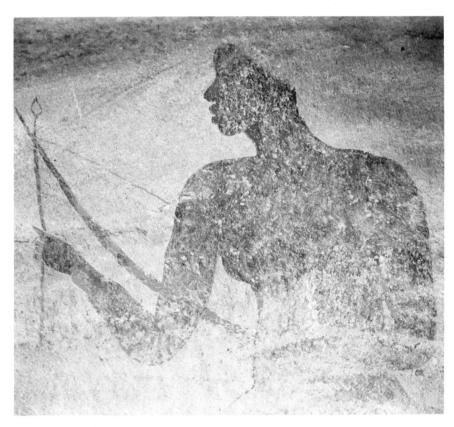

Detail of archer (9 feet high), Tin Aboteka, Tassili.

A meeting with the Tuareg family at Rayaye, Tassili.

Not all Tuaregs are alike. The ones that live in Djanet tend the palm trees, till the soil, or perhaps work at a distant oilfield. Their children are gaily dressed and attend school, there is a movie and a few shops, dinars are earned and spent. But the last few remaining inhabitants of the plateau flatly refuse to conform to such a way of life and their visits to Djanet are rare. They eke out an existence by grazing a few goats on the scant pastureland and hunting what little wildlife their surroundings may have to offer.

The head of this family, with a light touching of fingers, shook hands with us all and smiled words of greeting. The children had never before seen white people, and were understandably scared. It was an open camp with no protective roof, but just the semicircular *asaber* to shield the occupants from the wind. Lying on the ground under a black cloak was a woman and newly born child—both completely covered—protected from flies and sand. The baby's cry and mother's movements were the only evidence of life. I had the guilty feeling of the trespasser.

We stayed half an hour at the camp, smiling and nodding, while Ali exchanged news with the tall Tuareg. With camera dangling at my waist, I pressed the lever and hoped. When we left, our polite host accompanied us for a mile or so, walking with the long, unhurried stride so typical of his race. Effortlessly and not seeming to move, they can cover great distances in a short space of time.

Finally, he touched our fingers once more, softly bade us farewell, turned, and was gone like a shadow. Looking back we saw him standing on a high point following us with his eyes.

The short stay at the Tuareg camp was a valuable and thought-provoking experience. My first impression was that here is a man with absolutely nothing, and any gift given to him—however trifling—would increase his riches tenfold. Twenty dollars could keep him and his family fed for several weeks with no need to hunt or tend the goats. But he hasn't got twenty dollars and never will have. His assets totaled nil. A few goats, a dented cooking pot, and a pile of rags. Nothing.

Yet he stood so proudly, with the breeze lightly disturbing the *gandurah* that covered his tall figure. What had he to make him feel such pride? One would think he owned the whole plateau.

Of course, that was it. He *did*!

Like a good host he had seen us to his front door; now he watched us move across his property. The plateau once belonged to the French; now it is owned by the Arabs. It matters little to the Tuareg. The deeds of ownership may be held by London, Rome, Paris, Moscow, or Washington. In reality the land is his and will always be.

He lives happily and independently in a region where other humans would quickly perish. This secret he has learned since birth, and in turn will teach it to his children. In winter he will lie secure and warm in the folds of the mountains, and in summer will wander as the mood takes him. He has nothing, and with it everything. To regale him with gifts would disturb the razor-edged balance.

Authorities repeatedly request him to send his children to live in Djanet and attend school; he adamantly refuses. They will receive from their father

Horse and chariot scene, Titeras N'Elias, Tassili.

the finest education possible. The practical and philosophical lessons will be integrated with their circumstances and environments; the secret will unfold.

They, too, will grow up and mate, have many births—of which two or three of the strongest may survive, for the rules are strict. Contemplating the future, it might well be that the lone Tuareg could find himself the sole survivor of a maddened world.

Let us hope that he steadfastly resists the type of help that has, in the past, been given to other sensitive and artistic races: the African bushman, the Australian aborigine, and the American Indian. But his castle—where he is king—has high walls and is guarded by the elements; his secret for the present is safe.

Then on to Tin Kani (yes, we made jokes about the name), following the Wadi Adjendjoum into Tamrit, thus completing a wide circular trek that covered a great deal of the known section of the plateau. It was here that I asked a donkey driver if I might take a close-up picture of him, for the headgear of the male Tuareg consists of a yards-long length of fabric which is wound around the head and over the nose and mouth, leaving a narrow slit for the eyes. It is a turban, veil, and mask all in one. He readily agreed and I bent my head to adjust the camera. Looking up, I saw that he had removed his *litham* from his face, and stood there serious and strangely exposed, like a tortoise that had lost its shell. He just couldn't understand why I should want to photograph him with his face covered!

The descent was steep and the drive to Djanet sad. But Ali softened the anticlimax by urging us to go at once to the outskirts of the village where an annual ceremony was taking place. We hurried through the palm trees and out to the great flat *erg* beyond. On a raised dais sat high-ranking Algerian

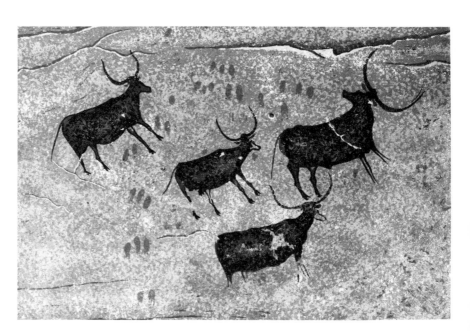

Herd of cattle, Akba Tafelalet,
*Tassili. (24 × 36 in.)**

Chariot scene, Tin Aboteka.

officials in slick European suits and shiny pointed shoes, and all around were a thousand or more Tuaregs, men and women, from far and near.

Ancient ceremonial dances were performed by men in dramatic uniforms; naked scimitars flashed dangerously while the lines of aggressive militants faced each other. The women, many of them quite old, shuffled along with fingers beating time on small drums. They were chanting, wailing, and one played a plaintive two-note tune on a reed pipe.

Perhaps old battles were being reenacted, dances that reflected for a fleeting hour the past glory of the vanishing Tuareg.

The mysterious ceremony was to us a fitting note on which to end our fascinating journey to the secret art gallery of the Sahara.

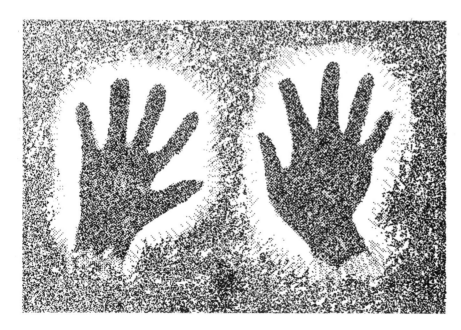

Stenciled hands, Jabbaren.

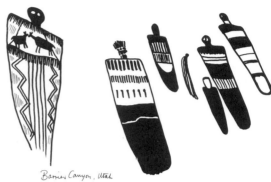

Barrier Canyon, Utah.

11
The Canyon Art of Utah

Engraving 20 inches high, Utah.

IT WAS STILL DARK when I was awakened by something gently touching my face—layers of cold confetti that stirred in a soft breeze. Snug and warm in my mummy-type sleeping bag I looked up at the sky; no stars, no moon, just inky blackness. With an effort I unzipped a few inches, extricated a hand, and cleared my face. It was snow, mingled with rain and falling heavily.

A large sheet of light plastic had been prepared for just such an emergency, and within minutes I rolled into it up to my shoulders. Inside my damp cocoon, sleep seemed as far away as the dawn, so I relaxed and let my mind wander back over the events that had led me to my present location—the wilderness of The Maze in southeast Utah.

Had our isolation near Valencia continued we might not have left Spain. But extensive building operations began all around us where noisy bulldozers were cutting away sections of the mountain and diverting the streams. Then late one stormy night the inevitable happened. In one frightful moment the hillside shrugged, and the cascading water and earth brushed away buildings, high retaining walls, and power cables.

The morning light revealed utter desolation. Later, when an army of men and heavy machinery arrived, we were already packing. Within a few weeks a new life had begun for us in the village of Yellow Springs, Ohio, U.S.A.

A few months passed and in 1970 I had the good fortune to be included in a group of Sierra Club members planning a hike into The Maze, Utah.

Aerial view of The Maze, Utah.

My interest had been aroused by a small detail in the itinerary which read: "The first day will take us to the pictographs in Horseshoe Canyon. . . ."

It was enough. I would soon be making my first examination of the rock art of the North American Indian.

At a movie many years ago, I enjoyed a color cartoon that pictured man's progress in locomotion through the ages—first on all fours, then standing upright to walk. After swinging through the air on vines, he invents the wheel and begins to move much faster. Nervous between paper-thin wings, he takes to the air. Fast jets follow the propellers, and we are right up to date.

If this same film could be viewed in reverse, it would describe exactly my October journey from my home in Ohio to The Maze in southeast Utah.

The flight to Denver, Colorado, was luxurious and swift, but the much smaller plane that took me across the snow-capped Rockies began a series of half-hour hops from one small airfield to another until it finally reached the end of the line at Moab, Utah.

The next leg of the journey was purposely delayed until late afternoon, when the sun would cast long shadows over the breathtaking beauty of the wilderness. A young man piloted our tiny single-engined aircraft which rose slowly, then circled the field, and headed into the setting sun.

The scene below equaled the strangeness of the Tassili Plateau. As I looked out over an eroded landscape of incomparable beauty, the pilot pointed and shouted to make himself heard over the engine noise.

"Upheaval Dome!" he called as we crossed a multicolored conical dome two miles in diameter. He dropped the craft lower until we passed among the orange-red canyon walls that rose sheer and almost touchable on either side.

Then came the Colorado River, a light green snake twisting leisurely through the cake layers of cliff, narrow and quiet here, then joining the Green River and widening toward Cataract Canyon.

Just west of the confluence we crossed an unbelievable landscape of compounded canyons meshed and intertwined like an intricate pattern of lace, an incredible wilderness of sunken rock that stretched for miles.

The young pilot jabbed his forefinger downward and shouted, "The Maze!"

We left the labyrinth of petrified spaghetti and swung north. Soon the

Large anthropomorphic figures,
Barrier Canyon, Utah.

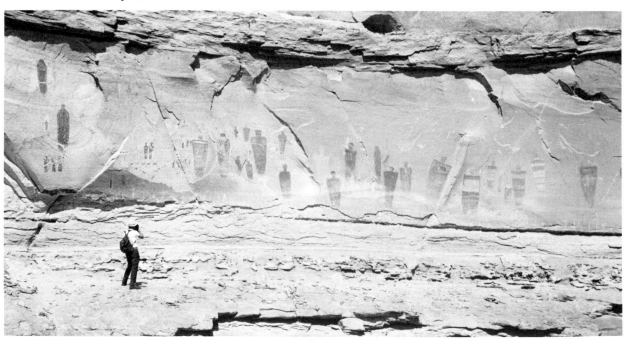

terrain leveled slightly and we lost altitude to taxi bumpily along the sand-driven airstrip of Hanksville.

It was deserted, and the Nissen huts bordering the tarmac were all locked. While the small plane was making a dusty takeoff, we approached the gate where a truck had suddenly appeared. The driver explained that he was passing nearby and happened to see the plane landing. Being group leader of the Sierra Club party, he had decided to stop in case the new arrivals were members in need of a ride to the distant village.

That night the village motel was full. At dawn our small convoy of trucks, spread out to avoid the dust churned up by the leading vehicles, headed northeast. With magnificent scenery all around us, we jolted across the desert plain along a barely recognizable track in Antelope Valley and branched right at a spot called The Mailbox.

I soon discovered that all the high monumental rocks were appropriately named and each one resembled its apt description: Sugarloaf Butte, Natural Arch, Black Ledge, Cleopatra's Chair, Teapot Rock, Gunsight Butte, The Golden Stairs, Joe and His Dog, Rooster Rock, and Mollie's Nipple.

On the high walls of Barrier Canyon we saw our first pictographs (rock paintings) and petroglyphs (rock engravings). To avoid any possible confusion, I will henceforth refer to the rock art as paintings or engravings, and not as pictographs, petroglyphs, or (as I have also seen published) petrographs and pictoglyphs.

In the warm sunshine I leisurely examined and photographed these

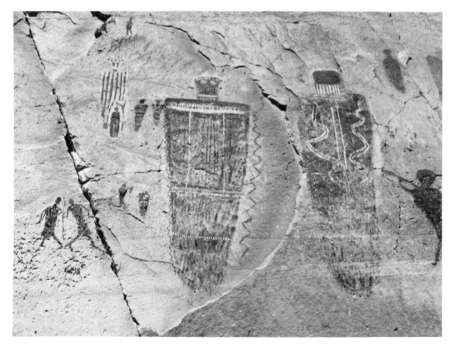

Detail of figures and pipe player, Barrier Canyon.

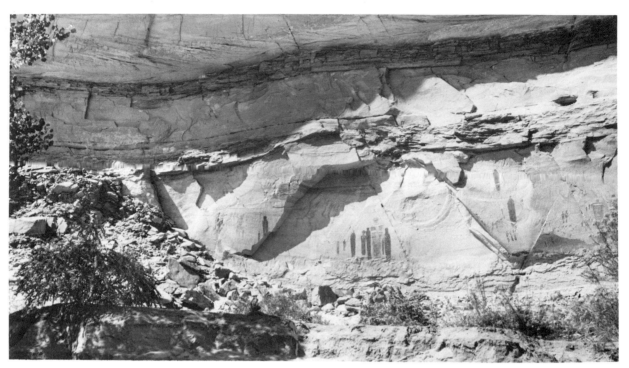

*Group of "mummy" figures,
Barrier Canyon.*

fine examples of early Indian art. There were few engravings, but many paintings, mostly large mummy-shaped figures drawn in a strong outline of dark red oxide. Some were silhouettes, nine feet high, with bodies filled with the same dark color. But many showed, inside their body outlines, geometrical patterns of zigzag lines, circles, and squares. Other "bodies" contained plants, trees, and foliage, while a few possessed animals and birds within their contours. During our Maze trip we were to find many other such figures, and around the campfire at night we would discuss the rock art we had seen. I was constantly bombarded with questions.

How old were the paintings?

As already explained, it is difficult to establish the age of rock art with any degree of accuracy due to the present lack of datable material. It has been asserted that owing to the exposed condition of the pigment, which suffers attack from water and wind, the paintings could not have survived longer than a few hundred years. I feel that this assumption is wrong. The rock art of Spain has undergone identical conditions, yet has withstood many thousands of years. The early Indian artist utilized mineral oxides, as did prehistoric man in Europe. There is little doubt in my mind that many of the paintings are far more ancient than most people believe.

However, some of the individual images portrayed supply us with clues. Warriors on horseback, for example (usually crudely painted), must date no earlier than the introduction of horses into the region—around the middle of the sixteenth century.

Detail of figures, Barrier Canyon.

The same rule would apply to hunters armed with bows and arrows, but here the margin of time would be much greater, as this weapon first appeared some 2,000 years ago. It is often possible to detect engravings of many different ages covering a single rock surface. A typical example is the appropriately named Newspaper Rock in the Petrified Forest National Park, Arizona. Others exist in large quantities in many parts of the

Riders on horseback and missionary building, Lower Pecos River, Texas, United States. (From photo by Alan Gingritch)

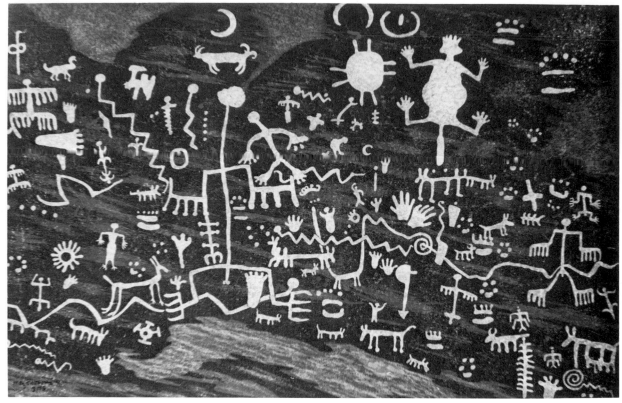

*Newspaper Rock, Petrified Forest, Arizona, United States. (31 × 48 in.)**

southwestern states, and there are particularly fine paintings in southern California. Few visitors to Hawaii know of the islands' rich treasure trove of mysterious rock carvings.

Leaving the paintings and Barrier Canyon, we followed the barely discernible jeep trail south along The Spur with the Orange Cliffs away to our left. The sun was low when we reached Panorama Point, an ideal time of day to photograph the breathtaking scenery which constantly changed colors as the day closed.

The second day was spent touring the rim and descending the Orange Cliffs via the Flint Trail into Elaterite Basin, where camp was pitched at the Maze Overlook (5,200 ft.). Here we had a close-up view of the blind canyons that give the region its name. Little wonder outlaws once lived here with impunity, safely beyond the arm of the law. Now we were obliged to transfer our limited baggage from the trucks to horses and continue on foot. Perhaps *hands* and feet would better describe our steep, thousand-foot drop into The Maze itself, where a veritable wonderland awaited us.

Surely nothing can be more exhausting than walking for miles through loose sand, but with scenes changing every minute and so much beauty all around us my fatigue was held at bay until I crawled into my sleeping bag and darkness blanketed the view.

*Painting in red and white on black ground, Burro Flat, California, United States. (31 × 47 in.)**

Descending into The Maze.

Guide leading the way through blind canyons; debris shows flash flood level, The Maze.

Inside my plastic cocoon, I began to contemplate the immediate future. Such a storm at this time of year was unexpected and would halt our progress. I felt concerned about missing some of the rock paintings, as I might never pass this way again. I hoped the storm would be brief.

It was now growing lighter, the snow had turned into a drenching rain, but the sounds of activity emanated from the kitchen area and hot coffee was close at hand. A canvas square provided a little protection from the downpour, and with cold hands cradling a warm mug I chatted with our knowledgeable and most likable guides.

We would be unable to travel, they said, while such weather lasted. The flash floods produced by heavy rain on bare rock would be dangerous and in most cases impassable. But they knew of some rather remarkable engravings about an hour's hike away, and as we were destined to get soaked in any event, we might just as well divert our minds from our present state of discomfort. A few of us set out.

The scene had completely changed overnight. From a land of sand and bare rock it had become a mud and stone receptacle for gushing streams. At times we waded knee-high through swirling brown water, emerging with squelching boots that immediately collected large quantities of mud and sand. Our ordeal ended as we climbed a short but steep slope that led to a flat bare rock face.

The engravings here had been made by striking, or pecking, the dark surface of the rock with the sharp point of a much harder stone. The exposed rock formations in the southwestern states have become heavily patinated by oxidization, thus providing the early Indian with a perfect surface on which to engrave and thus expose the much lighter color of the natural rock.

But for the rain I would have missed seeing these interesting art works; full of excitement I photographed the whole wall in carefully matched sections. The main figures featured a frieze of big-horned mountain sheep, with bodies and heads shown in profile while the curling horns were drawn front view. This style of "twisted perspective" is identical to the cave art of Europe. Furthermore the panel of sheep was an exact replica in manner and execution of a shelter engraving I had seen and recorded on the Tassili Plateau in the central Sahara. The strong likeness was really uncanny. During my research work I have encountered many comparisons and likenesses, but none so vivid and striking as this.

The weather improved, and the next day brought us to many more large figure paintings. Surely these represented supernatural bodies? Gods of sun and seasons, of growth and harvest, of game and hunting. High up and out of reach, these enormous figures were suspended on the rock face mostly in groups, but in one instance the frieze of figures covered sixty feet of smooth rock wall—a large, wide, isolated gallery of man-made art that screamed for attention in the stillness of the silent canyon.

What do the paintings mean? What thoughts are they meant to convey?

Viewing these large groups at leisure in the late afternoon sunshine, I was suddenly struck by their similarity to the animals painted on the ceilings of Altamira Cave in Spain. The same feeling of reverence and care given to their execution. And almost certainly an identical motivation!

If the purpose of the Upper Paleolithic cave art in Europe 20,000 years ago was to ensure a continual supply of food, then these great canyon gods of sun and rain, of animal and plant life, were intended to perform precisely the same magical purpose.

Whether in cave or canyon, church or chapel, work or play, in illness or in health, man has always held on grimly to a belief, religion, or superstition that may assist him and answer his hopes and prayers. In the dawn of time when art was born, man realized that his scratched lines could be made to appear weak or strong. Endowed with this power, he used it to his advantage, utilizing this extra ability along with special songs and dances to strengthen his contact with the supernatural.

Who were the men that painted and engraved these rocks?

The American Indians, of course. But we must first go back perhaps 20,000 years. The great glacier masses had increased, causing the ocean levels to lower and in turn exposing a stretch of land that joined Siberia with Alaska. Across this "bridge" wandered herds of animals such as the bison, mammoth, mastodon, camel, and horse.

In due course the herds were followed by men hitherto confined to

Painted god-figure, Lower Pecos River. (From photo by Alan Gingritch)

Painted figure, Lower Pecos River. (From photo by Alan Gingritch)

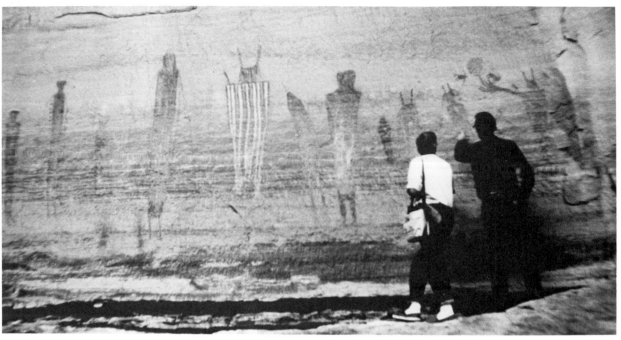

Author examines frieze of figures, The Maze.

Europe, Asia, and Africa. Into the New World they came, hunting and tracking the animals south along the foothills of the Rockies, spreading to the east and west. This migration continued over many centuries. The glaciers finally retreated, the land bridge was inundated by the oceans, and access became more difficult.

With his crude weapons, man hunted the now extinct animals. By 5000 B.C. the mastodon, mammoth, horse, and camel had disappeared. The great herds of bison, however, continued to thrive.

Almost 2,000 years ago the occupants of what is now Utah, Arizona, New Mexico, and Colorado were called Anasazi (Navajo for "the ancient ones"). They were simple farmers who lived in cliff shelters near watersheds with good hunting grounds nearby.

It is thought that they finally left the great canyons 600 years ago, an emigration that probably lasted over many years. Why they left is not known. Advancing enemies? Illness? Failing crops that brought starvation? In the cliff dwellings of Arizona the evacuation was hurried and valuable belongings abandoned. But here in The Maze the transfer would have been slow, for marauding enemies would hesitate to penetrate the blind canyons where they might be easily ambushed. There exists the possibility of disease, or perhaps a change in climate that brought disaster to the area. With a persisting dry period, game would seek other pastures, and man's food gathering and simple cultivation activities would come to a standstill. He too would be obliged to leave his safe haven and venture onto the exposed plains, vulnerable to attack by other tribes.

The Sahara paintings had already described to me a similar story. Did the early canyon Indian suffer the same fate? Could a drastic change in climate force him to seek new lands? We must return to the paintings. Perhaps they alone hold the answer to our questions; they certainly offer an alternative theory.

As I have already mentioned, there appears to me a strong affinity between the cave art of Europe and the canyon art of Utah. The prehistoric artists of France and Spain were not cave dwellers; this has been proved beyond doubt. They did, however, penetrate deep into the hillside caverns where their work would have the greatest effect: a sanctuary apart, a place not normally frequented by man.

Would the dangerous blind canyons of The Maze provide a similar magic? Were these awe-inspiring and inaccessible sites also prehistoric sanctuaries, set aside for observing religious rites and ceremonies?

During the time I spent in the region, I saw only a few traces of game —an occasional deer—and hardly any space that could be reasonably cultivated or lend itself to food gathering. I did see several stone grain caches, untouched except by rodents for many centuries.

Very few symbols were visible. By far the biggest proportion of the paintings were of the earliest style, large anthropomorphic figures peculiar to this region alone. One of them held an arm outstretched, and the hand, which was grossly exaggerated in size, is the most interesting part of the scene. From it grows a tree with leaf-laden twigs that fan out; birds and other small creatures surround the branches to complete the charming and decorative picture.

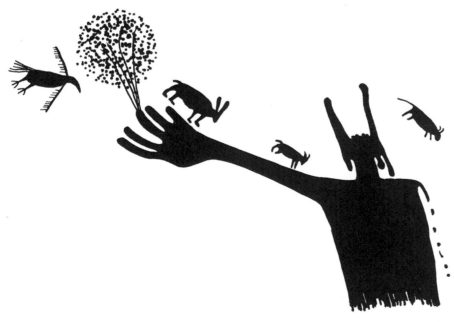

Detail of figure showing animals and plant life, Barrier Canyon.

A smaller painting of a shaman seemed more recent than the mummylike figures. Dark red oxides and white pigments had been used. The headdress appeared to be made from the upper part of a skull with antlers attached, and the face was covered with a mask of beaded leather. The loose-hanging clothing showed studded adornments, which also decorated the strange objects, probably corn symbols, held in each hand.

As I travel in the United States and Canada, the problems surrounding rock art increase. Prior to the white man's invasion, this vast region was peopled by many hundreds of tribes with a variety of cultures. Each group had its own laws and customs, beliefs and rules, that integrated with nature's pattern and fitted well within their immediate environment. These groups confined themselves within their given boundaries, and had little or no knowledge of what was happening a few hundred miles away.

So it is not possible, indeed it would be entirely wrong, to embrace the early Indian art of America as a whole. It comprises many styles, adopted for several different reasons, each of them dependent on prevailing circumstances.

But underlying the various styles we can sense, and quickly define, the one strong ingredient that is common to all—motivation: the enlisting,

*Detail of Painted Cave, Santa Barbara, California. (31 × 46 in.)**

*Painting in red, Arrowhead Cave, Santa Barbara. (31 × 44 in.)**

through art, of the help of the supernatural, the unseen spirits that rule man's destiny.

Around the campfire each night we would discuss many topics, and listen while our guides sang or related stories of the early settlers in the region—men like Butch Cassidy, who used The Maze to hide from the law, and great pioneers like Brigham Young, who, for his followers, achieved miracles, and of men who found uranium and became millionaires overnight.

So would end another day spent tramping through the unparalleled grandeur that is southeastern Utah, remembering the trembling cottonwood leaves that shook like golden stars against a background of deep red rock, the wonder of petrified wood, the structural layers of earth that made towers above us, nature's cake of chocolate, vermilion, gray, and pink layers, topped at times with white cream.

It was time to leave, time to demonstrate man's history of transportation in the correct chronological order.

We climbed the thousand feet of colored rock on hands and knees, then aided by ropes we made the final and rather frightening ascent to the top. It was unlike any mountain climbing I had ever experienced in the past, for, instead of escaping from the humdrum world of today, we were actually undergoing strenuous physical exertion to get back to it! For here, at the top

of a mountain ridge, we would soon reach our mechanized transport. Following the stiff climb, our four-mile hike into camp passed comparatively quickly and we reached the vehicles before dark.

Around the fire that evening, the songs were sad as we willed our minds to wander back, recapture, and hold on to the memories of recent experiences, recollections that would, in time, fade all too quickly.

For me, the large mysterious paintings that I had seen overshadowed even the natural beauty of the region. This was the sincere work of sensitive humans, simple-living men with highly developed traditions. It was an art form utilized to what we would consider its fullest extent—yet going even further, beyond our comprehension.

Christopher Columbus once wrote of the Indians:

"They are very well made, with handsome bodies, and good countenances. . . . They are a loving people, without covetousness. Their speech is the sweetest and gentlest in the world."

We can see this peace and innocence reflected in their paintings. Let us ensure that the canyon art of Utah is preserved together with its surroundings, and remains forever one of the world's great treasures.

*Engraved figures and bison, Dinosaur National Monument, Colorado, United States. (31 × 44 in.)**

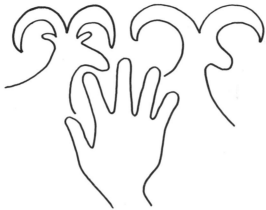

12
Strange Comparisons

TAKE A GROUP OF ADULTS into the garden, point to the sky, and ask them to describe what they see. They will see clouds, blue sky, and maybe a vapor trail left by a jet. They will see nothing more.

Take a group of children into the garden, point to the sky, and ask them what they see. They will look up at the clouds passing across the sky, and they will see flowers, ships, and castles—the list will be endless.

Children observe with an inward eye, letting their imaginations assist the description, and while they describe these things, they will at the same time be stirring *our* imaginative powers, enabling us to form a more exact image of how the clouds appear.

This brings us to an important point. A good artist should be a commentator and not a reporter. A reporter states the obvious: "The sky is blue and there are clouds." The commentator would describe the scene thus: "The sky is blue and across it float clouds shaped like flowers, ships, and castles."

Now we have an improved mental picture of the scene.

It is a great pity that as children grow older they lose this charming ability, this freshness that is so strongly reflected in their simple, spontaneous art work. When drawing, children will seldom look at the object placed before them. They will not make a realistic copy of the subject but a drawing that represents it, using their "inward eye" to select what they feel to be the important details, certain aspects of the object which cannot be seen. The completed work may entirely lack those details that appear to us the most obvious.

This is where we find a similarity between the art of young children

Running figure, from a child's drawing.

and primitive races. Both are highly imaginative, yet neither departs far from the truth. The child's stick figure of a man is an abstract portrayal, simple in the extreme yet entirely sufficient. It doesn't tell us whether the person is tall or short, fat or thin. He wears no clothing so we have no indication as to his race, or when he lived. We are completely in the dark; the answers elude us.

But this drawing of a man may provide us with some surprising and unexpected information.

Firstly, the drawing is unmistakable; it is a man—a man that represents all men. If we look closely we will discover some important facts. The legs are widely outstretched; he is running. Is he running away from or is he hurrying toward something? There is a short pencil stroke where his hand should be—he is armed. Being armed, he is attacking and not retreating.

We now see what the child's drawing has in common with prehistoric and primitive art. It is the simplicity, the directness, and the total absence of irrelevant detail.

I once viewed an international exhibition of children's art, and was impressed by the remarkable similarity of style that was common to them all. It was difficult to distinguish between the work of children from Japan, England, Africa, and Canada. These children, separated by thousands of miles, instinctively drew things in the same way. Unfortunately, this is a trait that disappears as children grow older, become more sophisticated, more involved in their respective environments where life grows increasingly complicated.

For the first seven years or so, children view life intelligently but simply, unexposed to the many problems of modern existence that await them. But this short span, grudgingly allowed to the child of today, has been the normal life of primitive races over the past thousands of years.

These prehistoric ancestors enjoyed the uncomplicated existence of a simple hunting and gathering economy. Born into a world of bare essentials, they lived, loved, and died. Compromising with nature, they harbored no hope, nor envisaged any improvement of their status. They were preoccupied with the present and the immediate future, particularly concerning their food and water supply.

Yet man possesses one great advantage over the animal—he has an imagination. Without food and water, the animal has no choice but to die. But in the mind of man there is the realization that outside forces direct the elements—gods or spirits of sun and rain that can control his destiny.

Supposing he is able to make contact with these supernatural beings, and offer them favors? Perhaps in return they will favor him? How to reach these unseen powers? We have witnessed several methods: by sacrifice, ceremonies, and masked dances, all of which are of a temporary nature. But there are more permanent alternatives, methods that will continue to work while men sleep—carved figures and paintings.

So it is not surprising that, like the art of young children, prehistoric paintings from different parts of the world possess a uniformity, and we can

detect characteristics that are familiar to them all. At times, the similarity is so strong that it is difficult to differentiate between the rock drawings of Sweden, Canada, South America, and Ethiopia.

When we estimate, however roughly, the various ages of the world's rock art, it appears that man has "progressed" more rapidly in certain areas than in others. We find, for instance, the Australian aborigine behaving today as prehistoric man did in Europe 15,000 years ago. This enables us to study today's primitive races, and from them glean an impression of early man's behavior and customs.

Much of the rock art of the aborigines in northern Australia is remarkably similar to the Bushmen's art of South Africa. The rock paintings of the Sahara echo the shelter art of eastern Spain, and so on. Of course, with the same underlying motivation, it is to be expected. There has been no physical contact between these sites, and in some cases the art work is separated by some thousands of years. These strong similarities that occur so frequently show that men, irrespective of age or geographical situation, will pursue the same avenues of thought and action.

I have discovered that some of the symbols portrayed on the cave walls in France and Spain appear in the art of the early American Indian; that certain deeply incised grooves over rock surfaces in the Sahara are to be found in Australia and Texas; that human "stick" figures engraved and painted on stone, and all alike, occur in Hawaii, Japan, Ethiopia, Russia, California, Sweden, Australia, and many other places.

I have often wished that there existed an international center for the study of prehistoric art! There are so many devoted people working and studying in their own particular regions throughout the world, all collecting vast amounts of valuable material, but with no central institution where this knowledge can be examined, assessed, and filed for reference. This large accumulation of information should reach a much wider audience.

My modest studio/workshop in Sonoma County, California, has steadily grown into a Gallery of Prehistoric Paintings, and has already become the nucleus of just such a center that is so urgently needed. The general public—as well as serious students—enjoy the impromptu gallery talks, and show genuine surprise when they discover the high skills and level of culture that our remote ancestors possessed.

Interested people in Australia, South Africa, Canada, and the United States keep me well supplied with color slides of their latest finds that make valuable additions to my already well-stocked collection.

As my work in producing accurate copies proceeds, I am continually impressed by the similarity of the paintings. Mineral oxides were used by all prehistoric artists—at least they are the only pigments to survive—so the strong resemblance in color is not difficult to understand. The strangeness is in the style of the paintings, for without knowing the location of the works, one would immediately assume that they had been executed by the same hand, one being almost a carbon copy of another.

Some of the most striking examples illustrated in this book warrant a brief description:

Shelter paintings, Lower Pecos River. (From photo by Alan Gingritch)

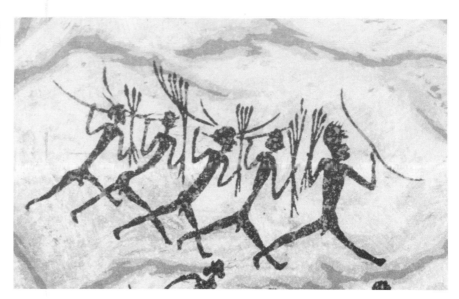

This painting shows a militant group of five archers marching in step, and moving from left to right. The leader wears a tall helmet or mask, and all five archers carry bows and arrows in their hands. It is from the shelter known as El Cingle, Gasulla, in the province of Castellón, Spain.*

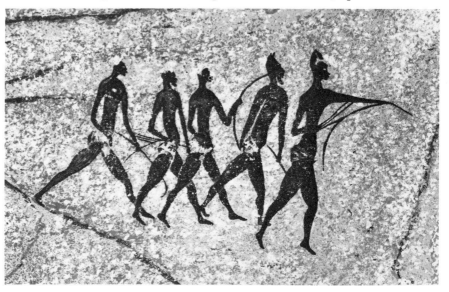

Here we see precisely the same number of men, also moving as one and carrying weapons. They too are being led by a helmeted archer who appears to point the way. The similarity is astonishing, the only difference being that the loincloths and hair of the figures are blank. Probably a less permanent color was used for these parts, a pigment that has long since disappeared. I recorded this painting while visiting the Jabbaren region of the Tassili Plateau in the central Sahara.*

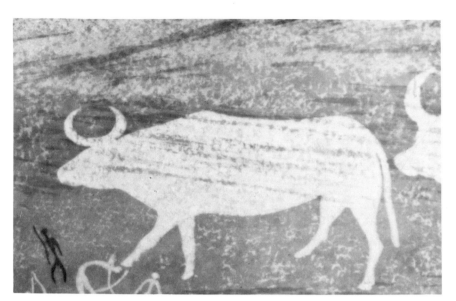

This bull in white pigment moves with a heavy tread slowly and ponderously across the gray background of the rock face. Yet the artist has captured a certain grace, and the animal's movements portray no feeling of awkwardness. The site is a shelter called Del Navazo, Albarracín, Teruel, in eastern Spain.

The giraffe is also an ungainly animal, yet this painting has so much charm. The smooth stride and fine details show the artist's keen powers of observation. It is from a shelter at Timenzouzine at Tassili.*

This example shows a detail that features animals pecked and engraved over the dark oxide of previously painted figures. The long curling horns show the creatures to be mountain sheep, drawn in profile, yet showing a front view of the horns. This scene was recorded at Tanzoumaitak on the Tassili Plateau.

This is an almost identical picture. It too has been lightly engraved into the dark patina of the rock. Again the horns of the sheep are shown front view on the profiled heads. Imagine my surprise when I saw this early Indian engraving during a trek through the canyons of Utah.

This is certainly the commonest symbol to be found in prehistoric art—the stenciled hand—that occurs in all parts of the world. This is from the cave of Pech-Merle in southern France.

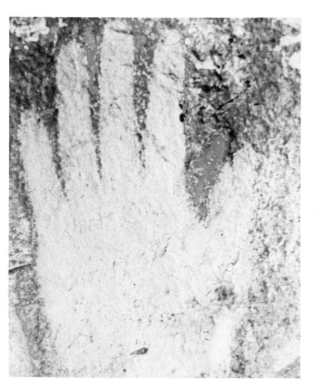

The air-spray technique has also been used to make this exact likeness, found on a rock face in Texas.

La Pasiega, Spain

Idaho

 Niaux

Arizona

Two symbols discovered in caves of France and Spain, and made some 15,000 years ago. Their meaning remained a mystery until quite recently.

Niaux, France

These same symbols were employed by the early American Indian many thousands of years later to depict the paw marks of a bear, clear information that the animals could be found in the vicinity.

Arizona

Here I have superimposed the cave and rock art symbols—the former scratched in outline, the latter an engraved imprint. Together they form a perfect whole.

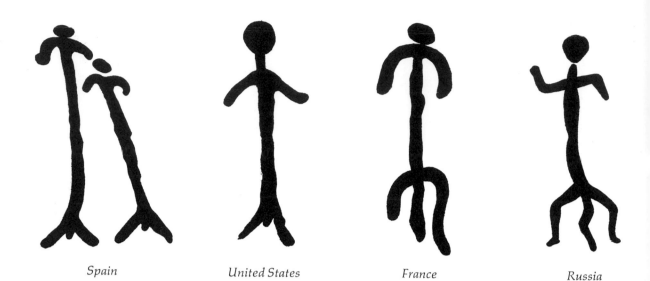

Spain *United States* *France* *Russia*

In rock art, highly stylized forms of men are very common indeed, and in every country where primitive and prehistoric art is found, man is portrayed in exactly the same manner. Even the varying evolutionary styles and phases are identical, such as the "stick figure," which is probably the most recent.

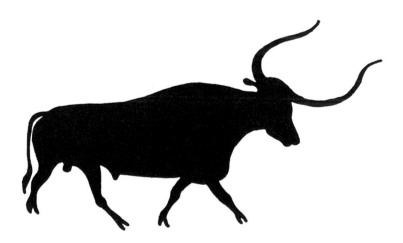

The animals also show a universally strong resemblance, with carefully drawn horns, antlers, and feet. This bull is typical of those found in eastern Spanish rock art.

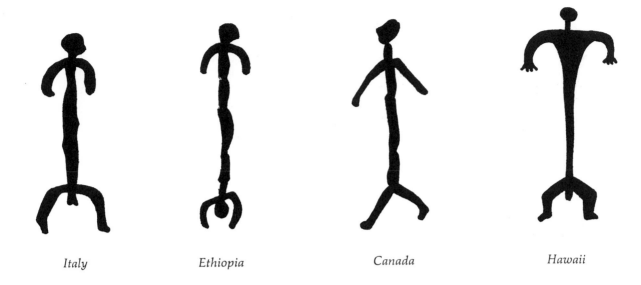

Italy *Ethiopia* *Canada* *Hawaii*

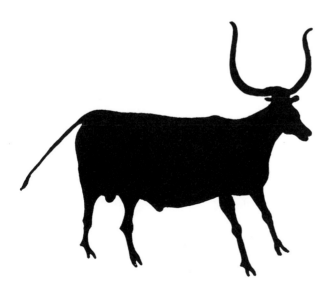

Precisely the same attention is given to the details of animals drawn on the rock face of the Tassili Plateau shelters.

Detail of the large monsterlike figure shown in Fig. 111 from Tassili paintings. It holds a large sacklike shape between its legs, and is surrounded by smaller female figures with hands raised in an attitude of prayer.

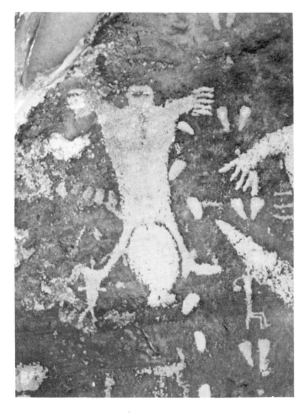

This engraved figure also carries a sack and is surrounded by smaller figures. The design is pecked into a rock face at Moab, Utah.

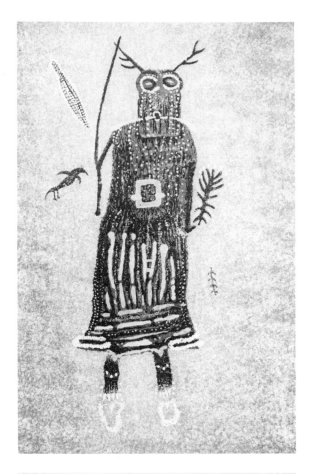

This shaman figure was discovered by the author painted upon a canyon wall in southeast Utah. It wears an antlered mask and carries corn symbols.*

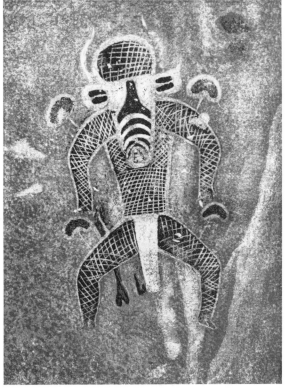

A witch doctor shuffles through a ceremonial dance on a shelter wall at Tassili, in the Sahara. Both figures, dressed alike, are performing a ritual that is common to all primitive races.*

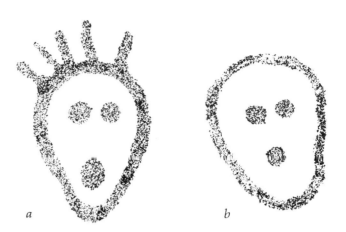

a *b*

Two startled expressions thousands of miles apart: (a) is engraved upon a rock at Peterborough, Canada; the other (b) is deeply engraved on stone in the province of Barcelona, Spain.

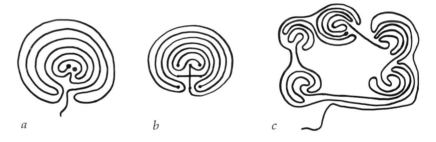

a *b* *c*

Complicated mazes such as these are to be found in all parts of the world. Here are seen some variations on the theme: (a) Italy (b) Spain, United States, Ireland (c) Algerian Sahara. Whether these design motifs were independently invented, or somehow transmitted, still remains a mystery.

And so we continue studying, comparing, recording recent finds, relating the paintings to excavated artifacts, and always discovering something new and interesting. There is indeed a tremendous amount of work to be done. Prehistoric art has been, and is still being, discovered in all parts of the world from Japan to Scandinavia, from South Africa to California, from Russia to New Zealand.

I cannot believe that there has to be proof of any physical connection between these various sites. In the opinions of some, the strong similarity in the paintings proves mass movement of people, and that the African artist moved north into Spain, or vice versa.

Painted and engraved symbols

| Spain | Canada | Italy |

My disagreement has no quarrel with the possibility—only the probability. May I repeat that today a Chinese child of three or four years draws and paints precisely in the same manner as our prehistoric ancestors. The answer is that man—no matter where geographically, or when in terms of time—will conform to a pattern of thought and inventiveness, a basic process that is common to all. The varying speeds of this advancement depend upon climate and food supply.

From the paintings of prehistoric man many patterns will emerge. One fact is already obvious: while he remained a nomad, a follower of herds, he possessed a true instinctive insight into the nature of the beast, and in line or paint could portray his quarry perfectly. But with domesticity, the growing of food and a static habitat, he lost his intimate contact with the animal, and the quality of his paintings show a marked deterioration.

But to be quite fair, the motivation had changed and his art work was fast becoming symbolic. He now had other gods to worship—circles of sun and zigzags of water. It was approaching the time when communication must be conveyed and understood more quickly.

The earliest alphabet was about to be born.

Engraved symbols, Barcelona.

13
Conclusions

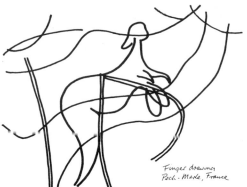

Finger drawing
Pech-Merle, France

APRIL 12, 1968, was a day of great importance to a young Spaniard named Celestino Fernandez Bustillo. He, with a team of companions, all members of the "white mountain" exploration group (Torreblanca), set out to search the narrow passages that twist and turn into the hillside near the town of Ribadasella in northern Spain. The site is on the coast fifty miles east of Oviedo, and overlooks the Atlantic.

Celestino Fernandez was known as "Tito" Bustillo by his family and friends, and on that April day a few years ago the group of boys had no knowledge that the name would later be featured in leading newspapers throughout the world.

Squeezing through tiny apertures in the darkness, they stumbled upon a large cavern so immense that one could walk upright along a wide gallery that stretched for almost a mile. At the furthermost end, where the rocks came down to prevent further exploration, the boys made their discovery. The walls were lined with paintings of the finest kind, animals that had been engraved and colored with deep red oxides and violet-black manganese. Here were bison, horses, stags, and young deer, many drawn one upon the other quite low on the rock surface.

The find was of such importance that the local authorities decided to keep the event secret—for a combination of reasons:

Access to the cave was so difficult and dangerous that to permit inquisitive visitors would certainly result in serious accidents.

Publication of such a discovery would attract a great deal of attention. Visiting authorities would demand permission to examine the cave, and

such a sudden influx of people might harm the paintings under the prevailing conditions.

So the well-kept secret permitted serious study to proceed without interruption. At the same time a search was made to discover the original entrance that had obviously been closed by a landslide of falling rocks.

Young Tito could hardly contain himself, however, and spent all his available free time in searching the area for other possible painted caverns. There must be many other important sites—and he was determined to find them.

It was nineteen days after his memorable discovery, and while exploring the dangerous galleries in the mountains, that he fell to his death.

A whole year passed before his find was officially announced and a few press representatives were allowed inside to view the paintings of "a second Altamira." But access was still too difficult and dangerous for the general public.

In the spring of 1971, I was fortunate enough to visit the cave while conducting a group of members of the Archaeological Institute of America on a tour of the caverns of France and Spain. There was, as usual, a delay while permission was sought and finally granted, but eventually all was arranged and we were led through an entrance that was being made by excavators and bulldozers.

Thirty yards inside the cave the noises of machines ceased and the darkness intensified. At well-planned intervals, concealed fluorescent lights dimly illuminated our path and revealed the absolute splendor of the cave's interior. Glistening white stalactites draped the ceiling, yet the floor, carpeted with golden sand, had absorbed the dripping water and allowed us to walk without concern for possible pitfalls and stalagmites. For almost a mile we penetrated the cave—surely the most enjoyable walk that any of us had ever experienced—but to reach a climax in a hall full of paintings was almost too much. I alone had been granted permission to take but one photograph inside the cave, and the choice of subject was not difficult.

On a low ceiling I beheld an outline of the head and neck of a horse painted in the now familiar violet-black manganese. It was one of the most beautiful works of cave art I had ever seen. The mane stood proud and upright in a laurel-leaf pattern, the ears pricked forward as if listening, and a muzzle seemed to test the wind.

I took great care over the photograph, desperately frightened of fumbling the operation, but the final result was excellent and immediately upon returning to my studio I made a print edition of the head.

After examining more paintings, including some extremely interesting fertility symbols portrayed in red oxide, we retraced our steps toward the cave entrance, observing several fine engravings on the way. On reaching daylight once more we were met by the director who had been responsible for the scientific research, lighting, and entrance excavation; work that had been carried out with the utmost care and with excellent results. We talked for a while, and I asked him if a name had yet been bestowed upon this important cavern.

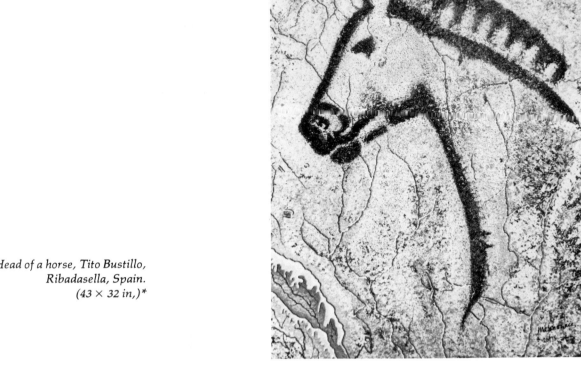

Head of a horse, Tito Bustillo,
Ribadasella, Spain.
*(43 × 32 in,)**

A decision had easily been arrived at, he explained. It was now proudly called "The Cave of Tito Bustillo."

How vitally important is the inquisitiveness of youth. There were Marsal and Ravidat at Lascaux, little Maria Sautuola at Altamira, the schoolchildren of Cuenca, and now, most recently, young Tito at Ribadasella. No doubt there will be many more.

. We must hope that these stories will be repeated and fresh discoveries made, for with each find will come a greater understanding. The need for more research into prehistoric art is urgent, and time is an important factor. Perhaps soon the opportunity will no longer present itself. The discovery of prehistoric paintings is young and still continuing. It is a field of study full of interest and by no means overcrowded, and one that embraces the nicer things in life. Exciting journeys to remote areas, enjoyment of books written by experts who provide surprising theories, and always there will be the great desire to know more about these artists who painted and engraved upon cave and canyon walls.

With this book I have not attempted to cover the subject as a whole. That is a task for which many books would be required, and each of the foregoing chapters would deserve separate volumes. This is merely an

introduction, and my intent has been to treat the subject as broadly as possible, and to describe its absorbing interest in precisely the same way as it was unfolded for me during the years. It is my sincere hope that these pages may provoke in the hearts of some readers a desire to learn more about our earliest ancestors, and to visit, before it is too late, at least some of the sites described.

A word regarding the illustrations. As I have stated previously, many of the paintings—particularly in the rock shelters—are rapidly deteriorating and do not photograph successfully. Many of the illustrations are from my screenprinted copies, and perhaps this is an advantage, for the mutilations caused by time and vandals leave little to be seen of the paintings' former glory. In making my copies I purposely leave out obvious graffiti and other mutilations. Thus we are able to study and admire, without being constantly reminded of the carelessness of modern man.

Many people are under the impression that all the caves of Europe have been closed to the public. This is not true. To help preserve the paintings, some are opened only when the serious visitor presents written permission. At a few sites this is easily obtained; at others it is more difficult, and at Lascaux almost impossible.

Therefore, a visit to the caves of France and Spain should be planned well ahead, allowing time for written requests to be received and dealt with. For the casual visitor who may suddenly find himself in the area of the caves, the appropriate place to inquire is at the nearest local museum. It is there he will obtain the latest information, and with luck permission, if necessary, to visit the sites. Like museums, caves have opening and closing hours, and all may vary. The guides and custodians of the keys may live nearby or several miles distant. Some caves stay closed all winter, to open only between June and September, during which time the many visitors are rapidly dealt with by harassed guides. The preceding chapters present some indication of conditions prevailing, but these are, of course, liable to change at short notice.

The rock shelter art of eastern Spain—or what is left of it—may be visited by ardent lovers of prehistoric art. Most sites, though not all, entail a long walk or stiff climb. Due to their inaccessibility, these shelter sites are the best ones to visit. Even so, they may appear disappointing.

The finest of the world's rock shelter art is at Tassili in the Algerian Sahara. The visit requires special preparations, and should be undertaken only by people in excellent health. The Touring Club of Algeria can arrange all details for a complete packaged round trip: Algiers-Tassili-Algiers.

The comparatively well organized itinerary of eleven days includes costs of air reservations, accommodation at Djanet, guides, truck and donkey transport, food and water, and even limited first-aid for cuts, bruises, and snake bites. For the Tassili journey, the best periods of the year are March/April and September/October, though the season runs throughout winter.

It is possible that you may not have to travel great distances to view the early art of man. Your local museum director can provide information on the

nearest available site, which may contain a great deal, or perhaps very little. Not always do the largest canvases contain the finest paintings.

But now is the time to examine the ones nearest to you. They may not be there for long. As villages become towns, towns cities, and cities spread and sprawl, so the countryside and her well-kept secrets will vanish beneath bulldozers and reservoirs.

Remember. To reach the site, you will have to leave your car. You'll have to walk—really walk—maybe climb and crawl. You will bark your shins and graze your elbows. You'll scrape your scalp and fall headlong over hidden boulders. But it will all be well worthwhile.

No true artist ever leaves a mark without trying to communicate *something.* So do not simply look at the paintings, observe them too. Whether you are a doctor, farmer, lawyer, hunter, craftsman, housewife, or student, it matters little. If you have troubled yourself to reach a painted or engraved site, then your own personal theories and opinions are of value.

In deep caves shrouded with silence, on walls of windswept canyons, in desert wastelands, on rocks hidden by thick forests, in these and other places man has left his mark: the animals he worshiped, the gods he feared, symbols and strange writings, his struggle for life, and the mystery of death.

Are the solutions to his problems portrayed in his art? Are they there awaiting the time when the key of our understanding will turn? And if we learn to comprehend, will the signs reveal more than just a story?

It could well be that they point a way.

Meandering lines made with fingertips in wet clay, Altamira.

Suggested Reading

Several of the books listed contain bibliography sections that will enable the keen reader to discover further avenues of research.

CAVE ART OF FRANCE AND SPAIN

Bandi, H., and Maringer, H. *Art in the Ice Age.* Praeger, New York, 1953.

Bataille, G. *Lascaux or the Birth of Art.* Skira Books, New York, 1955.

Breuil, H. *Four Hundred Centuries of Cave Art.* Montignac, France, 1952.

Daniel, G. E. *Lascaux and Carnac.* Lutterworth Press, London, 1952.

Giedion, S. *The Eternal Present Vol. 1.* Princeton University Press, Princeton, 1962.

Graziosi, P. *Paleolithic Art.* McGraw-Hill, New York, 1960.

Laming, A. *Lascaux.* Pelican Books, London, 1959.

Leroi-Gourhan, A. *Treasures of Prehistoric Art.* Thames & Hudson, London, 1968.

Oakley, K. P. *Man the Tool-maker.* British Museum (Natural History), London, 1956.

Sieveking, A. and G. *The Caves of France and Northern Spain.* Vista Books, London, 1962.

ROCK ART OF THE TASSILI PLATEAU

Lajoux, J-D. *The Rock Paintings of Tassili.* Thames & Hudson, London, 1963.

Lhote, H. *The Search for the Tassili Frescoes.* E. P. Dutton & Co. Inc., New York, 1959.

ROCK ART OF NORTH AMERICA

Dewdney, S., and Kidd, K. *Indian Rock Paintings of the Great Lakes.* University of Toronto Press, Toronto, 1962.

Grant, C. *The Rock Paintings of the Chumash.* University of California Press, 1965.

————. *Rock Art of the American Indian.* Thomas Y. Crowell Co., New York, 1967.

————. *Rock Drawings of the Coso Range.* Maturango Museum, California, 1968.

————. *Rock Art of Baja California.* Dawson's Bookshops, Los Angeles, 1974.

————. *Rock Art of Cañon de Chelly* (in preparation).

Heizer, R. F., and Clewlow, C. W. Jr. *Prehistoric Rock Art of California.* Ballena Press, Romona, California, 1973.

Kirkland, F., and Newcombe, W. *The Rock Art of the Texas Indians.* University of Texas Press, 1967.

Schaafsma, P. *The Rock Art of Utah.* Harvard University Press, Cambridge, Mass., 1971.

————. *The Rock Art of New Mexico.* State Planning Office, Santa Fe, 1973.

Swauger, J. *Rock Art of the Upper Ohio Valley.* Akademische Druck u. Verlagsanstalt, Austria, 1974.

GENERAL WORKS

Kuhn, H. *The Rock Pictures of Europe.* October House, Inc., New York, 1967.

Pericot-Garcia, L., Galloway, J., and Lommel, A. *Prehistoric and Primitive Art.* Abrams, New York, 1966.

Powell, T. G. E. *Prehistoric Art.* Praeger, New York, 1966.

Index